CAMP
GOOD DAYS
AND SPECIAL TIMES

CAMP
GOOD DAYS
AND SPECIAL TIMES

THE LEGACY OF TEDDI MERVIS

LOU BUTTINO | Foreword by Gary Mervis

THE
History
PRESS

Published by The History Press
Charleston, SC 29403
www.historypress.net

First published 2015

ISBN 978-1-5402-0226-0

Library of Congress Control Number: 2015938641

Perhaps we cannot prevent this from being a world in which children suffer,
but we can lessen the number of suffering children. And if we do not do this,
then who will do this?
—Albert Camus

To all children with cancer—yesterday, today and tomorrow.

Contents

CONTENTS

Foreword

The idea for this book came on a cold February day in 1982 as I sat alone with Teddi in her room on the fourth floor of Strong Memorial Hospital in Rochester, New York. As I looked at Teddi lying there in a deep coma, I couldn't help but think back on all that had happened during the almost three years since she was first diagnosed as having a malignant brain tumor. Now, more than thirty years later, the reach of Teddi's life has extended nationally and even internationally.

Camp Good Days and Special Times: The Legacy of Teddi Mervis shows how our family tried to make something positive out of the devastation of childhood cancer. It started as an attempt to bring childhood cancer out of the dark ages. Now, we have built one of the largest and most unique organizations in the world that deals with childhood cancer and other life-threatening challenges. Camp Good Days and Special Times is an obligation fulfilled—the obligation that adults have to suffering children.

In 1982, when Teddi died, childhood cancer was the second leading cause of death in children. The statistics have not changed much. What has changed are the hearts and minds of literally thousands of others—children, brothers and sisters, parents, grandparents, sports and entertainment celebrities, politicians and so many more, in America and around the globe—who have become part of Teddi's story.

In preparing the main body of this book in 1982, Lou Buttino conducted more than fifty interviews to ensure that Teddi's story was told honestly and from many points of view—those of family, doctors, nurses, classmates, friends, other children with cancer, clergy and neighbors. *Camp Good Days* is a real-life drama,

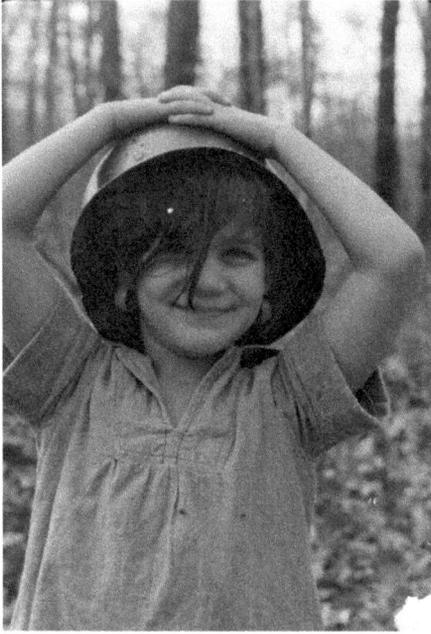

Teddi was always ready for a little mischief.
Courtesy of the Mervis Family Collection.

a story of compassion, courage and hope. But most of all, it is the inspirational story of how something good and enduring can come from an experience as uniquely tragic as the death of a child.

This book carries new additions, including this foreword. The main body of the book has been revised, and there is a brief, though comprehensive, overview of Camp Good Days for the past thirty-five years—our progress, programs, accomplishments and the challenges that lie ahead. Foremost among these challenges is Cancer Mission: 2020, the goal of which is to make cancer a disease with which those diagnosed can live *and* still maintain a decent quality of life. In other words, our aim is to move cancer from a terminal illness to a chronic disease (similar to what has been done with AIDS). Lou has also furnished a new introduction and a chapter titled "A Spiritual Journey," which contains his reflections on the camp and those involved, including me. There are also many more photographs in this edition of the book. It should be noted that Lou was given complete freedom in the writing of this book, in the beginning and now, without interference from anyone. And that includes me.

The most significant thing to happen to me since publishing this original story is my marriage to Wendy Bleier. In terms of the camp, she has gone from being one of our best volunteers to being one of the most important people at Camp Good Days. A former elementary school teacher and coach, Wendy started as a volunteer lifeguard, took on other responsibilities over the years and is now the executive director. She is an integral part of the Camp Good Days future.

I hope that as you read this book, it will be as inspiring to you as Teddi's short life was to all of us who knew and loved her. Though she is missed deeply, her presence is felt in the faces and words of so many of those I have met and heard from over the years. And now, you can join her circle of friends.

GARY MERVIS
Chairman and founder of Camp Good Days and Special Times
March 13, 2015

Acknowledgements

I am very grateful, in this round of revisions, to acknowledge the research and managerial support of Olivia Gosdeck and Philip Martello (Camp Good Days). Others from the camp's staff—including Samantha Looker—also graciously contributed their time and skills. My longtime friend Marlowe Moore helped fine tune the manuscript. Deedee Carey was, as always, helpful as a sounding board, and I am grateful for her insights. Her excellent photographs appear in this book. Laura Osborn, long considered Gary's "chief of staff" at Camp Good Days, read over the manuscript for accuracy and supplied useful commentary. I appreciate Lorraine Bruno Arsenault's support with the ups and downs of my experience with this book.

I appreciate the support and encouragement from The History Press—Whitney Landis, Katie Stitely, Leigh Scott and most especially senior commissioning editor Hannah Cassilly and publishing director Adam Ferrell. I am grateful for newspaper accounts, mostly from the *Rochester Democrat and Chronicle*, which helped fill holes in the story, and especially to Jeff DiVeronica, a sportswriter and friend, for his archival search at the paper. Without them, the chapter in this book titled "A Place in the World" would have been sparse and incomplete. Of course, Gary Mervis, one of my oldest friends, never hesitated to respond to my questions and shared his knowledge and experience, which is evident everywhere in this book. Wendy Bleier-Mervis, executive director of Camp Good Days, was also very helpful in her interview and in other conversations I had with her.

ACKNOWLEDGEMENTS

Last and foremost, my daughter, Megan, assisted in ways too numerous to cite here. Without her, I would have been lost. Though it was sometimes difficult to write this story about a little girl who dies, having a wonderful daughter of my own, I began to realize that, in truth, Megan is and always has been the North Star of my spiritual sky.

Introduction

It does not seem that long ago that I first met Gary Mervis—yet it has been more than thirty years.

When we met in April 1982, both of us were in our late thirties. I was a writer and professor of political science at St. John Fisher College in Rochester, New York; Gary was an up-and-coming strategist for the Republican Party. We knew each other by reputation, often the result of students at the college telling him about me and vice versa. Prior to that, I had read about him, and he had seen my work in the newspaper and on television.

It was late afternoon. I had received an invitation from Gary to meet with him at New York State assemblyman James F. Nagle's office in East Rochester, New York, where Gary was the executive assistant.

Gary took a seat at a large wooden desk, cluttered with papers and files. Behind him was a big picture window. I sat in a chair at the front of the desk and could see the gloomy, overcast sky. Gary spoke so softly that I had to lean forward to hear. He is a mesmerizing storyteller and remains so to this day. But that afternoon, he sounded sad, even depressed, as he rightly should have. His daughter had died a few months before.

We chatted some about mutual acquaintances and how we had come to know each other. Then he said I was probably curious about why he had called me. I was.

He said that he and his wife, Sheri, had seen a short story I wrote called "A Cloud for Kate," which had been published in the local newspaper. Because of its contents, they wanted me to write a biography of their daughter.

Even though it was so soon after his daughter's death, Gary believed it was important that others learn what it was like for children with cancer. At the time, and even today, in America and in other parts of the world, the attitude toward childhood cancer is still in the dark ages. Gary had experienced that attitude firsthand with his own daughter. He also wanted the book to include varying perspectives on the care of children with cancer. This point of view was to include doctors, nurses, teachers, parents, siblings and friends. Because there was little known about the treatment and care of children with cancer, he felt Teddi's experience would be helpful to others.

I waited for more, but he was quiet. "Anything else?" I finally asked.

"I want you to tell the truth," he answered. "Whether it's good or bad, and no matter how painful it might be to hear." He paused. "You will have unrestricted access to everyone you need to talk to, including Teddi's doctors, as well as full access to her medical records."

"Will there be any editorial control over what I write?"

"No," he said, shaking his head.

It had grown dark in the office without either of us noticing or bothering to turn on the light. We sat in shadows.

"I'm still not sure, why me?" I asked.

"Because your short story had the same sentiments as Teddi did before she died. Sheri and I both thought you had to be the one to tell the story."

We shook hands, and I left.

I drove off knowing this would be a life-changing experience but didn't know how or to what depth. I was in awe that a father would entrust me, someone he barely knew, with such a personal story. I also knew I wanted to work hard to fulfill the vision of this mourning father.

As Gary Mervis says in the foreword, I interviewed more than fifty people for the book. Some, like the Mervises, I interviewed several times. There was a priest, too, with whom I spoke. He had weekly talks with Teddi at the Mervis home before she died, and neither Gary nor Sheri knew what had been said during those conversations. They would find out from me.

We—Gary and I—had just one conflict over the book, as I recall. He was reading a little of one chapter and took issue with what I had written. I considered his point of view. I recall it was a minor point, but I could sense his anger at something much, much larger. I reminded him of his promise to let me have complete editorial control, and he relented. I thought it generous of him.

I am not certain whether Sheri has read the book, but I know that Gary still hasn't read it all, even after all these years. He'll read a paragraph or two,

maybe a chapter, but not the entire book. I wonder if he will ever do so—or needs to. After all, he lived the story.

The connection between what Teddi found at the end of her life and my words in the short story caused me to wonder about this journey I was about to undertake. I highlight what became a profound spiritual journey at the end of this book.

The main body of this story is in its third revision and update—a snapshot of childhood cancer in the late 1970s and an account of what happened to a ragtag organization that Teddi inspired. Camp Good Days and Special Times has emerged as an army of volunteers, a powerhouse of an enterprise, the goal of which is to help all manner of childhood afflictions today.

We live in a death-denying culture, and this book can be helpful because it is a real-life exposure to how an assortment of people, including a child, dealt with death and its aftermath. It's a book about human beings at their best in the worst of situations. It's about family, friendship and the better angels that reside inside us. It's also proof positive that if each and every one of us took the tragedy in our lives and made something good out of it, then we could push the darkness further and further away.

This book is important for another reason, as well: it is sometimes easy to forget the good that enters the world and stays. This story is a reminder of that. People who became a part of Teddi's story did things that were unselfish, not knowing anyone would ever find out about them. For these reasons and more, while the book and Teddi's story have helped many, much still needs to be done. We can also measure our progress as a civilization by the attitudes and responses to this one particular child. Teddi remains very much in this only world of ours through words, memories and Camp Good Days and Special Times. These things and more are also this spunky, honest and courageous child's legacy.

Those looking for pettiness, meanness or even scandal will not find it in these pages. Oh, there have been squabbles, miscommunication, differences of opinion and all the rest to which humans are heir. There are even those who put ego first and found the camp was not for them.

For the most part, children with cancer exist in a world all their own. As Gary said:

> *Children with cancer wage a daily battle with life. These special children have done nothing to cause their disease, and they carry no chips on their shoulders about the hand in life that they have been dealt. They learn at*

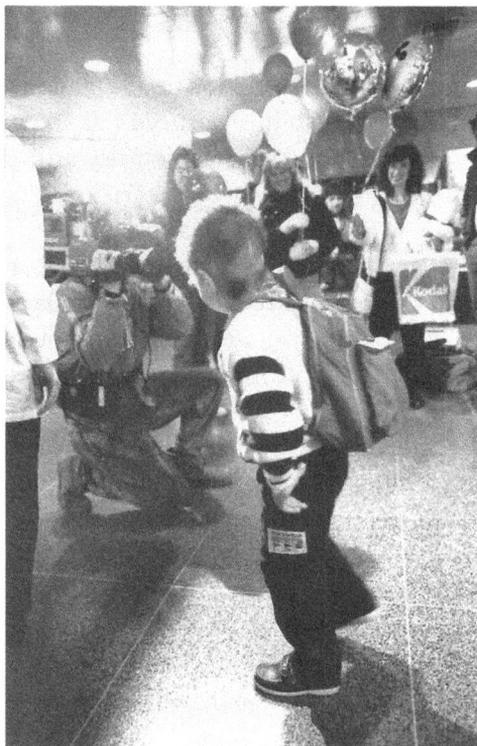

A child in remission leaves for Disney World. It was a last wish, sponsored by the Teddi Project. Unfortunately, he had to return home mid-week. *Courtesy of Lou Buttino.*

a very early age to say what they mean, and they know not to put off until tomorrow what they can do today. They grow up very quickly, and they know the true meaning of living life to its fullest.

Though these children occasionally leave the world Gary describes for treatment or to get something that can be provided only by the adults, they return to that world of their peers because they feel comfortable and safe—safe from ridicule, safe from being misunderstood and safe in their mutual knowledge of the painful brevity of life. In short, they have a kind of "death wisdom" not available to the able-bodied who believe they will remain disease-free and for whom time will never run out. Being around these children is humbling. And more often than not, they make a person better than he or she might otherwise have been.

LOU BUTTINO
Professor and former chair, Department of Film Studies
University of North Carolina–Wilmington
March 15, 2015

I

A World Comes Apart

That First Night

April 18, 1979, started off as a beautiful spring day. Winter had suddenly shrugged off its long stay, like an overcoat, and flowers, shrubs and trees exploded with new life.

Sheri Mervis, in her early thirties, was at work. Employed by the Monroe County Sheriff's Office, she was part of a security team responsible for safety in the courtroom and the transfer of prisoners. Gary, her husband, also in his early thirties, spent part of the day at the Mohawk Printing Company where he worked as director of marketing and public relations. He was a part-time employee of the New York State Legislature as well. Smart and a good strategist, Gary was making a name for himself in local and state Republican politics.

The couple married young and had three children: Tod, thirteen; Kim, eleven; and Teddi, nine. Sheri, with blond hair and blue eyes, was more reserved than her dark-haired, outgoing husband, whom all the children resembled.

It was the start of Easter vacation, and Tod had gone off with some friends for the day. Kim and Teddi, along with their friend Chrissy, had stayed home and played dress up in Sheri's clothes. The three caked themselves with make-up and looked somewhat less than beauty queens with the generous coating of lipstick that they painted on one another. Then, after spraying themselves overmuch with Sheri's perfume, the three headed for the driveway, where

Teddi Mervis enjoying life. *Courtesy of Tony Pierleoni.*

they pranced, danced and practically screamed the words to the top rock-and-roll hits from a radio in the garage.

It would be a hard day for Teddi because her mother had decided that it was time for Kim to develop friendships of her own and have experiences independent of Teddi. Teddi and Kim had done practically everything

together at that point, but their mother, having grown up with a younger sister, thought it best to begin separating the two. And so Kim was going to spend that night with her friend Chrissy without Teddi.

Late in the afternoon, the three girls went inside to wash up and change. Chrissy's mother, Irene, was to arrive shortly.

Irene Matichyn, who was in her thirties like most of the Mervises' friends, had come to know the family through her political work with Gary. Blunt and often irreverent, she had been Gary's assistant at the Republican state assembly office and then took over his job when he went on to become an assistant to Assemblyman Jim Nagle of East Rochester. Over the past few years, Irene and Sheri, like their daughters, had developed a strong friendship.

Kim and Chrissy climbed into the car in silence. Irene waved and called out to Teddi. "She was crying her heart out," Irene recalled. "As if I was taking her sister, and we didn't want her. As if nobody cared about her."

Teddi and her mother ate supper together that night. Teddi wasn't talkative, nor did she show much enthusiasm for doing anything in particular. She did complain about her eye twitching, and her mother rubbed it for a while. Being active herself, Sheri knew about muscle spasms. Though Teddi liked to read for herself, on this night, her mother read to her.

Gary had tickets to the Red Wing opener, Rochester's minor-league team, and had gone to the ballgame with a friend. He stopped home briefly after the game on his way to the state assembly office.

Though home for only a little while, Gary mentioned Teddi's unusually subdued mood. His wife reminded him that this was the first time Teddi had been left behind. Gary wasn't sure it was the right thing to do but didn't say anything. He said goodbye and left the house.

Later in the evening, Sheri and her daughter sat on the couch.

"Mommy, my teddy bear doesn't have a name," Teddi said.

Teddi's bear was brown with shiny black eyes. Its red felt mouth was partially gone, and the area around its nose and mouth was threadbare with wear. It had been Teddi's very first bear.

Sheri, a matter-of-fact kind of person, didn't skip a beat. "Of course it has a name," she said. "It's 'Teddy Bear.'"

"Oh, Mommy," Teddi said, shaking her head, "that's a boy's name. My bear's a girl."

Her mother thought it over for a minute and then suggested they call the bear "Teddietta."

Teddi smiled and seemed satisfied, and her mother returned to reading aloud to her. Sheri glanced over and saw in the reflective stare of her daughter that the

one thing in the world she needed most now was a friend of her own. "Teddietta will have to do for now," Sheri thought to herself.

"My eye's still twitching," Teddi said, interrupting.

Her mother rubbed it again, questioning, "It stopped for a while, though, didn't it, Teddi?"

Teddi didn't think it had. Her mother thought perhaps the child had not noticed.

The Mervis children were allowed to go to bed at whatever time they chose—there were no curfews unless a child had been unusually bad. Teddi was seldom a bad child, though. She was the helper around the house, a giver, somebody who smiled a lot and seemed to enjoy life immensely.

Teddi decided it was bedtime and went to her room to get changed. Sheri put the book away, and Tod came home. Shortly afterward, Gary arrived.

The couple talked about the day's events and then focused on Teddi—how quiet she had been and how hard it must have been for her to see Kim leave without her.

Sheri left to see how Teddi was doing and was shocked to find her with all her clothes still on, standing, her left eye and left arm twitching erratically.

"What are you doing, honey?" Sheri asked, alarmed but trying to keep control.

"Nothing, Mommy."

"What do you mean you're doing nothing? You're twitching."

"But I can't help it," Teddi answered.

"Stop it, Teddi!" Sheri blurted.

"I can't."

"You're scaring me. I'm going to call an ambulance to take you to the hospital if you don't stop," her mother said. Teddi was usually honest, but Sheri, panicking, felt that a threat like that would put an end to what was happening if Teddi were faking.

The child nodded her head yes. "Okay, Mommy," she said. "Please do that."

Sheri, her heart pounding, went to her daughter and knelt beside her. She held her for a moment.

"Come into the living room, Teddi," she whispered. "We'll sit you down."

Teddi was too wobbly to walk. Her eye and arm were still twitching, and now her face began to twitch. Sheri picked up her daughter and carried her to the couch in the living room. Hearing troubled voices, Tod came from his room. Gary came as well.

All three took turns rubbing Teddi's eye, arm and leg, trying to get the twitching to stop. Gary thought that maybe she was having a small epileptic seizure, a petit mal. He had worked with children as a recreation supervisor

and had seen similar symptoms. It also crossed his mind that perhaps Teddi was more upset by her separation from Kim than anyone originally imagined and that the emotional trauma had triggered the physical reaction.

Gary told his daughter to try to calm down. "Just relax," he said. The urgency and fear in his voice did not go unnoticed by his son and wife. Gary tried to hold on to Teddi's arm, but it jerked violently out of his hand, as if it had a life of its own.

"Call an ambulance," Sheri urged.

"I can't until I know what's wrong," he shot back.

"I don't know," she said, shaking her head. "But I think you ought to call one."

Sheri was afraid that some sort of paralysis was setting in and that Teddi's lungs would collapse. She called her pediatrician for advice. The doctor recommended that Teddi be brought by ambulance to Strong Memorial Hospital immediately.

The family members were not prepared for the fact that the ambulance took nearly forty-five minutes to arrive. They were anxious and upset. The Mervis home in suburban Pittsford was only about seven miles from Rochester, where the hospital was located. But the spring explosion of new plant growth had blocked the street sign. The ambulance couldn't find the house. The Mervises tried to remain calm, for Teddi's sake, but were unsuccessful. The ambulance finally arrived about ten o'clock.

Gary and Sheri followed the ambulance as it stormed its way to the hospital. They were speeding, too, and could see Teddi vomiting. Her mother knew that Teddi hadn't vomited since she was one year old and would be frightened. Gary still kept thinking the cause of Teddi's problem was petit mal. As they turned into the hospital parking lot, he mentioned this to his wife. Sheri shrugged, and the scene flashed before her of Teddi having a seizure at school, being embarrassed and her classmates rejecting her.

Several people—including nurses, the attending physician and other personnel—hovered around the child. The seizure activity was worsening; Teddi still vomited. Her arm shook violently, and she had no use of her left hand. The left side of Teddi's face was also twitching erratically, her mouth moving up and down uncontrollably and without sound, like a puppet's jaw.

The Mervises watched the feverish activity from its fringe. They took comfort in the arrival of their pediatrician, the one whom Sheri had called.

Though what was happening to and around Teddi was bewildering, she nevertheless kept her composure. She had a strong will for a child so young. The hospital's official admission chart documented her responses to standard

orientation questions: "I am at Strong Memorial Hospital. The president is Carter. This is Thursday."

It was just a little after midnight when Gary went to call his younger brother, Bob. He explained what was happening and asked if Bob would mind picking up Tod and letting the boy stay with him that night. Bob said that of course he wouldn't mind. Gary promised to call him sometime the following morning.

Gary then called Irene Matichyn. He told her what was going on and asked to speak to Kim. His daughter had been asleep.

"This is Daddy, honey," Gary said when Kim answered. "Teddi's pretty sick. Your mommy and I are here at Strong Memorial Hospital. What I wanted to know—did anything happen to Teddi today? Did she fall?" He paused. "Please tell me the truth, honey, did you push her or anything like that?"

Kim assured him that nothing like that had happened. They talked a few minutes more and said goodnight. Kim sat down next to her friend Chrissy, who had gotten up and was now sitting on the living room couch, and began to cry. Soon, they were both crying, believing that if they hadn't left Teddi behind, then none of this would have happened.

Chrissy's mother, Irene, tossed and turned for the remainder of the night. She kept going over the scene in her mind of Teddi standing in the garage alone, crying. She had thought nobody wanted her, Irene repeated to herself. "We should have never caused her to feel so rejected." Soon, they would all discover the truth was far worse than they had imagined.

Tod, Teddi's elder brother, had a difficult time sleeping that night, too. Before bed, he asked his uncle, "She's going to be okay, isn't she?" Bob tried to reassure him.

Gary also placed a call to his friend Skip DeBiase. Though it was late, he knew that Skip and his wife, Cheryl, would want to be told. Skip, whose baptismal name was Salvatore, was president of Mohawk Printing Company, where Gary worked. The couple was close to the Mervises.

Skip told Gary not to think the worst, that almost anything could have triggered the seizures. Gary agreed to stay calm and wait it out. He told Skip he'd call him later the following day. Meanwhile, Teddi had been given phenobarbital and Decadron. The twitching subsided but did not stop completely. A decision was made to keep Teddi in the hospital overnight for observation.

As she was being wheeled to the pediatric unit, the resident physician walking with them decided to take a detour. Why not take an X-ray of Teddi's head to see if they could find anything that may have caused the seizure? The X-ray was taken, nothing was found and grins broke out all around.

It was dark, and other children were asleep in the large room where Teddi was taken. She was exhausted at this point. "What time is it?" she asked her father. Her voice was but a whisper from the large bed in the large room. Gary looked at his watch. "It's almost two thirty in the morning," he told her. Displaying some of the same matter-of-factness and honesty evident in her mother, Teddi responded, "Oh, that's way past my bed time. I have to go to sleep now."

Gary turned to his wife. "Maybe you better stay with her."

Sheri didn't like the idea. "Why me?"

Gary was abrupt. "I can't stay in a hospital. I hate hospitals. I've never been in a hospital. And I never plan on being in one!"

Sheri maintained her control even though she was angry. "I'm not particularly fond of them either," she said.

They realized that they were both tired and decided to go home together, get a good night's rest and return to the hospital early the next morning. After all, the seizure activity had all but stopped now, and Teddi began to look like she always did. The doctor told them that the medication would make her sleep until late the next morning.

Sheri kissed her daughter good night. They whispered "I love you" to each other. Gary kissed his daughter good night as well. Before leaving, he turned the radio on so that Teddi would have some soft music; he thought it might make her feel as though she were not alone.

The drive home was a relaxed one. Everything seemed to be in control. The X-ray hadn't turned up anything. For all they knew, a fall, or even something as minor as an allergic reaction to cats, could have triggered the seizures. The couple felt confident and slept soundly that first night.

THE FIRST DAY

Early the next morning, the Mervises returned to the hospital. Gary dropped Sheri off and decided to head for a downtown department store. He remembered Teddi talking about a special teddy bear in the store window, and he wanted to get it for her now.

Sheri walked directly to Teddi's room on the fourth floor, the pediatrics unit of the hospital. She paused in the doorway of Teddi's room and saw an iron lung, which was widely used in the days of polio. This one was small enough to hold a child. Sheri put her hand to her mouth to

Teddi with her dad. *Courtesy of the Mervis Family Collection.*

stop the emotion rising up inside her. "Teddi's lungs did collapse," she thought to herself.

She turned. The night before, there had been a skeleton crew on duty, but now there was a full complement of nurses and a lot of activity. She could feel herself beginning to panic. She walked unsteadily toward the nurse's station.

"Did Teddi stop breathing?" she asked, point blank. The nurse was doing paperwork and now looked up.

"Who's Teddi?" the nurse asked.

"She's my daughter," Sheri answered. Though she had made the claim many times in the past, at no time were the words more painful to say than now. It was as if Sheri was not only laying a claim to her name but also to her life.

The nurse looked through some papers. "I'm sorry," she said, "but we don't have a Teddi here."

Sheri then motioned to what was Teddi's room the night before. She thought maybe Teddi was in the thing that looked like an iron lung.

"Oh, no," the nurse answered. "His name is Johnny—Johnny's in that."

Sheri tried to hold back her tears. "Well, then where's Teddi?" And then she remembered, "Oh, try Elizabeth. Elizabeth Mervis. It's under that name."

The nurse again looked through her papers. She shook her head. "There's no Elizabeth Mervis here, either," she said.

"Does that mean that Teddi died during the night?" Sheri asked, surprised by her own words.

The nurse turned ashen, rose and told Sheri to wait. The nurse then talked with others on the floor. A second nurse came over to where Sheri was standing. "Oh, I think I recall they put her in a private room next to the one she was in last night." The nurse pointed. "Over there," she said.

Sheri walked to the room the nurse had pointed to. She and Gary had requested a private room the night before. She just wished somebody had told her from the start, saving her all the aggravation and fear.

But when Sheri got to the room, it was empty. Another nurse came over to Sheri and said she thought Teddi had been sent upstairs for some tests. Back at the nurse's station, a nurse placed a phone call upstairs, but no one there had heard of a Teddi or Elizabeth Mervis.

One of the nurses located Teddi's admission papers. Teddi had been exposed to chickenpox recently, and early that morning, doctors had decided to move her to the adult neurological unit to prevent possible contamination of other children on the floor.

Sheri went to Teddi's room on the sixth floor and was now shocked to see her daughter asleep beneath a plastic oxygen tent.

"Does she need that?" Sheri asked the nurse.

The nurse shrugged. "We thought she might need it," she answered. Minutes later, the oxygen tent was removed.

Sheri sat beside her daughter. She gently rubbed Teddi's arm. Her daughter's face, normally pink, now looked pale; there were also dark shadows around her eyes. Teddi's hair, thick and curly, was matted in the back. Tears welled up inside of Sheri in reaction to how her daughter looked and at the madness of the morning. Sheri didn't cry.

As soon as Teddi woke up, she began to vomit. Her left side was nearly paralyzed, and because she was on medication, she was unable to move and began to choke. Sheri tried to turn her over, but her daughter's limp body made it too difficult. She yelled for a nurse. The nurse who came told Sheri matter-of-factly, "Oh, you have to tip her on her side like this."

Teddi was taken downstairs for a CT scan, also called a CAT scan. Positioned head first on a table, Teddi passed slowly through what looked like a giant, white-enameled doughnut. The scan provided pictures at one-inch intervals in a 180-degree arc. Painless and with no after-effects, the entire process for the area of the brain took about half an hour. Yet Teddi had to take the test alone in the brightly lit room. The heavy, leaded doors were closed tight, and doctors observed the procedure from an adjacent room. Test results showed that there was scattered swelling on the right side of the brain.

Dr. Curtis N. Nelson stopped by Teddi's room with the test results. Handsome, athletic-looking and careful in the words he gave to patients and their families, Nelson introduced himself to the Mervises, including Teddi. He said he was a neurosurgeon. Sheri liked him immediately. Her English heritage and mannerisms and her reserved style coincided with Nelson's calm, almost emotionless, demeanor. Gary, on the other hand, was initially more uncomfortable with the doctor when they met a few days later. Dr. Nelson told Sheri that the couple probably wouldn't be in need of his services. He had examined Teddi and thought the child was progressing normally.

In the hospital chart for the day, Dr. Nelson wrote that the CT scan was "not very suggestive of a tumor, though this is possible." He also noted that Teddi was "drowsy but wakens and gives name as 'Liz.'"

At that point, usually only her family, close relatives and friends called her Teddi. The name on her birth certificate was Elizabeth, after Gary's mother, who had died suddenly when Sheri was pregnant with the girl.

Gary had wanted to name her Elizabeth, but Sheri, hoping for a boy, wanted the name Ted. When the child was born, Sheri thought she looked like a little teddy bear. She was soft and pudgy with a furry crop of hair on her head, and so Sheri nicknamed her "Teddi"—changing the spelling to make it feminine—and the name stuck.

Later that first day in the hospital, Teddi was given an electroencephalogram, or EEG, to record brain-wave activity and see if the brain was functioning abnormally.

Teddi was tired, and Gary, after presenting her with a new teddy bear, was aware of her anxiety. While the medical personnel busily set up their equipment to conduct the EEG and prepared the two dozen electrodes to be attached to Teddi's head, Gary asked his daughter to whistle for him. This made Teddi laugh. Then Gary started laughing. Teddi, ever obedient, began to whistle. Gary was asked to leave.

Teddi's nurse noted in her report that Teddi seemed lethargic, though she could be aroused through verbal stimulation. Teddi had vomited at about 5:00 p.m. that day. At about 7:00 p.m., noted the nurse, Teddi was alert, talkative and better oriented.

That evening, Gary's brother, Bob; Skip and Cheryl DeBiase; and a few other close friends and relatives arrived. Most thought Teddi didn't look bad at all. Most thought, like Gary, that Teddi had developed some form of epilepsy but that—with modern drugs and other treatment—it could be controlled and Teddi would have a normal life. The Mervises expressed their concern that the medical staff was looking for problems that weren't really there. Gary even thought the CT scan was going too far.

Irene Matichyn arrived late. When she saw Teddi, she saw that something was terribly wrong. Skip, seeing her reaction, took her arm. Irene caught herself and didn't say anything, not even to Skip later, but she thought something in Teddi's eyes had changed, that something was different. Again, she played over that scene in the driveway when she had come for her own daughter and Kim, leaving Teddi crying and alone.

THE ANTE GOES UP

Doctors administered a second brain scan with radioisotopes the following morning. Radioisotopes are non-radioactive chemicals that allow the scanner to locate any abnormality in the brain without

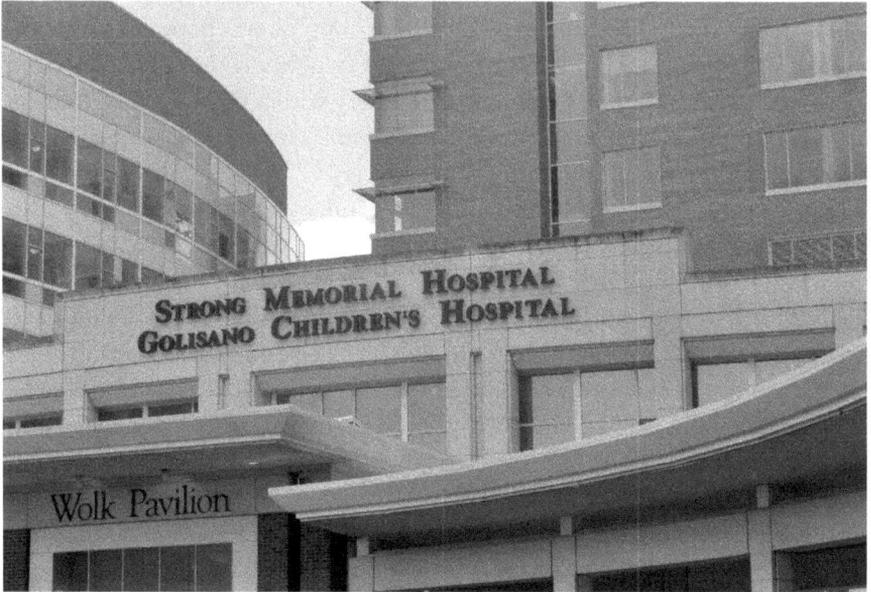

Strong Memorial Hospital, Rochester, New York. *Courtesy of Deedee Carey.*

harming normal tissue or causing pain to the patient. Doctors asked Teddi to change positions several times during the test so that images could be taken from the front, back and side.

The brain scan was unofficially reported as normal, and Dr. Nelson proposed a wait-and-see attitude. If the swelling in Teddi's head went down and her overall condition kept improving, then maybe she could go home. In any case, he suggested that further testing be deferred for a few days.

No overt seizure activity was reported on that day, though it was clear that Teddi's left side was weak. Her grasp on that side was less than firm, and she had trouble walking. She also complained of numbness in her left hand and on the left side of her face. The nurse also thought she was moodier, noting in her chart that Teddi seemed to be "emotionally depressed."

The following morning, the orderly who brought Teddi breakfast forgot to put the side rails up on her bed. Teddi fell from the bed and struck her head. A pediatrician was called to examine her but found no other damage than a bruise that was developing. But when Gary and Sheri Mervis arrived, they were furious about what happened. Another CT scan was done that day. Dr. Nelson came to the room afterward. Trying not to over- or underestimate the situation, he said the scan now definitely showed something. He wasn't sure yet what it was. He said it could be an aneurysm, a sac that forms on the

wall of an artery as a result of disease or injury. Sheri winced. Was it because of Teddi's fall earlier that morning?

The doctor went on to say that the scan might turn up something caused by the seizure activity itself. He also added it could be a tumor. Sheri, startled, immediately wanted to know if it was cancerous or not.

"It's in the light gray area," Dr. Nelson said, pointing it out to her on the scan. "That would indicate to me that it is not cancerous."

Sheri couldn't let go of her fear. "Are you sure?" she asked.

Dr. Nelson repeated that his experience with tumors taught him that if they were found in the light gray areas, they were generally not cancerous.

Sheri asked a third time. "Did you say not cancer? N-O-T?"

He nodded. "That's right," he said.

Sheri did not fear tumors if they weren't cancerous. She felt relieved now. In her childhood, she had had a tumor removed from her leg. The doctor had made a slit, popped it out and snipped it off. But when Gary heard that there might be a tumor growing inside his daughter's head, an old fear surged within him.

Though never an avid reader, Gary remembered one book that had a tremendous impact on him as a youngster, a book he read cover to cover despite its sad tale. John Gunther's *Death Be Not Proud*, the author's personal account of the death of his son as a result of a malignant brain tumor, had haunted Gary throughout his life.

A shift was now occurring in the Mervises' response to Teddi's developments. Sheri, upon hearing that the tumor was in all probability not cancerous, returned to Teddi's bedside. She would leave the medical and other details to Gary and instead concentrate her efforts on comforting Teddi.

Dr. Nelson suggested to Gary that they do a cerebral angiogram. The swelling in Teddi's brain had not diminished, and he wanted to find out why. But the stakes were getting higher. A cerebral angiogram contained inherent dangers; there was a consent form to sign.

The form was written in the first person, so Gary would be signing for his daughter. It read, "[Using] local anesthesia (Novocain) a needle will be placed in my groin, a flexible tube passed through the needle, and the tubing advanced into vessels going to head and neck; then dye will be injected and pictures taken with x-ray."

The form also explained some of the details of the procedure and then went on to cite the potential risks involved: stroke, bleeding, clot formation, infection, respiratory complication and reaction to the anesthesia.

Gary couldn't bring himself to sign the form. He talked it over with his wife, and they agreed they needed some time to think it over. Though both never said it out loud, each hoped that by postponing a decision, they could buy a little time for Teddi. Maybe she would get better. Maybe she could go home, and all the tests would stop.

On the surface, Teddi was, in fact, looking better. The phenobarbital was controlling the seizure activity. She was regaining the use of her left hand and was generally becoming more active. And Teddi herself kept asking why she couldn't go home.

Later that evening, two doctors entered the room. Their intention was to convince the Mervises that signing the consent form for the cerebral angiogram was the right thing to do.

After hearing them out, Gary shook his head. "It's pretty powerful stuff to be asked to make a decision for someone else based on so little information." He paused. His voice faltered, just for an instant, but it did not go unnoticed. "Especially someone so precious to you."

One of the doctors spoke up. "Well, you know, Mr. Mervis, we're talking about something that's potentially very serious. If the neurosurgeon has to operate, he needs to know where the blood supply is—where the vessels are located. The only way he can know that is with the results from an angiogram."

Gary wavered. The other doctor intervened. "We're talking about your daughter's life, Mr. Mervis," he said, his voice rising. "The likelihood of surgery is increasing every day. If it's an aneurysm or a tumor, then it will require surgery to correct."

Gary wanted to know the details of their argument. One of the doctors explained that if it was an aneurysm, then the operating team would try to repair the blood vessel. If it was a tumor, they would try to take it out. "You must understand," said the doctor, "that the neurosurgeon is not able to do anything unless he has these results."

The next morning, Teddi was wheeled into a large room lined with wooden cabinets containing medicine and angiogram testing materials. Placed on her back, Teddi was given a local anesthetic. A clear dye was to run through a catheter but the attempt to put the catheter in Teddi's artery, near her groin, failed. After several more time-consuming tries, the staff tried the artery on the opposite side of Teddi's groin. These attempts also failed.

Meanwhile, the local anesthesia was wearing off, and Teddi grew restless. It was imperative that Teddi be able to lie perfectly still because the angiogram required the catheter to be threaded through Teddi's system of arteries until it was able to reach the brain. The radiologist's job was

to guide the catheter through the network of blood vessels via the use of a fluoroscope, which provided a picture of the catheter's movement. The fluoroscope was like a small TV and hung just above the table.

Because the anesthesia was wearing off, the doctors thought they would postpone the test until the following morning. The danger was that a restless Teddi could cause the catheter to pierce or otherwise bruise a blood vessel, causing a clot, which could result in death.

Gary and Sheri were waiting impatiently for news from the doctor. The procedure, they had been told, could take anywhere from one to four hours. Teddi had been in the room for four hours, and now all three were told they had to go through it all again the following morning.

On the fifth day of Teddi's stay in the hospital, April 24, 1979, the doctors performed the angiogram, this time applying general anesthesia. They were successful in inserting the catheter and completed the angiogram. Attempts were made to lift Teddi from her anesthesia at about 12:15 p.m. At about 2:30 p.m. that afternoon, she was alert and hungry. She took short naps for the remainder of the day. After the second angiogram, she was described as stable but uncomfortable. Teddi seemed even more alert and aware by suppertime. Gary mentioned this to the nurse and said he believed the muscle tone in Teddi's face had improved. He also told the nurse that she was walking more that day. Her grasp was better, and her smile, he thought, looked almost normal again. The nurse reported these comments. She also noted that Teddi seemed increasingly worried about what was happening to her.

Dr. Nelson brought the results of the angiogram to Teddi's room that night. It revealed a mass in the brain. He favored a craniotomy and biopsy.

Gary reacted in anger, masking his pain and shock. "Why weren't there any signs?" he wanted to know. "Why didn't we notice it? Why weren't there any problems before Teddi had that first seizure?"

Nelson interrupted, trying to comfort this father, whose eyes were now reddened. It was the doctor's strong belief that the tumor was in a place that wouldn't affect Teddi physically or psychologically.

Gary interrupted. "Tumor? Did you say tumor?"

The doctor nodded. "Yes. It appears to be a low-grade tumor. There was a pause, and then he added, "But it is operable."

Nelson went on to explain that he believed the tumor was a low-grade astrocytoma tumor and that this type of tumor doesn't normally receive a lot of blood. This deficiency of blood, Nelson thought, might explain why it didn't show up on the CT scan, which was about 98 percent accurate in

diagnosing brain tumors. The good news, he told the Mervises, was that the astrocytoma tumor, when found in children, was not generally cancerous. He said it most often showed up in older people.

Gary shook his head, repeating the same phrase again and again. "I want you to be very aggressive and get it all out," he pleaded.

Dr. Nelson paused but then added, "Once you two get over the fact that what she has is a tumor—get used to that—then everything else will be all right."

Nelson explained the risks, complications and alternatives to the Mervises, including Teddi. He wanted to schedule surgery for the twenty-seventh, three days from then, and Teddi and her parents reluctantly agreed to go ahead with the operation.

Nelson left, and Teddi's parents tried to put a positive spin on this new development. They went over the basic facts for Teddi's benefit and their own: it was a low-grade tumor, a type that was generally not cancerous, and it wasn't in an area considered dangerous.

There were other things to consider as well. Dr. Nelson had a great reputation as a surgeon. Though the Mervises knew the waiting and wondering would be hard, they believed that once the surgery was over and Teddi recuperated, they could all forget about this unspeakable moment in their lives and go back to being a family again, with only normal problems and challenges.

A World Comes Apart

The new morning brought more anxiety and apprehension as Gary reviewed the latest consent form that he would have to sign. He didn't like it. Its contents—the risks and complications—were even more serious than the ones for the angiogram. The consent form this time also pointed out that death was a possible risk.

A nurse named Charlie had befriended Teddi. She sometimes came in to see the child on her day off. Now, she tried to comfort Teddi, who was extremely upset because her head was going to have to be completely shaved for surgery.

"Why can't this have happened to me when I was smaller and didn't know anything about it?" she complained. "I'm going to look awful without my hair. I wish I could die rather than have no hair."

Charlie read Teddi a book about surgery, supplied by the pediatric unit. Teddi cried at certain points. She talked about her fears regarding the operation. She said she was afraid of surgery and also of dying.

Nurse Anne Cameron came down from the pediatric unit to greet Teddi and escort her on a tour of the floor. Because Anne was young, gentle in her ways and a good nurse, she and Teddi quickly became friends. Their tour together, it seemed, lightened Teddi's sadness some.

Nothing unusual marked Teddi's preparation for surgery. Routine blood and urine tests were conducted; there was also a meeting with the anesthesiologist, who conducted the preoperative evaluation, which included selection of the proper anesthesia. Teddi was allowed a light supper the night before surgery but would have to fast until the operation was over.

Bob Mervis, Skip and Cheryl DeBiase, Irene Matichyn and a few other close friends and relatives stopped by the night before the operation to comfort the Mervises and to wish Teddi luck. They all said they would return the following day, except for Irene, who said she had a demanding day ahead. Sheri promised to call her once Teddi was out of surgery. They hugged, and Irene said she would come by after Sheri called.

It was quiet in the room now. "How soon can I go home?" Teddi wanted to know.

"We'll see, honey," said her mother, quickly glancing over at Gary. "The operation will hurt some afterward," Sheri said. "But not before that. It's nothing you can't tolerate, honey."

Gary again explained to Teddi that she had a tumor in her head and why the doctors had to take it out. Teddi wanted her dad to explain what a tumor was like, and Gary told her all over again that it was kind of like a mass of things—of cells—that had grown into a ball. He told her to just make it through the operation, and after that, whatever she wanted, he would get it for her.

Sheri and Gary assured their daughter that they would be back the following morning before she went into surgery. Teddi eventually fell asleep, and her parents kissed her goodnight. They were both alone and silent with their thoughts and prayers. As they were leaving, a new resident physician came in to introduce herself. She said she would be participating in the operation. The Mervises wanted to know if it were possible for her to leave the operating room at some point and tell them how Teddi was doing. She assured them that about halfway through the surgery she'd be able to leave momentarily. That made the Mervises feel somewhat better as they headed home.

Early the next morning, Teddi was further prepped for the craniotomy, including premedication to help relax her. Teddi's parents arrived, as did her uncle Bob, Charlie and a few others. They all walked with her as she was wheeled on a gurney to the operating room.

Her parents were the last to say goodbye. Gary kissed Teddi, saying, "Don't worry, honey. Everything will be all right." Sheri couldn't speak. She squeezed Teddi's hand instead. And just as Teddi was about to enter the operating room, her mother asked Charlie if Teddietta could stay by her side. Charlie said it would be all right.

The main area where the Mervises had to wait was busy with human traffic. The electronically operated doors dominated the lobby's soundscape and seemed to open and close thousands of times during the seven hours they would wait. Strangers rushed by or paused to ask directions of the receptionist. Others seemed to be looking for a familiar face. People also seemed to reach for each other's hands more once they got inside the hospital.

Not long after Teddi went into surgery, a nurse came from the operating room and gave Teddietta to Sheri, who would spend the long time waiting by bandaging Teddietta's head so that it would look like Teddi's after the operation. She thought it would make Teddi feel less different and alone. Gary talked with well wishers who had come by during the day. He spent time with Skip, who kept trying to reassure Gary that everything would soon be all right.

The sounds of a drill and saw dominated the initial activity in the operating room. Dr. Nelson made a rectangular incision on Teddi's clean-shaven scalp on the right side of her head. Four holes, each just a little smaller than a dime, were then drilled into Teddi's skull. These holes were connected with a saw cut and the window of bone removed.

A leathery membrane prevented Dr. Nelson from having a clear view of Teddi's brain. He proceeded slowly, looking for signs of the tumor. Then he cut into the membrane and could feel his heart sink.

To his surprise and dismay, Teddi's tumor had invaded the surface of the brain. Multiple implants were also visible. He cut into the tumor itself and found it rubbery. Nelson took a piece from the tumor's surface and sent it out for a frozen section. This would give him a preliminary reading as to the tumor's true nature.

He continued to explore the tumor, finding that it had grown into the brain tissue. Though it had not altered the brain's consistency, it presented dangerously few clear borders marking it from the brain itself. It had grown wildly, looking like the tentacles of an octopus, strangling parts of the brain and entangling itself elsewhere. Getting the entire tumor out was impossible.

Based on what he saw and the returned biopsy report, Dr. Nelson decided that the location and interlocking nature of Teddi's tumor meant that if he cut into the brain, the child might suffer personality changes and, in all likelihood, end up paralyzed on her left side. He decided against it, though he took out as much of the tumor as he could. He did not want to diminish Teddi's capacity to have a normal life in the time she had left.

Dr. Nelson put back the window of bone and unfolded the patch of scalp over it. He closed the incision. When he was done, his thoughts turned to what he would say to the Mervises. The most difficult part of his day was still ahead of him.

The Mervises were extremely agitated at this point. Sheri fidgeted with Teddietta as she sat in one of the large, brown hospital chairs. Gary paced and then stopped in front of Skip. "We'll have her out dancing tonight," Skip joked. Bob sat in a chair, watching the scene play out before him. He was too drained to move anyway.

One by one, the Mervises and their friends saw Dr. Nelson and a resident physician walking toward them, but all remembered the scene differently. Cheryl saw a smile on Dr. Nelson's face and was sure he was going to say that everything was all right. Skip, her husband, however, felt himself grow cold and tried to slip into the background. Bob could never remember that moment.

"We'd like to talk with you," Nelson said, motioning the Mervises toward the surgical waiting area, which was in a more private part of the lobby. Sheri's knees buckled, and she grabbed onto Gary's arm. Gary felt a terrible moan rise up inside him. They walked as if in a trance, oblivious to all sounds, movements and faces around them. Sheri sat down in a chair near a window; Gary stood beside her. Not far from them was a sculpture by Achille Forgione. One of its figures played a mandolin, the other a flute. Carved in stone at its base were the words:

> Gently they go, the beautiful, the tender, the kind;
> Quietly they go, the intelligent, the witty, the brave

Dr. Nelson's words drifted in and out of the fog the Mervises were in. They would both remember, however, that Nelson seemed rattled. "I was so surprised when I opened her up and saw the cancer," he said. "I was so surprised I couldn't believe it." He then explained that Teddi's condition was extremely bad, that the biopsy taken during surgery revealed that the tumor was malignant. He told them that it was in a section of the brain critical to

Teddi's life, and because of that, he had not tried to take very much of it out. As bad as that was, he then went on to say that the immediate concern was whether or not Teddi would survive the surgery itself.

Nelson continued, telling the Mervises that they were going to have to begin exploring forms of treatment other than surgery to combat the tumor. He explained some of the alternatives, commented on their feasibility and effects and offered his opinions. But the Mervises had stopped listening. They couldn't hear anymore.

They had been waiting most of the day for Teddi to come out of surgery, to just get through that part of it. They had come to believe that surgery was the last step—not the first—of Teddi's ordeal. Never had they contemplated Teddi's death, either then or in the foreseeable future.

As Dr. Nelson and the resident physician left the Mervises, Sheri's mother went to her, afterward returning to tell the others what had happened. Cheryl went over and slipped her arm around Sheri. Cheryl remembered how tense she was, emotionless except for the slow tears that began to fall from her eyes. They hugged each other. All the while, Sheri kept squeezing the bandaged Teddietta close to her heart.

As Gary turned, Skip could see that his eyes were red. Skip got closer and saw tears beginning to stream down Gary's face. As their arms met, Skip felt his friend go limp. He held Gary. "Come," he said, "walk with me."

As they passed by the electronic doors to the outside, Gary began to cry. "Why? Why my baby?" he was saying. "Why Teddi?"

Skip still wasn't sure exactly what had happened, but it no longer mattered to him. He wouldn't let himself cry; it was clear his friend needed him. He could feel sorry for himself later. Once again, Skip kept trying to reassure Gary, who was still crying and asking why. Skip didn't remember what he said, but that didn't seem to matter either; it was almost as if the sounds the words made mattered more than the words themselves.

"Gary," he told his friend, "whatever it is, it's going to work out. And it might look bad right now, but they're coming up with things all the time. She's going to be responsive to treatments." He kept talking and all the while knew Gary wasn't listening to a single word.

Suddenly, after about twenty minutes, Gary caught hold of himself and said, "Where's Sheri?"

Skip took the remark as a sign that Gary was ready to go back inside. He took Gary's arm, and together they walked toward the hospital door.

The rest was like a slow motion scene in a movie. Those with Sheri slowly began to leave her side. Gary, overwhelmed by his own sorrow, now saw

the self-same sorrow in his wife's eyes. It was about Teddi, the child they had loved into the world. And now they would have to wait until she was taken from them forever. They couldn't know, nor would they be capable of knowing, that this was the beginning of many such moments.

Moments later, Irene came bounding through the main lobby looking for Sheri. She had been worried, then angry, that Sheri hadn't called her at work as she promised. "Damn it!" she said, "I'm one of her closest friends, and she hasn't even let me know what's happened."

Irene saw Skip and Cheryl both crying and stopped dead in her tracks. It was going to be bad. Deep in her heart, she knew all along it was going to be bad.

Skip saw what was happening with Irene and went over to her as quickly and discreetly as he could. She collapsed in his arms. "It isn't good," Skip whispered. "They're worried she might not even make it through the night."

"Where are the Mervises?" she asked, weeping heavily now.

"Be strong," Skip answered. "They need you to be strong."

Irene found Gary and could see he was devastated. Though they had worked together for five years, sometimes ten hours a day, they had never hugged each other. But they did now.

Sheri had slipped away from the others and was trying to gain entry into the recovery room. A nurse stood in the doorway, forbidding anyone to enter. Only medical personnel were allowed to go in.

Sheri was suspicious. They told her it wasn't cancer and it was. Then they said they were going to take the entire tumor out, but they didn't do that either. She wondered if Teddi was already dead. Was that why they didn't want her to go in? Sheri couldn't breathe.

Seeing her, the nurse allowed her to go in, but only for a moment. Sheri saw that Teddi was breathing and put the bandaged Teddietta on the bed next to her daughter. She shook her head and exited the room.

Gary had also left the others now. He found Dr. Nelson talking to another doctor and interrupted. He began to ask every question rushing through his mind.

The doctor was aware there was still a great deal about the tumor he didn't know. "Well, Mr. Mervis," he said, "I've got to be careful how I talk to you."

Gary misinterpreted Dr. Nelson's words as those of a man who was afraid. He exploded. "Forget about me suing you or anything like that!" he shouted. "I've got two other kids at home! I've got to go back and tell

them what the hell is happening!" And then the words came out, the words Gary himself didn't know he was about to say. "What are we talking about, doctor? Christmas? Is she going to be alive by Christmas?"

"I don't know," Nelson answered. All he could tell Gary, he said, was that the next twenty-four to forty-eight hours were going to be critical. She needed to make it through recovery without infections or other serious complications.

Gary wasn't satisfied. "I'm not going to let you off the hook," he told the doctor. "It's not my nature. You're Teddi's doctor now, and you're going to stay with us until the end."

Wrestling with the Devil

The elevator doors opened, and Teddi was wheeled out on a bed. Her head was bandaged, and iodine dripped from beneath the white gauze. Her face looked almost bruised, ashen and blue with a tinge of green. The bandaged Teddietta lay beside her.

Sheri touched Teddi's face and found it freezing cold. "They lied to me," she muttered, too soft for the others to hear. "They lied to me. She's going to die right now. She's gone."

An orderly wheeled the bed slowly down the corridor, Teddi's parents following. Sheri's mother, Bob, Skip, Cheryl, Irene and a few others also walked behind. Some held hands; each one was alone with his or her thoughts. Heads shook in disbelief and grief. Skip thought it resembled a funeral procession.

Once Teddi entered the intensive care unit, the medical staff went to work. First, they hooked her up to a heart monitor. It was small, like a television set; three wires connected it to Teddi's body with a sticky substance. The apparatus was so sensitive that if the patient moved suddenly, a shrill, persistent alarm sounded.

Two IVs from a pressure pump measured the amount of fluid entering Teddi's body. It was necessary because any error in measurement after surgery could be fatal. The machine was also capable of alerting the staff if air entered the tube or if the fluid was going into the skin rather than a vein. A different alarm sounded if these problems occurred.

A long tube extended from another bottle through Teddi's nose to her stomach. From it, a greenish-yellow fluid slowly dripped from Teddi's stomach

into the bottle. The purpose was to drain her stomach so she wouldn't vomit. Over Teddi's head, on a shelf, was a black bag used when breathing stopped. Each of the six beds in the pediatric intensive care unit had a similar setup. The room was either noisy or quiet. That afternoon it was noisy.

Gary watched as Skip poked at Teddi's cheek. She opened one eye, a smile starting in the corner of her mouth. "Don't you bat those eyelashes at me," he kidded.

Almost immediately, Teddi drifted back into sleep.

Skip looked up at Gary. "It can't be," he said, shaking his head. He left the room. He felt himself short-circuiting and left the hospital, pacing in the parking lot alone.

Teddi was restless that first night after surgery, and there was almost constant activity in the room. Every hour for the first ten hours, her heart rate, respirations and blood pressure were checked. Neurological checks were also done nearly every hour. Their purpose was to test whether her brain was functioning normally. Nearly every hour, a nurse opened Teddi's eyelids and looked in with a flashlight to see if her pupils would contract. Teddi was also awakened each hour and asked her name, how old she was, where she lived and if she knew where she was. Despite the apparent absurdity of waking somebody so gravely ill, the procedure was vital: failure to respond properly was the first sign of increased pressure on the brain. The child was in critical condition.

The Mervises, too, had a restless night. Sheri went over all that had led to that moment. She thought about the future, the slow undoing of all their lives, the slow breaking of her heart. She prayed for courage and for mercy.

Gary was angry at God. He wondered why God would want to take a child. His child. His Teddi. Why wasn't a crook or rapist or murderer chosen instead of his baby? He wondered why God hadn't picked him instead.

What made it even harder was that Teddi was such a good kid, thoughtful of others, cheerful and kind. She carried his mother's name, the name of the woman who had been central to his life. Gary thought about her now and how she had encouraged him through all his difficult years of raising a family, going to school and becoming his own person.

His mother had died relatively young, at the age of fifty-one, choking to death on the floor of a restaurant while Gary, Bob and Sheri, pregnant with Teddi, frantically tried to revive her. Skip would note that whenever Gary talked about his mother, it was the only time he showed emotion. "Not a day goes by," he had said to Skip, "that I don't think about my mother." He

also told Skip that he didn't think anything as devastating as the death of his mother would ever happen to him again.

Unable to sleep, Gary went into the kitchen. He had a glass of water. He looked at the clock. It was 3:30 a.m. Then, he sat at the table. Sheri had fallen asleep by now. Tod was at his uncle's house. Kim was staying at Irene's.

He wondered about his children. What would he tell them? How would it affect them? He wondered about his wife and how she would hold up under the strain. Could their marriage endure all the challenges and pain that lay ahead?

His thoughts turned to his own life and career. Every decision in his control during the course of his political life had been carefully calculated to maximize his strengths and bring him to the center of power. For eight years, he made contacts, developed his skills and built a reputation as one of the best campaign managers around. He was one of the youngest and best of a new breed of Republican politicos.

Gary wondered what would happen to all that now? Would the power brokers in Albany dismiss him now that there was something else on Gary's mind, something without parallel? "Where will it all lead?" he wondered again and again.

Just a month before this development, he had taken a position offered to him by Skip. Skip was his friend and would understand what he was going through. But how long could he lean on him? How well could Skip's business compete when a key team player had his heart elsewhere? Gary wondered if he'd be able to hang on to his job. Would developments affect his friendship with Skip? If he couldn't hold on to his job, then how would he support his family? Keep the house? Keep his self-respect?

Gary pushed himself away from the table. He looked out the window, staring into the darkness. He thought about Teddi again, remembered how her face had looked after surgery, how bruised it was, the gauze with the iodine dripping down. He wondered how much time Teddi had left. Would the hospital be calling to tell him that she had died? Would he and Sheri arrive at the hospital that morning to find the room empty, the bed being readied for a new patient? Would anybody except God really know for sure how much time his daughter had left to live? Gary's anger returned now, but this time, he wasn't sure who or what he was supposed to be mad at.

Something began to change inside him. Gary Mervis was not the type of person to feel sorry for himself, at least not for long. He didn't like being on the sidelines, part of the crowd or stuck in the audience. Had Gary been born in a different part of town or in a different city or even era, he might have been a winning football coach or the manager of a world-champion

boxer. Instead, he chose to compete in politics, traditionally the place where dreams and self-interest, purpose and practicality nestled together under the same roof.

Though involved in politics for only eight years, he had already managed or helped to manage more than 150 state and local campaigns. Restless, even bored with the day-to-day functioning of government, Gary's passion was for the race itself. Though soft-spoken and even a little shy, inside he was a ferocious competitor who loved to win.

One thing Gary began to understand was that no matter how brief Teddi's life might be, he wasn't going to be on the sidelines any longer, leaving her fate to others. "I owe Teddi more than that," he said in the empty house, startled by the words he had spoken out loud.

A new campaign began to take shape in his mind. This time it wasn't going to be politics; it was going to be for his daughter. He'd use what he had learned, lean on people he knew and wouldn't quit until he had his Teddi back on her feet. On the wall of his office at Mohawk Printing were Vince Lombardi's words, "Winning isn't everything, it's the only thing." One of Teddi's counselors remembered Teddi telling her, "My dad is not a quitter, and neither am I."

There was a relationship between politics, even war, and cancer long even before Gary Mervis elected to join the fray. President Richard Nixon had proclaimed a "war against cancer" in 1973. Medical textbooks described cancer as an "army" of cells "invading" or "infiltrating" healthy parts of the body. Doctors referred to the disease as "the enemy." Further, without provocation, these cells crossed "borders" and "frontiers." Being the "aggressor," cancer had to be dealt with swiftly, usually with a "surgical operation," like they called certain types of operations in Vietnam. The struggle for the "hearts and minds" of combatants and victims alike didn't get talked about much, as if failure were a nonissue.

The campaign Gary Mervis was to embark on was against a tiny cell in his daughter's head that had somehow gone berserk—dividing and subdividing and dividing and subdividing, over and over again, until it outpaced the growth of healthy, "good" cells. The bad cell and its terrible offspring, now a mass inside of Teddi's head, was medically described as "malignant." The Latin root of *mal* means "bad" or "evil."

The word "evil" pushed Gary's battle to a higher plane. People were afraid of even saying the word "cancer" out loud, as if doing so would somehow awaken it, beckon it to one's own door.

Cancer seemed to mock America's faith in the infallibility of doctors and the ability of science and technology to defeat any medical foe. Cancer had

become synonymous with death itself, sinister and mysterious, unpredictable in its coming and indiscriminate in the lives it claimed. It was a twentieth-century plague.

But unlike earlier plague manifestations, with fleas on mice and rats as carriers, cancer's cause remains largely a matter of speculation. Its symptoms, unlike the plagues, are not always the same. It can show up as a severe pain somewhere inside the body, or as twitching, as in Teddi's case.

Gary Mervis was about to begin the toughest and most important campaign of his life. It would require everything he knew and all of his energy. He would need to learn all there was about the opposition and recruit to his side the very best there was in the medical world. He would have to lean on others and ask those he had helped to now help him.

The campaign Gary Mervis was about to wage was a campaign of the heart. Its goal was to save Teddi's life, and the competition was as small as a cell and as big as God.

Starting Over

Gary showered and dressed. He paced. He wandered about as dawn's first light filtered into the house. Around him was his life, what he had worked and sacrificed for, all he had built. He walked into the bedroom used by Teddi and Kim, which was empty now. He knew he was back to square one and that he and Sheri would have to struggle uphill again.

He and his wife had married young, just out of high school, and nobody—not even their parents—thought their relationship would last. Gary had come from the city, from a working-class family that struggled and scraped, never owning a home. In contrast, Sheri's father came from the corporate world; her family owned a lovely suburban house.

After exchanging their marriage vows, Gary, a family man now, went to college full time and worked full time. In a typical day, he would come home after work, talk to his wife briefly, look in on his kids and then stay up late doing his homework. On the weekends, Gary hustled other jobs to bring in extra money for his growing family.

After finishing college, Gary took a job in New Jersey, commuting home to Rochester every other weekend. Then, he began to work in Albany as a chief legislative aide. He was always away from his family, his children. Incidentally, he was to leave his Albany job for Nagle's office

Rochester Public Library, Rochester, New York. *Courtesy Deedee Carey.*

in East Rochester just one month before Teddi got sick. It was closer to home, where he wanted to be.

Because of Gary's school and work, Sheri assumed most of the responsibility for raising the children and caring for household details. "She's an extraordinary woman," noted a next-door neighbor. "You could see her mowing the lawn in the morning, on a ladder fixing the gutters in the afternoon and at night she would be looking absolutely radiant in an evening gown."

What Gary had done seemed absurd to him now. He had worn out his heart in order to make a decent living for his family and, in the process, had sacrificed his time with them. Now time was the only priority—for his family and for Teddi.

Sheri listened as he talked, sitting on their bed. He told her of his desire to consult with the best doctors in the world and to search out what was being done to cure brain tumors in children. Sheri nodded, understanding her husband's driving love and the nature of his heart.

Then, they talked about practical matters. They had read about and seen stories on the news and, in fact, knew personal examples of people who had lost everything they owned because of the onset of catastrophic illness. Now, with a sudden wrenching swiftness like an oncoming tornado, their own lives had completely changed.

How much was in their savings account? How much would Blue Cross/ Blue Shield cover? They searched their insurance policies and talked about taking out a second mortgage on their home.

The fullness of the morning sun was on them now. Outside, a dog was barking. Down the street, a garage door opened. And Sheri and Gary agreed, just as the world was awakening, to spend whatever money it might take to save Teddi's life.

Gary called his brother, Bob, to ask if they could meet at the library. Bob didn't hesitate. "Sure," he said.

The nights had been hard for Bob. Like everyone else close to Teddi, he thought the operation would be successful and everything would return to normal. But when he heard Teddi might die, he became depressed. He was not only troubled for Teddi but also for his brother. Bob poured himself a second cup of coffee and thought about Gary and their years growing up.

Though Gary was the older of the two, Bob felt he had been the one to take care of his brother. He remembered ironing Gary's clothes, making his lunches and sometimes cooking supper for him. Bob considered his brother almost helpless in such matters and thought he could probably never be self-sufficient. Yet he also admired his brother's capacity to motivate, organize and manage people. One thing was for sure: they loved each other.

Gary and Bob spent the day researching magazines, journals and newspapers. They looked for anything remotely related to Teddi's particular type of tumor and the kinds of treatment available for it. When they found something that looked useful, Gary, in his careful, neat handwriting, recorded it on a yellow legal pad.

Skip went to the hospital early that morning. He didn't knock at Teddi's door for fear of waking her. As he slipped silently inside, he found Sheri sitting on the bed. He took the moment in.

Sheri was holding Teddietta. Teddi was awake, and Sheri stroked her hand. She also occasionally stroked Teddietta. "God only knows," he thought, "where a mother would be at a time like this." In a way, Skip was grateful that visitors were allowed in intensive care for only a few minutes. He didn't know how long he would be able to hold up. Afterward, Skip went looking for Gary at the library. He was surprised at the look in Gary's eyes. It was different than it had been the night before. Skip saw that the fight, and the hope, was back in them. A father himself, he knew that if his child faced death, he'd move heaven and hell to try to stop it from happening.

"I've got to find out who to contact, Skipper," Gary said. "I've got to make sure Teddi will get the best care possible. I owe her that." He told Skip that

he was going to do anything and everything possible to save his daughter's life. If he had to take her to the four corners of the earth, he'd do it. If he had to spend every dollar and every minute he had to find a cure, then he'd do that, too. He said he wasn't going to have Teddi die only to have somebody say afterward, "Well, you know Gary, there is a guy in Taiwan you should have talked to. He might have helped." Gary was looking for gold and wasn't about to leave a stone unturned. "A man possessed" is how Skip described him at this point.

Skip joined the two brothers at the long wooden table, looking up books, articles and magazines. Bob photocopied the longer pieces that weren't overly technical and seemed close to what they wanted. The stacks of collected material grew higher; the list of doctors and hospitals that might be of help grew longer. What started to bother them, however, was the accumulated evidence of what they were finding: there didn't seem to be much agreement about the cause and cure of malignant tumors in children. Much of what they were reading was still experimental or speculative. Gary relieved Sheri at the hospital for part of that afternoon and evening.

Teddi seemed to be doing well, given the circumstances. Her right-hand grasp was stronger than that of her left hand, but she was able to move all her extremities now. She talked some, though her speech was somewhat halting.

An argument developed between Gary and one of the doctors. Skip arrived but tried to stay in the background.

"When can I get one of you guys to sign a form like the ones you make me sign?" Gary was saying, in a loud voice. "When can I get you to do what you promise you'll do?"

"We're not God," the doctor answered coldly.

Skip couldn't restrain himself. He stepped forward. "Then why in hell do you act like you're God?" he asked.

The next morning, the Mervises met with Teddi's pediatrician and Dr. Nelson. Gary told them both he was going to seek other opinions on Teddi's diagnosis and potential treatments. "I have made a list of some of the best doctors in the world, and I plan on contacting them." He paused, wanting to make sure they understood his intent. "I would like your fullest cooperation."

Dr. Nelson was uneasy. He wondered if the Mervises were going to go hospital shopping, desperate for a miracle cure that didn't exist. He had confidence in the personnel, technology and care at Strong Memorial Hospital and told Gary he didn't think there was much point in looking elsewhere. "If you want a second opinion, Mr. Mervis," he said, "we can

get one for you." Gary shook his head no. He told him he wanted to do that for himself. He was going to personally send out Teddi's records, tests and reports and have the results sent to him directly. He wanted the information to move swiftly, and with the minimum potential for error. He owed Teddi that, too.

The doctors tried to convince Gary that the people he wanted to contact were very prominent in the field and would in all likelihood be unavailable to help him.

Gary listened, taking it all in, mulling over how he'd get the prominent physicians to see him. He knew he had done a lot of favors for people, some of whom owed their present jobs to him, and he could count on at least some of them for help. He could count on other political debts. He had helped a lot of people over the years, often sacrificing time with his own family. Now, it was his turn to ask for help. If he couldn't open doors himself, he would try to get others to do it for him, even if it meant asking a state legislator or a United States senator.

When the doctors finished, Gary stood up. "I don't want you people to take the next step in Teddi's care until I've had a chance to talk to these people."

Dr. Nelson rose, telling him not to wait long, that Teddi's survival might depend on an early decision regarding treatment.

The Mervises walked in silence and took the elevator to Teddi's room. They were stunned by what they found. Teddi's face was swollen so badly that her eyes were closed.

"Daddy, am I blind? I can't see, Daddy," Teddi cried. She was sitting up in bed and reached out her arms toward the sound of their footsteps. They calmed Teddi. After that, Gary stormed from the room. He was stopping anyone he found. "What the hell is going on? Can't somebody tell us what is going on so that little girl in there doesn't have to live in terror when she wakes up in the morning?"

After that, at least one of the Mervises arrived early each morning and stayed late each night. They left only when Teddi was deep asleep and the floor quiet, when they could reasonably be sure that nothing adverse was happening, or would happen, to their daughter. Even still, they phoned the hospital from home at night to check on her. Both would be vigilant mother and father to Teddi, whether she was at home or in the hospital.

Looking for Miracles

The following morning, Gary placed a phone call to Kathleen Rose in Albany. Kathleen was Assemblyman James Nagle's administrative assistant and secretary, a person whom Gary had helped obtain her present job.

"Kathleen," Gary began. "How are you?"

"I'm fine," she answered. "I heard about things at your end and I'm sorry, very, very sorry, Gary. Is there anything we can do?"

"Yes," Gary answered. "I need your help."

"Name it," Kathleen said.

Gary smiled. This was one of the people on whom he would have to lean a great deal, someone he had confidence in and trusted.

He explained the basics of what had happened and said he needed her help in two major areas. First, he was seeking professional agreement on Teddi's pathology report. Pathology, in the medical field, was the attempt to understand the nature of a disease. In Teddi's case, Gary wanted to find out about the tumor. Was it a low-grade tumor? Slow growing? Was it highly malignant? How soon would it start to grow and get larger again? Determining the degree of malignancy would influence the course of Teddi's therapy, which was the second search that Gary would need to conduct. He wanted to find the latest and best cancer therapies and available treatment centers, no matter where he had to go and no matter what it might cost.

Kathleen was good at investigative research; she was dependable and persistent. She would make the phone calls, track down leads and suggest new possibilities. She liked helping, liked seeing politics used in the old-fashioned way, as an instrument for human betterment. Because she had a daughter herself, Kathleen felt she understood what Gary was going through. This only increased her determination to find the information and answers he was looking for.

It was May 1 now, and the first words in Teddi's chart that day were "malignant astrocytoma." The phrase hung there like a death sentence. Dr. Nelson also noted in his report that day that "the tumor looks quite aggressive." He thought she should be referred to the radiation therapy team but wrote, "The patient's father would like several opinions about tumor therapy." Teddi's condition was stable. She had several visitors, and gifts started to arrive. Word had gotten around that Teddi, like most children, loved stuffed animals. Her collection, consisting mostly of teddy bears, now numbered close to forty. Despite the newness and glamour of some of the bears, monkeys and even a large stuffed St. Bernard dog,

Teddietta—bandaged and looking even more worn and torn—remained a constant companion at Teddi's side.

Later that night, after everyone had left, Teddi complained to the nurse that her "stitches and head hurt." The swelling on her face, the nurse noted, seemed to have subsided.

One of the first pieces of information Gary asked Kathleen to investigate was an article, left anonymously on his desk at work, about the experiments of a Japanese doctor with a new drug called ACNU. Billed as a "medical breakthrough," the headline read: "Experimental Drug Destroys Brain Tumors." Though the reporter's name was given, there was no clue about the article's source.

The article told the dramatic story of an eleven-year-old boy whom the drug had saved. "When he came to the hospital, he could not stand up by himself," said the researcher, Dr. Yoshikazu Saito of Japan's Tottori University. "He had a brain stem tumor. In two months, with ACNU, there was a huge reduction in the size of the tumor. In eighteen months," the report went on, "he became a normal child again, returning to school. Since then he hasn't shown any symptom of the tumor."

Attempting to track down the source of the report, Kathleen contacted the science editor of the *New York Times*. She finally found out that the article was from the *National Enquirer* and obtained the reporter's phone number. He confirmed the story.

Kathleen told Gary, who was then in Albany himself, about her conversation with the reporter. Gary, in turn, put a call through to Dr. Saito in Japan. What he had forgotten was the time difference and that he couldn't speak a word of Japanese. Dr. Saito answered, groggily, and Gary tried to tell him in English that he was sorry and that he would try to call back later. Kathleen went to work trying to find someone who could translate for Gary.

On that first day, Kathleen also called the National Cancer Institute in Bethesda, Maryland, the organization charged with developing a coherent and systematic national program in the fight against cancer. It shares information, provides funding for research and establishes standards for research facilities and treatment centers.

Kathleen forwarded the *National Enquirer* article to the institute. Through the help of Barber Conable, a former western New York congressman who was now head of the World Bank, an appointment was arranged for May 17. Gary wanted to see if he could help.

Toward the end of the day, Kathleen also made contact with the chief oncologists at two of the leading cancer centers in the world: the Memorial

Sloan-Kettering Cancer Institute in Manhattan and the Roswell Park Memorial Institute in Buffalo, New York. The last phone call of the day was to the chief of pediatrics at the Hospital of the Albert Einstein School of Medicine. He agreed to review Teddi's records when her stay at Strong Memorial Hospital was over.

Meanwhile, at Strong, a resident had come by to talk to Teddi about the operation. The doctor noted in her report that "Liz" knew she had a tumor and that it could not be completely removed. She also added that Teddi was aware of the X-ray treatments but was not sure exactly what they were for. She said the child "expressed her desire to know."

Though in the morning she felt unusually tired, clinically, Teddi was doing well. There were no complaints of headaches, and she didn't vomit. The surgical wound, according to the nurse's examination of it, seemed to be healing well.

Bob Mervis was sensitive to the fact that, at that point, Teddi was becoming anxious about missing school. An elementary school teacher, Bob began to tutor his niece, picking up her homework himself after school.

It was May 2, and Kathleen Rose was trying to locate prominent neurosurgeon Dr. Michael Walker at the Baltimore Cancer Research Center. Walker had moved to the National Cancer Institute, and the assistant to Congressman Conable was trying to help contact him. Kathleen also telephoned the Child Cancer Study Group at the University of California in Los Angeles for advice regarding Teddi's condition. Experts there suggested she contact Sloan-Kettering and Roswell Park.

Having gotten through to the chief of pediatrics at Sloan-Kettering, Kathleen was told that if Gary had all of Teddi's records sent to them from Strong Memorial Hospital, they could then make an appointment. He felt that Dr. William R. Shapiro, a member of the American Association for Cancer Research and the American Society for Clinical Oncology, Inc., would see the Mervises without hesitation.

This part of Gary's campaign had a positive effect on him. Doctors and others had cautioned him that he might not be able to see these prominent people and yet here they were, ready to review the records of his little girl.

On May 3, Kathleen checked on a new radiation microwave treatment discovered by a doctor in Australia. It was reported to have dissolved tumors or reduced them and had few side effects, including no hair loss.

Teddi seemed to be making an astonishing breakthrough of her own that day. The nurse reported in her chart that Teddi "looked wonderful" and had no complaints, no headaches and no dizziness. She was out of bed and

walking, and there was no sign of irregularity or weakness. The nurse also noted that because of Teddi's improvement, her Decadron dosage was being tapered down. Teddi wanted to know when she could go home.

Later in the day, the doctor removed Teddi's sutures. The wound had healed well. He noted in her chart, "Father's wish to seek alternative opinions as to therapy discussed on 'rounds,' and feeling was that this should be supported to an extent in order that he will feel that he has done 'all' for Liz."

The next day, May 4, Gary drove to Roswell Park in Buffalo. He wanted to deliver Teddi's records himself. He was told that Teddi's pathology and a recommendation for treatment would be prepared as soon as possible.

An appointment for Gary was made at Albany Medical College with Dr. John Horton, head of oncology. Other professionals Kathleen spoke with suggested she contact Dr. Chu Chang of Columbia/Presbyterian Medical Center. It was located on Manhattan's Upper West Side and was part of a consortium that included Columbia University's Cancer Center Institute of Cancer Research. The consortium was one of the three federally designated "comprehensive cancer centers" in New York City. There were only twenty-two in the entire United States.

Both Kathleen and Gary made special note of both physicians and hospitals that were mentioned more than once. They would take a similar approach later in confirming Teddi's pathology and therapy options.

Kathleen called Dr. Paul Kornblith's office that day to schedule an appointment. Kornblith, with the National Institutes of Health, had been Dr. Nelson's mentor at Massachusetts General Hospital.

Teddi kept progressing. She could sit up in bed and in a chair. She wanted to and did walk more. Still, there were minor yet worrisome occurrences: one day, she had a nosebleed; another day, her left pupil was more dilated and slower to react than the right one. Teddi didn't complain about these occurrences, and according to the doctor's report, she seemed neurologically stable.

The doctor told Teddi that she could go home on May 7, and after nearly two weeks, she left the hospital. One hand was wrapped around Teddietta, and the other held on to her mother's hand. Once outside the hospital, Teddi asked that they stop momentarily. She took a deep breath, enjoying both the warm air and freedom.

Gary wasn't there to join them. He had remained in Albany because there had been a break in trying to communicate with Dr. Saito, who had experimented with the ACNU drug. Kathleen found a Japanese doctor at Albany Medical College who agreed to serve as an interpreter in the

proposed conversation. She had gone into Professor Hideshige Imai's office without an introduction or appointment.

"Look," she said. "Can you help? We've got a big problem, and we think you can." After explaining the situation and that they needed someone to translate Japanese, Dr. Imai said he would be glad to help. Kathleen had the overseas operator begin putting the phone call through.

Gary called home and talked with both Sheri and Teddi. He was feeling buoyant. As they waited for the overseas connection to be made, evening fell. Downstairs, in the state legislative office building, a celebration for Republicans was taking place. But Gary, along with Dr. Imai, was on the fifth floor in Jim Nagle's office, waiting. Irene Matichyn, in town on legislative business, was also present, there to lend moral support. The phone rang. It was Dr. Saito.

The questions poured from Gary. Had Dr. Saito published more information about his work with ACNU? He asked about the starting clinical conditions of the tumors Dr. Saito had studied. Had the doctor divided his study into those who did and those who did not have radiation therapy? Could other nitrosourea drugs compare with ACNU? What were the survival statistics of those treated with ACNU?

Gary was anxious. As soon as Kathleen nodded, indicating she had gotten all of Dr. Saito's remarks as translated by Dr. Imai, Gary was on to the next question. Satisfied, he gave Dr. Saito a rundown of Teddi's case. He finished with a final question: "Would you treat my daughter?"

Afterward, according to Kathleen's notes of the conversation, Dr. Saito had said his procedure involved surgery and the removal of as much of the malignancy as possible. Then radiation and ACNU as the chemotherapy treatment was applied. Dr. Saito said a sample of the drug could be sent to a doctor in this country but that it could not be sold because the FDA had not approved of it yet. The doctor went on to say that ACNU was not on the market even in Japan and that he used it solely on an experimental basis. As far as the United States was concerned, Dr. Saito said the best he could do was recommend that Gary contact Dr. Edward Laws of the Mayo Clinic in Rochester, Minnesota. Dr. Saito added that Dr. Laws would probably be reluctant to guarantee any cure even if Gary did take Teddi to Japan for treatment.

Dr. Imai hung up the phone, and Gary felt his discouragement return. There was a large gap between the headline announcement of a new miracle cure and the qualified comments of Dr. Saito.

The next morning, May 8, Gary met with Dr. John Horton, head of oncology at the Albany Medical College. Dr. Horton recommended radiation

therapy as the best alternative, though he confirmed that it could not cure Teddi's condition. He recommended radiation over chemotherapy but also told Gary that studies demonstrated that patients treated with radiation and the drug BCNU were doing better after two years than those treated with radiation alone.

For radiation treatment, Dr. Horton recommended radiation oncologist Dr. Omar Salazar. One of the best in the field, Dr. Salazar was at Strong Memorial Hospital. Horton told Gary, "I wish we had the money to bring him here."

Dr. Horton had also suggested that Gary contact Dr. Chu Chang at Columbia/Presbyterian Medical Center. That was the second time Gary had heard Dr. Chang's name mentioned, and Kathleen immediately placed a call to him. Dr. Chang said he would be willing to look at Teddi's records but that Gary would have to get them released by Strong's medical staff. It was hospital policy.

Time was closing in. Teddi's doctors at Strong had told Gary that whatever he decided to do on Teddi's behalf would have to be done quickly; otherwise, whatever benefits were gained from the surgery would be lost. It was also necessary for therapy to begin as soon as possible, before the dreaded tumor started to grow again.

Gary put in a call to Roswell Park. Were they ready with Teddi's diagnosis? Could they suggest a "protocol" or plan for medical treatment?

The pathologist said Teddi had an astrocytoma, a low- to intermediate-grade tumor, with some rapid growing. He recommended radiation treatment combined with chemotherapy.

"Where should I take Teddi for treatment?" was Gary's next question. The pathologist recommended Strong Memorial Hospital. All the frustration came to a head now for Gary. "Give me the chief of neurosurgery," he told the Roswell switchboard operator.

The doctor came on the line. After saying who he was and what the call was about, Gary asked for advice.

"Chemotherapy and radiation," the doctor said.

Gary hung up the phone. "Hold my calls," he told his secretary. Closing the door, he collapsed in his chair.

In spite of all the phone calls, travel and worry, he found little consensus or assurance about what was the best course to take. He had looked into the reality behind the headlines, had talked with the best in the field and what he found was that there was no miracle. In fact, the high priests of medicine were not at all certain about what to do.

As parents, he and Sheri would have to make a decision that was going to be hard on Teddi and costly to them, one with no guarantees about its effectiveness. On top of everything else, Gary had been told there was no cure for Teddi, a reality he didn't share with anyone, including Sheri. The couple was going to have to make what could be the most important decision in their daughter's life, and there was precious little to base it on.

The New Terms of Hope

Of the non-experimental therapies available to the Mervises, the best seemed to be radiation. After surgery, radiation was the second most common form of cancer treatment. More than half of all cancer patients received radiation as part or all of their treatment therapy.

The purpose of radiation is to alter the chemistry of the cancer cells themselves. Radiation causes cells to die immediately or sterilizes them, rendering them incapable of reproducing. It is also possible that treated cancer cells can fail to subdivide later, thus ending their reproductive process.

Another form of treatment is chemotherapy, which involves the use of drugs. Literally hundreds of drugs have been, and are being, tested for cancer treatment in the United States and around the world. The purpose of chemotherapy is to kill cancer cells quickly. The drug used must also be eliminated from the body quickly or it will damage or destroy healthy cells.

Chemotherapy is not without serious side effects, however, and these include nausea, vomiting, hair loss, susceptibility to infection and "blown veins"—veins that are hard, cord-like and ultimately useless. Because the drugs are so strong, veins inevitably become damaged or collapse, and blood cannot flow through them. More specific side effects depend on the particular drug being administered.

The cancer experts Gary talked with at Sloan-Kettering suggested that Gary meet with Dr. Lawrence Ettinger at Strong Memorial Hospital, a specialist in brain tumors in children. Gary set up a meeting. He and Teddi waited for half an hour. Dr. Ettinger didn't show, so they left, frustrated. A second meeting with Dr. Ettinger produced more positive results. Gary was surprised, and pleased, to see Dr. Nelson also attend on his own.

Even though Ettinger recommended chemotherapy, after the meeting was over, both Gary and Dr. Nelson were uncomfortable putting Teddi through the agonizing ordeal of chemical treatment when the proposed benefits were

so minimal. "If we do chemotherapy and Teddi goes through a lot of pain and still ends up dying," Gary asked his wife later, "would she have been better off if we hadn't done it at all? Would she have enjoyed the remainder of her life more?"

It was May 9, and Sheri met with Dr. Omar Salazar, the University of Rochester radiologist recommended by Dr. John Horton. A second appointment was scheduled for two days later so Gary could meet with him as well.

In the meantime, however, Gary had made up his mind. He phoned Dr. Salazar even before their meeting, telling him he had decided on radiation therapy only at this point. The pathologist at Roswell had recommended it, and so had Drs. Horton, Chang and Shapiro. The next day, Dr. Edward Laws from the Mayo Clinic recommended it too. Later, specialists at the brain tumor clinic at the University of California recommended radiation treatment as well.

Salazar sent what's called a "consultation report" to Dr. Nelson. In it, Salazar recommended that Teddi receive 150 "rads" daily, five days a week for seven weeks. This strategy was based on his observation, noted in the report, that "the tumor is deep, is related to ventricles and is already identified with dural implants." Salazar noted that increasing the radiation dosage was also a possibility.

When Dr. Salazar met with the Mervises on May 11, he told them Teddi's tumor had grown, was large and was now an astrocytoma grade three. This made it an intermediate-grade tumor. While Gary was searching for answers, the tumor had become even more dangerous. Salazar said it was more than five centimeters in size, and there was considerable swelling around it. "This is a very unusual tumor," he said. "It normally occurs in people who are quite a bit older, maybe in their fifties or sixties." While most of those Gary had talked with said radiation could not cure Teddi's tumor, Dr. Salazar wanted to try for the cure. There would be serious risks, to be sure, but the Mervises knew that death was waiting no matter what they tried or failed to do.

Salazar wanted to be clear about the risks: hair loss, severe swelling and possible brain damage. He told them, almost as an afterthought, that there was no way of telling when or if the tumor would continue growing.

As they left Dr. Salazar's office, the Mervises knew another tough part of their ordeal lay ahead: they had to explain their decision to Teddi. They would explain radiation therapy again, why they wanted to go ahead with it and what might happen to her as the therapy proceeded. And they would have to tell her that—despite all their logic and reasoning, despite

what she would have to endure—there was no guarantee that radiation treatment would kill the tumor and save her life.

As they drove home that evening, each parent wondered whether Teddi would be able to understand. Would she be overtaken by fear? Would she begin to lose confidence and hope? In the doctors? In her parents? In herself? Would she become so discouraged that she wouldn't care anymore? Wouldn't fight hard to stay alive?

Gary's first campaign had failed to accomplish what he had hoped for. But he felt it wasn't for lack of trying. What he sought, to the best of his knowledge, simply did not exist. The door to finding a miracle cure, certitude in treatment and confidence in therapy had pretty much slammed shut.

As the days turned into weeks, and the weeks into months, Gary continued to explore developments in the field of cancer research. The drug Interferon was hailed as one of the most promising discoveries of the decade, and yet its promise was more in the future than in the present. There was an attempt by the scientific community to discover the cancer equivalent of a guided missile, designed to harness the body's immune response. Hyperthermia was a method of heating the tumors to eradicate them. Laetrile—a chemically modified form of amygfalin and a naturally occurring substance found mainly in the seeds of apricots, peaches and almonds—was a controversial treatment.

Kathleen in Albany kept trying to find a breakthrough cure. She tracked down new leads and went back over old ones. She contacted holistic health centers both in the United States and Canada. She also had a friend, a psychic healer, whom she privately asked for help. He touched some things owned by Teddi that her father had dropped by. The healer told Kathleen things about the child he could not have possibly known or guessed at. But then he became silent, almost withdrawn. Kathleen never revealed what the man told her.

Gary, Kathleen and others continued to search for a miracle cure, but Gary's heart wasn't in it anymore. Under the circumstances, he felt he and his wife had made the best possible decision. Dr. Salazar was good, radiation received widespread support and Strong Memorial Hospital had emerged as a highly recommended treatment facility.

Gary also thought it best to be at Strong because then he would not have to uproot his family. He thought Teddi would benefit by being around familiar surroundings and her friends.

As the first phase of the most important campaign in Gary Mervis's life, the one to save his daughter, was drawing to a close, a period of discouragement set in. Others could tell. Skip thought Gary looked like a "little boy who had lost his way, like somebody whose whole world had been

turned upside down. He didn't know where things belonged anymore, where he belonged."

At this point, the struggle—for Gary, his family and friends—was how to keep hoping. They tried to comfort themselves with the chance of a miracle cure. It could come at any time, so it was important to keep Teddi alive as long as possible.

There was great love in Teddi's world. It kept coming, even getting bigger, like a river overflowing its banks. And there was also faith: faith in radiation, in doctors, in the power of love and in God.

In the time ahead, faith would have a more difficult time of it than love. But neither faith nor love would have as hard a time as hope. The things hoped for seemed beyond reach, and time was growing exceedingly short.

A Hard Lesson

"It's like a beam of light," Sheri told her daughter. "It goes into the tumor and it stunts its growth. It burns it, frizzles it up like a leaf that's been left in the sun too long. The tumor stops growing and turns brown. It would still be there, but it would be dead."

Teddi nodded, accepting the explanation about what radiation was supposed to do and what she would have to go through. She began treatment immediately and went every day of the week at 1:30 p.m. for eight weeks.

Sheri usually took time off from work to take Teddi. Sometimes Tod, Kim or one of Teddi's friends went with them. Afterward, depending on the time of year, they went shopping, to the park or to the zoo.

Gary also took Teddi in for treatment. His experience troubled him. Radiation therapy at Strong Memorial Hospital is administered in the radiation oncology department, which was separate from pediatrics. This meant that when Teddi went in for treatment, she saw only adults. There was never a child her age present who was going through what she was going through.

The procedure for radiation therapy was also isolating and intimidating. To prepare the patient for treatment, doctors put a mark on the body where the radiation beam would be aimed. The patient is told to lie perfectly still on a table and then wheeled into a room and left alone. Doctors communicated with the patient via a loudspeaker. The rooms where all this took place looked to Gary like the set for *Star Wars*.

Treatment made it difficult for Teddi to attend school. Though her parents arranged for a tutor to come to the house, not being with her friends and doing what they were doing compounded Teddi's growing sense of being left out and alone.

Teddi began to ask questions about God.

"Am I being punished, Dad?" she asked. "Is God mad at me?"

The questions hurt both father and mother. Teddi had always been a sweetheart—thoughtful, cheerful and without a mean bone in her body.

"Why me, Mom? Why me? None of my friends have cancer, even those older and younger than me. Why was I singled out to suffer and maybe die?"

Gary knew religious rationales for situations such as these: God was testing the person; God wouldn't give the person more than they could bear. But Gary knew he couldn't tell that to his nine-year-old daughter, who grew up believing in a good and loving God.

He did tell Teddi that it was natural for people to get sick because something didn't balance right. That's how the tumor got its start: something wasn't working right inside of Teddi. He encouraged her to not ask God why but to ask God for strength and to be there for her when she felt alone. Gary would later say that Teddi's dark eyes searched his, wondering if there was more he wanted to say. She'd then say, "Okay, Dad." But it wasn't long, her father remembered, before she asked the very same questions all over again.

Gary focused on the Serenity Prayer for Teddi: "God grant me the serenity to accept the things I cannot change, the courage to change the things I can change, and the wisdom to know the difference." He tried to get Teddi to understand the prayer and repeat it. They recited it over and over again before bed. Gary knew she was trying hard to understand, and sometimes after he closed her door, he broke down. Fortunately, Teddi didn't have many side effects during radiation therapy. She seemed more tired than usual, but that was about it.

The Mervis family journeyed to visit Dr. Paul Kornblith at the National Institute of Health in Bethesda, Maryland. Dr. Kornblith reviewed Teddi's records prior to the meeting. While the whole family had traveled together, only Gary and Sheri met with him that sunny May afternoon. After chatting for a few minutes, Dr. Kornblith got down to business. He knew how worried they were, and he didn't want to prolong their anxiety. "If there was something we could use to save your daughter, that could cure her—I don't care what kind of hell we would have to put her through—we'd do it," he told them. He paused, shrugged his shoulders and added that there was

nothing they could do to save or cure her. Silence fell over the room. Gary was the first to speak. "How much time does she have left?"

Dr. Kornblith answered, "Unfortunately, nobody can deal with the quantity issue. I can't tell you whether she's going to live a month, six months, a year, six years—nobody knows."

The doctor didn't think that was reason to despair however. "The quality of life she has, you can deal with. You can control that. What you should do is take what time you have and try to make it the very best time possible." As the family drove home, Gary kept thinking about Dr. Kornblith's words. He thought of the prayer he had encouraged Teddi to memorize and understand, and he began to see that the prayer was as much for him as it was for Teddi.

THE QUALITY OF TIME

After returning home, one of the first decisions Gary and Sheri made was to buy Teddi a dog. She was fond of pets, and pets brought comfort to their owners. Gary took out books from the library so Teddi could see all the different kinds there were. Her decision: a bulldog.

"You don't want that thing, really," her mother said. Gary told her it was ugly. Still, Teddi insisted it was the dog for her. Sheri went through the newspaper each night with Teddi until they finally found an ad for a bulldog for sale. Kim went with Sheri and Teddi to buy the dog. Teddi named it "Sweet'ums," and it was a big, ugly-looking dog that grunted whenever it moved.

Not long afterward, they bought Teddi a horse. Teddi had always loved horses, and her parents felt like there was no better time than now to let her have one. They let her play baseball, too, and do just about everything else a nine-year-old would want to do. However, they worried she'd fall off the horse and hurt her head or that a pitch would hit her.

The horse and the later trip to Disney World were part of the promise Gary had made to his daughter the night before surgery. He felt it important to keep her spirits up and her will to live strong.

It had been a hard spring. Never before had Sheri and Gary been so deeply hurt or bewildered. Their anxiety levels heightened, and sometimes it showed. For example, during the Disney World trip, Sheri anxiously called Kim over to her. Kim had been roller skating, and now Sheri nervously

examined Kim's leg. She thought she saw a bump, something that looked like a tumor.

Kim, like Tod, wondered if she and her brother would get cancer too, whether it was something a person inherited, like hair color or body size. In adulthood, another set of worries followed: would their children also become victims of cancer?

Teddi continued to respond well to the radiation treatments. She still wasn't becoming sick afterward as was expected. The fact that the heavy doses of radiation were not directed at an internal part of her body, such as her stomach or lungs, seemed to reduce the likelihood of vomiting, cramps and nausea. She still was tired after treatments, though, and often took an afternoon nap.

The medicine Teddi had to take along with radiation therapy was causing her weight to fluctuate significantly. This troubled Teddi. One time, she vomited during a doctor's visit. Dr. Salazar found out it wasn't from the radiation but because she was fasting to lose weight.

Then, one of radiation's key side effects occurred: Teddi began to lose her hair. One night, playing cards with her sister and her sister's friend, Teddi tugged on her hair and a handful came out. Surprised, she pulled on her hair in a different place. Startled, Kim and the friend began to laugh nervously.

Teddi turned to her mother for comfort. "I'm going to be bald," she cried. Sheri reminded her that the doctor had predicted this might happen. She also told Teddi the doctor had said it might grow back, too. They would have to wait and see.

"I'm going to be ugly, aren't I?" Teddi said.

Her mother would never accept such a statement from her daughter. "You could never be ugly to me," she said, holding Teddi as she cried.

The next day, Sheri and her daughter went shopping for wigs. They couldn't find one suitable for Teddi because wigs were made for adults, and none was designed to hide baldness. They did find an oversized wig that Teddi liked; it would have to do until they could figure something else out. Teddi called it her "Roseanna, Roseanna Danna" wig because it was similar in hairstyle to that of the Gilda Radner character on *Saturday Night Live*.

Kathleen in Albany mentioned Teddi's problem finding a child's wig to her ex-husband, a hairdresser. He had a child's wig, which had a ponytail, made up especially for Teddi. Gary took his excited daughter to the Greyhound Bus station where it was shipped.

Sheri also found a pink terrycloth hat for Teddi to wear. It was soft and floppy, and Teddi seemed to like it the best out of everything that went on her head.

After it became special to Teddi, Sheri couldn't, for the life of her, remember where she had gotten it and so could never replace it. Teddi kept wearing it anyway. It was washed so many times that it lost its shape and became so faded and frayed that it began to resemble Teddi's worn-out bear Teddietta.

By the start of summer, Teddi was looking better. Gary had wanted his family to make a commitment to be positive. He told them that, as a family, they were going to stick together and be there for Teddi. His family was pulling together.

The only practical thing that began to bother Gary that summer was how hot it was and the fact that Teddi didn't want to go swimming with the family at nearby Canandaigua Lake or Conesus Lake, as they had done in previous summers. Teddi was ashamed of being bald.

Gary and Sheri talked about getting a pool. Gary thought an aboveground pool would do; Sheri was concerned about the family budget. One early August morning, they called a contractor to get an estimate. They liked the bid, but the contractor couldn't install it the next morning as Gary had wanted. The telephone and electrical wires were in the way.

"You be back in the morning, and I'll have the wires moved," Gary told him.

The contractor came back but didn't bring his crew with him. He was surprised to find the wires moved. Gary had gone to the top at both utilities for help.

Late that month, Teddi was due in the doctor's office. Her radiation treatments were now over, and this examination was crucial. Dr. Salazar did a CT scan and noted in Teddi's medical record that the tumor "shows a favorable response at this point and this becomes a critical scan to compare with subsequent treatments." He also noted these troubling signs: slight incoordination with rapid alternating movements, a little tendency for the right eye to go inward, evidence of some dry blood in Teddi's right ear canal and some moderate changes in skin color as a result of the radiation. Dr. Salazar told the Mervises that he was generally pleased with the CT scan results and expressed his hope that Teddi would continue to improve. He told Teddi he expected her hair to grow back. Finally, he said if Teddi went back to school and continued to do as well as she was, he wouldn't need to see her for three months. He said a repeat CT scan would not be necessary for another six months.

This was the best news Teddi, the Mervises and their friends had received since before the surgery, which seemed so long ago now. Everyone was excited. When Cheryl DeBiase heard the news, for example, she got into her car and drove from Rochester to Canandaigua Lake, miles away,

to tell her husband, Skip. She stood on the dock shouting, "Teddi's going to be okay! Teddi's going to be okay!" as Skip sped toward her in his boat.

To Gary, Teddi looked good. With the radiation treatment over, her medication was reduced. That meant her weight started to come down. Her spirits were revived, and she was regaining her confidence and looking more like the old Teddi. There was a little more hope in his heart.

Sheri was troubled, however, even though she kept most of it to herself. There was, for one thing, the fact that Teddi seemed to tire so easily. Sheri also kept waiting for the dark circles around Teddi's eyes to go away.

Teddi's school friends started to come by, as well as some of her parents' friends—Irene Matichyn, Skip and Cheryl and others. Skip sometimes came with his new yellow Corvette on Sundays to take Teddi to the grocery store for candy or ice cream or just to cruise through the city and countryside. Sometimes he'd buy her things just to get the family in an uproar, like the button Teddi proudly came home with that said "A Bad Woman Is Good to Find."

One Sunday before Skip left with Teddi, he told Sheri that he and Teddi were going to go out drinking. "We'll be back in three days!" he said, taking Teddi's hand and heading for the door.

"You're not taking my daughter alone with you for three days!" Sheri shouted.

"C'mon, Teddi," Skip laughed, "don't listen to your mother—listen to me!"

They all laughed more; it seemed to come with the optimism. The radiation treatments were over, the tests were positive and Teddi was looking like her old self. The bounce was back in her step, and the ease was back in her smile. She flirted and was as talkative as she had always been. Those who watched sometimes nodded their heads as if to say, "She beat this thing. Thank God, she looks like she beat it." But not once in the presence of Teddi or her parents did these things get said out loud.

Teddi started to drop by and visit the Scobells, the next-door neighbors. Teddi had asked for permission to call the Scobells "Aunt Betty" and "Uncle Jim" because she felt they were more like family or friends than just neighbors. She would have tea and sometimes play cards. Betty Scobell, silver-haired and in her sixties, also had cancer. "We're going to beat this thing," Teddi said to her once.

Throughout autumn, Gary grew increasingly restless. He was doing the best he could in terms of trying to provide Teddi with quality time, but there still seemed to be more that could be done. He felt the call of yet another campaign, one that would provide Teddi with something that was larger than the moment, maybe even larger than her life, but for the life of him, he couldn't figure out what it was.

II
The New Terms of Hope

Back to School

Teddi was anxious to return to school that fall, hair or no hair. She liked to learn, read avidly on her own and often completed assignments long before they were due. Teddi also liked to socialize, and school was a great social experience for her.

Sheri talked with Teddi's homeroom teacher. She knew that he had recently lost two brothers to cancer and was worried about how he would react to Teddi. She feared he would either consciously or unconsciously keep Teddi at arm's length, afraid of getting close to still another person who might die. Sheri began by telling Edward Dwyer that if Teddi had a seizure, one of her girlfriends would take her to the nurse's office. Teddi would have phenobarbital with her, and it would, in all likelihood, make the seizure stop.

Dwyer, in his late forties, listened patiently. He nodded his head from time to time in understanding.

"I'm concerned," Sheri said finally, "that the recent deaths in your own family might somehow reflect on Teddi. That it might be hard for her and for you."

Dwyer shook his head. "No," he told her, the deaths of his brothers hadn't frightened him or made him afraid; they had deepened his capacity to care. Dwyer became a good teacher and friend to Teddi. Teddi would talk about him to her girlfriends, saying that when she grew up, she wanted to be a teacher just like Mr. Dwyer.

The role of educators and the educational system in relation to childhood cancer concerned the Mervises from that time forward. Sheri's feeling was that anything being structured into the educational system would serve only to draw attention to the child; she would be treated more specially than other children.

Gary, however, felt that Teddi's teachers and peers ought to be educated about what children with cancer deal with and endure. He thought teachers ought to be prepared in regard to what could physically and emotionally be expected of a child with cancer. Gary thought, perhaps, specific science units could be devoted to cancer and its treatment. He also believed that if children with cancer were encouraged to talk about their illness, their fears and the fears of their peers might dry up and wither away. Gary believed that when shielded from reality, fears become exaggerated, especially among children and specifically those with cancer.

Dr. Harvey Cohen, chief of the department of pediatrics/oncology at Strong Memorial Hospital, opted for a place somewhere in the middle of where Sheri and Gary stood. Cohen believed in "qualified truth." This meant that children were told difficult information only when they provided clues that they were ready to hear it. He also believed such information had to be couched in phrases and with feelings children could understand in regard to their own particular stage of development.

As the day marking the beginning of school approached, the summer optimism about Teddi's condition began to wane somewhat. The dark circles under Teddi's eyes remained. The radiation had affected her skin. Now, especially on her neck, the skin peeled and looked pitted. Lowering her Decadron dosage had made Teddi extremely thin. One day, Sheri noticed that Teddi's handwriting had also changed.

Teddi's writing sloped, first to the left, then to the right and then back again. The various letters of a single word might be leaning in several directions at the same time. It bothered Sheri, and it bothered her daughter, too.

"I can't control it," Teddi told her mother, exasperated.

Sheri told her not to worry about it, that it was legible enough to be read. But handwriting is a form of identity, and Teddi was losing hers.

The night before that first day of school, Sheri told Teddi she would drive her the next morning. Teddi disagreed, something she didn't do often. Instead, she wanted to ride the school bus with her friends. After some debate, Sheri relented. She didn't tell Teddi that she worried that other children would taunt her for being different or, worse, point her out as somebody so diseased that she shouldn't be gotten close to or touched.

The following morning, Teddi waited for the bus at the usual stop with her girlfriends and other kids who were waiting as well. She was adjusting the pink hat Sheri had bought to hide her baldness when suddenly one of the boys began to pull on it. But Teddi's friends stuck up for her, and the boy stopped.

Teddi's brother, Tod, also attended the same school. Though not a big kid, he was tough. After hearing about what had happened to Teddi, he went around the hallways telling some of the boys that if they picked on his sister, then they would have him to deal with.

And if that wasn't enough, Teddi's sister, Kim, heard her mother talking about the incident that night. She told Teddi to let her know if anything like that happened again. She told some potential troublemakers the following morning, "Be cool or I'll have to do something about it," though she was not all that sure what, in fact, she would do.

Kim seemed to have a more difficult time dealing with her sister's illness than Tod. Only a year older than Teddi, she was popular and very pretty. These things compounded normal sibling rivalries; cancer compounded them even more.

Kim had been a thoughtful caretaker of Teddi at the hospital. But it had seemed easier there, with Teddi clearly in pain, with her head bandaged and tubes tied to her. Doctors and nurses were always coming and going. But at home, with Teddi somewhat back to normal, the edge seemed off, and the rivalry resurfaced. In one of her angry moments, Kim had yelled at Teddi, "You have cancer!" It was unlike Kim, but sibling rivalry had heightened because of the special attention Teddi received at home. Kim would be haunted by what she said for years to come.

Fortunately for Kim, she met another girl her age at school that year who had a sister with cancer. This other girl was going through many of the same things that Kim was experiencing. They talked, told each other secret fears and worries and became fast friends.

NEW HOPE

The time for Teddi to go to school came and went, and she seemed to adjust well. Gary, however, still struggled with the feeling that there was more he could and should be doing. Dr. Kornblith's advice that the giving of quality time itself was important churned over and over in his mind. He also thought about the request he'd heard time and again from

friends and strangers alike who wanted to do something more for him and children like Teddi.

That fall, Gary made his first contact with one of Rochester's long-established cancer organizations. He had talked to a friend about sharing the massive amount of material he had accumulated regarding the pathology and treatment of brain tumors in children. He thought the information might be helpful to other mothers and fathers whose children had them.

The organization, when Gary approached it, asked him to serve on its public relations committee. He accepted the assignment even though his real interest was to be more directly engaged with families affected by cancer. Though discouraged at times, Gary continued to look for a way to fulfill this goal.

Then, early one December morning as Gary was getting ready to make a political trip to Albany, New York, he heard words coming from the small TV set in the corner of the bedroom that made him stop. Tom Brokaw, NBC's *Today Show* host, was speaking. "And when we come back from this commercial break, we're going to be talking to some very special children."

Gary walked to the edge of the bed, sat and waited for the program to continue. He left his tie unfastened. The word "special" had drawn him like a magnet, for the word is often used to describe children who are severely handicapped or terminally ill.

The story was about a Camp Special Days in Jackson, Michigan, for boys and girls with cancer. Children with cancer played near the reporter as he told how they often couldn't go to "regular" camps with "regular" kids because most camps weren't equipped to deal with their special needs. The result, said the reporter, was that children with cancer were excluded from most summer camps.

Camp Special Times, however, was different. Its only purpose was to serve children with cancer. The children talked about how much fun they were having swimming, hiking, camping and meeting other kids like themselves. They didn't appear self-conscious, Gary thought as he watched, and they didn't seem worried about getting sick or not being able to do things other children could do.

This was what he had been waiting for. He instinctively knew this camp matched his experience with childhood cancer and his skills and desire to do more. It was something practical and positive. He could think of little more on his drive to Albany.

After arriving, he called the *Today Show*, which put him in contact with the Camp Special Times reporter, Eric Burns. Through Burns, Gary contacted

some of the key people at the Michigan camp, finally reaching Dr. George L. Royer, the camp founder.

They spoke that morning and several times over the following weeks and months. By Christmas, Gary had accumulated an extensive amount of information about the camp, which he added to his earlier notes and documentation regarding Teddi's tumor.

Teddi's medical condition remained stable. Dr. Salazar noted in his report following Teddi's examination that she was "doing remarkably well." He noted that some of her hair was growing back. He shared this with the Mervises and said they would have to do another CT scan in February. If there were no changes in Teddi's condition by then, they wouldn't have to meet for another month.

The Mervises' friends and family were present at dinner on Christmas Day. Afterward, Gary told them about his plan to start a summer camp for children with cancer in New York State. People listened and asked questions. Some shook their heads, saying there was too much to do and so little time to do it.

Sheri Mervis may have been the only person listening that day who had no doubts that Gary would have a camp in place for children with cancer the following summer. She knew her husband well, knew his passions as well as his relentless ambition to make important things happen.

Gary contacted his friend Skip DeBiase to tell him what he had in mind. Skip listened carefully, thinking to himself that this was just like Gary, trying to take a negative situation and make something positive come out of it.

When Gary finished, Skip told him he thought it was a good idea. "Two, maybe three years down the road," he said, "yeah—I can see it happening."

Skip couldn't see Gary shake his head no. "You don't understand. I want to have the camp for this summer."

Skip didn't think it was possible but didn't have a chance to say so. "Can I count on you?" Gary asked, and Skip couldn't find it in himself to say no.

Later, as Gary began to spend more and more of his time trying to get the camp started and as Skip himself became increasingly involved, Skip would worry about his business and the time taken from it. But Skip was also a philosophical person. So when the doubts rose within him, he made himself think about all the good the camp would do, and this rekindled his faith that everything else would balance out in the end.

The day after Christmas, Gary made a presentation to the cancer organization's executive committee. He solicited the organization's help in establishing a camp for children with cancer in the Rochester

area. They asked him to make the same presentation to their board of directors.

Dr. Royer was on the phone with Gary and invited him to see the camp in Michigan. Gary thought that perhaps it would be best if Royer came to Rochester, bringing his slides and literature with him, as part of an effort to start a similar camp. Royer said he would be pleased to come, and the cancer organization in Rochester made arrangements, setting the date for Thursday, January 17, at 11:00 a.m.

Gary did the legwork of getting people to attend the meeting. He sent out invitations, which he followed up with phone calls. Sande Macaluso was in Gary's office the morning the telephoning began. A deputy marshal and one of Monroe County's civil defense officers, Macaluso helped make the phone calls, along with others who had dropped by.

Gary began nearly every conversation with, "Hey, do you remember when you asked me if there was anything you could do?" He said it over and over again, to each person he called, and after they answered yes, he'd tell them what they could do.

He talked of the proposed camp for children with cancer that he wanted to see realized by summer; he asked them to make a commitment to hear Dr. Royer talk and to see what had been done for children with cancer in Michigan.

January 17 arrived, and more than one hundred people came to hear Royer's talk. Royer himself was surprised at the turnout and the positive publicity that had preceded his visit. Not all who had come were friends or acquaintances of Gary and his wife. Some had read about this young dream in the newspaper and had come to see if they might want to be involved.

One such person was Polly Schwensen, a pediatric social worker at Strong Memorial Hospital. In her late twenties, Polly worked with children with cancer and their families.

Polly's father had died while she was young; her mother had polio. Her choice of profession, and what to do within it, was based on a strong philosophical conviction that no one knew how long they were going to live and that every life, however brief, should be afforded the same opportunities for love and happiness. Polly also possessed a deep and abiding faith in God.

After Royer's presentation, Polly made her way to the front of the room.

She was angry at something he had said. Challenging someone did not come easy to Polly, and as she struggled to get Royer's attention, she felt her heart pound and her face become flushed. "Excuse me, sir," she said, and Royer turned in her direction. Her tone silenced those around him.

"You said in your talk that you didn't want any social workers at your camp because all they wanted to do was analyze the kids and that made the kids uncomfortable and homesick for their parents." She paused, knowing that she was talking too rapidly and too loudly. "You said you'd rather see the kids go off and have fun."

Many were looking at her now. The only thing that kept her from fleeing at that point was the respect she had for her profession.

Royer seemed surprised. "I'm not saying all social workers are like that," he replied. "But this has been my experience."

"I just wanted you to know that there are a few of us who see ourselves differently, and if you write off the whole social work population, then you're writing off people who can help you out."

At the next cancer organization meeting, a commitment was made to set aside $12,000 from the budget to establish a summer camp for children with cancer. Gary felt he would have to raise at least three times that amount in the short time ahead to make the camp a reality.

Still, this was a beginning, and in the midst of winter, Gary felt a new burst of energy. He was not on the sidelines now; he was in the arena. He was about to launch a second campaign.

To organize the camp, Gary turned to key people, among them attorney Tom Gosdeck. Gary had helped Tom find a job when he was first out of law school; now, Tom proved invaluable by volunteering to handle the camp's legal matters. Doug Brown, a college buddy of Gary's, took charge of the day-to-day operations of the camp. Fran Russo, chief fiscal officer for Monroe County Human Services, and Raymond Cordello, comptroller of the county, developed a budget and established bookkeeping procedures. Dr. Klemperer was key in establishing medical care at the camp, as was Sande Macaluso, who was prepared to take care of the camp's many details without hesitation or complaint. Adele House handled correspondence, typed letters and made telephone calls. Jack Slattery, a man with an impressive newspaper background, took care of press releases. In the process of volunteering his time, Slattery found a new meaning for his life.

Young attorney Tom Gosdeck looked around at what was happening and saw something providential in it all. Gary's range of friends had always been wide, from the city's political leaders to those who fixed the roads. "It was like it was already planned," Tom thought to himself. "All planned somewhere years ago. It had to be Gary Mervis."

After key organizations made initial commitments to the camp, it was somewhat easier to lean on others for help. The Northeast Kiwanis Club

in Rochester held a huge benefit that included all Kiwanis organizations in the Greater Rochester Area to support the proposed camp. The Pittsford Welcome Wagon was an initial and sustained supporter.

The first priority of the founding organizers of the camp was to decide on a name. Gary thought that the children attending would come when they were reasonably well or feeling good. He also hoped their experience at camp would be a special one. Combining the two sentiments, he came up with the name "Camp Good Days and Special Times." Though there was initial resistance to the name, mainly because of its length, it stuck.

Then, Gary received a phone call from Joseph "Bello" Snyder. Snyder, who was in his late sixties, received the nickname as a Jewish kid growing up in an Italian neighborhood. *Bello* means "beautiful" in Italian, and Snyder used the word often when he spoke. Sometimes, apparently forgetting he was Jewish, he would make the sign of the cross if he was particularly moved by something.

"Gary," said the elderly man, "I remember you from high school. Remember me?"

Gary remembered. Bello had been a local basketball star who played professionally for a decade before retiring. Since that time, he had owned and operated a private summer camp for boys and girls somewhere in the Adirondacks.

"Look, Gary," said Bello, "I read about you and your daughter in the newspaper, and how you want to have this camp for children with cancer. It touched my heart." Bello paused. "Beautiful," he said and then repeated the word. "I'd like to meet with you and tell you a little about the camp I own."

Bello was in Rochester, so the two met the following day. Gary learned that Bello's place, called Camp Eagle Cove, was on the south shore of Fourth Lake in Inlet, New York. He showed Gary color photographs of the camp, with its cabins, indoor bathrooms and big recreation hall. The camp had athletic fields for archery, horseback riding, tennis, basketball, baseball and an excellent waterfront for swimming and boating. Bello also pointed out things of interest to children—such as the Enchanted Forest amusement park, the Adirondack Museum and Lake Placid, which were close enough for day trips.

As Gary listened and looked over the photographs, he knew Bello's camp would be perfect. In addition to all the features Bello named, it was beautiful, pollen-free and one of the choice camping spots in New York State.

"Sounds wonderful," Gary said, nodding.

Bello leaned across the table, wanting there to be no mistake in what he was about to say. He told Gary he wanted to donate the entire fifty-five-acre

facility to children with cancer for one week the following summer. Gary was too surprised to respond, but Bello could tell by Gary's expression that he would accept the offer. "Beautiful," said Bello. "Beautiful."

Not long after that, Dr. Robert Cooper, head of the University of Rochester Cancer Center, searched Gary out. "You're going to have your camp, Mr. Mervis," he said. "We're behind it here at the hospital."

Dr. Martin R. Klemperer, chief of pediatric hematology/oncology at the University of Rochester, then approached Gary. The Mervises had never met him because Teddi received her radiation treatments in that part of the hospital separate from pediatrics.

Klemperer, a medium-sized man with thinning hair, ardently wanted to see people's attitudes toward children with cancer changed. The prevailing view, he thought, was medieval and prevented such children from experiencing much of what could be normal in their lives. He felt prejudice warped the thinking of others, including that of parents of children with cancer, further diminishing a child's chance of enjoying a piece of his or her childhood.

Dr. Klemperer wanted to help others understand that just because a child had cancer, it did not necessarily mean he or she was bedridden or had to be treated in an over-protective manner. Children with cancer were physically capable of doing many of the same things children without cancer were capable of doing.

The doctor introduced himself to Gary. He told him of his roles at the hospital and said that he had heard about Gary's desire to have a camp for children with cancer. He then asked Gary if the camp had a medical director.

"No," Gary answered.

"You do now, Mr. Mervis," Dr. Klemperer said.

The Second Campaign

It was February, and Teddi had to go in for another CT scan. The doctors advised that this was an important one because enough time had elapsed after Teddi's surgery and radiation treatment to tell if the tumor was growing. While there was every reason to be confident, nagging doubts continued to haunt the Mervises. Teddi had not completely returned to normal, either in appearance or coordination, and the fact that the tumor was still inside Teddi's brain was an unspoken cause of horror.

Dr. Nelson's voice, normally reserved, sounded excited when he called the Mervis home with the results. "It shows remarkable improvement over the CT scan of six months ago," said Nelson, much to the surprise and delight of Gary and his wife.

One month later, Teddi went for a medical examination with Dr. Salazar. He wrote in her chart for that day:

> *I have performed a total neurological examination on this patient and the only abnormal finding that I was able to detect was in coordination with the left hand and clumsiness particularly when doing rapid alternating movements. Upon questioning the parents, she has been favoring the right hand ever since her original operation.*

But there was even more good news. Unless there was a dramatic change in Teddi's condition, Dr. Salazar told them that there was no need for him to see her until May. Though outside his office the March winds howled and fought the onset of the sun, it didn't seem to matter to Teddi or her parents. They knew spring was coming; they could feel it in their bones.

These hopeful developments in Teddi's condition gave fire to her father. In order to raise money for the camp, he was often out late four or five nights a week that spring and early summer. He spoke whenever asked and went wherever invited. He spoke with people at breakfast meetings, at lunches and after dinner; he talked with people over the phone and across the table.

His campaign was turning into a crusade. He knew it, and others could feel it. He wasn't only trying to raise money to establish a summer camp for children with cancer; he was also proclaiming in his corner of the world that the isolation, prejudice and downright humiliation children with cancer suffered was at an end.

The heart of Gary's message was always the same:

> *In our society, we tend to treat children with cancer differently. Teachers, neighbors, friends—and especially families—look upon them differently. There is always that over-protective hand on the shoulder. And, I've been just as guilty of this as the next father or mother...But I'm convinced that what all these children with cancer want is just the same as what other children their own age want: they want to have fun, they want to live a little dangerously, they want to be with their peers. For most kids with cancer, there is a time of remission, when there are no bandages or any other reason*

Still only a promise: out of isolation and into the bright light of day at the first Camp Good Days, Eagle Cove, 1980. *Courtesy of the Camp Good Days Photo Collection.*

why they can't go out and play with their brothers and sisters, roller skate and ride a bike. Inside, they want to know why they can't be out there too; why they can't be playing the same way too.

Gary would normally reach deep inside himself then, to that beautiful spring day not more than a year ago when his entire world collapsed under him, the false promises of a miracle cure, the long nights of worry and waiting.

"Attitude is important," he said to individuals and to gatherings. "If you have a positive attitude, then you will begin to realize that it isn't the length of somebody's life that matters—it's the quality of that life…And I'll tell you something: when I began to think this way, then the entire idea of starting a summer camp for children with cancer began to make a lot of sense."

Gary loved it, every minute of it. Though sometimes discouraging, and tiring, he had run other people's campaigns and listened to hundreds of others speak, and now it was his turn, his campaign and his speech. There were moments when, out of exasperation, he wondered if it was all worth it: somebody would plan to have him speak and he would make the trip, only to arrive and find somebody forgot to send out an announcement. There

were moments when he was so tired he didn't think he would be able to get out of bed the next morning to begin again. But he found the strength. He always would.

But this campaign wasn't for somebody's election or reelection, it wasn't for his own gain; it was for Teddi and other children in her condition. He was a champion for suffering children. To Gary and the others involved, it was the highest of causes—maybe the only cause that truly matters. "This is a world in which children suffer," Albert Camus once said, "and all we can do is lessen the number of suffering children. And if we do not do this, then who in the world will do this?"

Though Gary didn't feel he could bring a child with cancer along to his speeches, he believed that people who would give their time, money or both expected something in return, even if it was a child's handshake or a smile. Additionally, Gary wanted to educate audiences about childhood cancer, to let them see that children with cancer were loving, vital human beings and that there was nothing horrifying or grotesque about them, as many seemed to believe. He wanted audiences to see that children with cancer did not have to be, nor did they deserve to be, shut away from the activity of the world.

Sheri enjoyed watching Gary and Teddi leave together hand-in-hand. "She acts just like a little old lady," thought Sheri. "Telling her father what to wear and what to watch out for."

After several joint appearances, they were riding home together one night, and Gary told Teddi what a good impression she was making on people and how much she was doing for children with cancer.

"Gee, Dad," said Teddi, "I really am important, aren't I?"

Teddi never mistook that the camp, and what her father and others were doing, was for her alone. A reporter asked Teddi, "What do you think about all your father is doing for you?"

Teddi told him straightaway, "Oh, he's doing it for all the kids with cancer."

By midsummer, the hundreds of details associated with opening up and running the camp were being hammered out. The medical staff, headed by Dr. Klemperer and other specialists from the University of Rochester Medical Center; Buffalo's Roswell Park Memorial Institute; and Upstate Medical Center in Syracuse, New York, considered first the feasibility of medical supervision and then developed plans to implement it.

Counselors were recruited, and training sessions were held. Each counselor was given a manual containing his or her responsibilities and duties. H.Q. Cooper wrote one passage about which counselors talked. Originally

intended to describe what it took to be a successful teacher, members of the staff thought it applied to counselors as well.

According to the passage, individuals would need:

> *The education of a college president.*
> *The executive ability of a financier.*
> *The craftiness of a politician.*
> *The humility of a deacon.*
> *The discipline of a demon.*
> *The adaptability of a chameleon.*
> *The hope of an optimist.*
> *The courage of a hero.*
> *The wisdom of a serpent.*
> *The gentleness of a dove.*
> *The patience of a Job.*
> *The grace of God—and*
> *The persistence of the devil.*

A Rochester-area newspaper, publicizing the need for counselors, described the work in a unique "help wanted" format:

> *Responsibilities—frightening. Work—very hard. Hours—interminable. Working conditions—beautifully wooded campsite on a lake in the mountains. Job opportunities—a multitude. Financial remuneration—non-existent. Compensation—boundless. Most important qualification—unlimited capacity to love.*

In addition to the medical staff and counselors, a waterfront director had to be found; specialists in arts, crafts, archery, games, woodworking and sports also had to be recruited. The camp needed a kitchen staff and drivers to take the children from the three launch sites in Buffalo, Syracuse and Rochester to the campsite. Athletic and camping equipment had to be purchased, meals planned and dozens of special programs and events mapped out and organized. Details ranged from whether there would be enough money to run the burgeoning operation to how many pounds of spaghetti would be needed for Wednesday's dinner.

A little more than a week before camp was to start, Teddi had another CT scan, followed by a medical examination with Dr. Salazar. The scan showed no evidence of recurrent disease, though Teddi complained of an occasional

What would come to pass: a counselor with two of her charges. *Courtesy of the Camp Good Days Photo Collection.*

headache, particularly when she jumped up and down. She sometimes had seizures and still had troublesome motor incoordination. Salazar noted in his report that "the neurologic and physical examinations are in status quo." Also in his report was mention of the fact that some members of a TV crew had come with Teddi, and her mother and father, as part of a story about Teddi to publicize the camp. Dr. Salazar wished Teddi luck at camp.

As Gary's interest and commitment to the development of a camp grew, he found himself drawing more and more away from the goals of the local cancer organization of which he had been a part.

The organization's emphasis was on raising money to fund research and look for a cure. While Gary agreed this had to be done, he also believed that something needed to be done to improve the lives of those who had the disease. And it had to be done now, not in some distant tomorrow.

The date for the camp's opening was near, and Teddi began to have mixed emotions about it and about going. Gary and the screening committee were reviewing applications for the camp. Along with their medical histories, the children were asked to submit photographs of themselves. The camp staff thought this would be a good way to come to know the children even before

they arrived. Sometimes, Gary brought a few of these pictures home with him to show Teddi, hoping to ease some of her anxiety.

The more Teddi saw of the other children, the more excited she became: they would be kids like her, with cancer, not always feeling well, some without hair and sometimes even without an arm or leg. They would be going through the same thing she was; they would know what her world was like from the inside. She didn't know and had never seen so many other children with whom she had so much in common.

But her excitement alternated with her nervousness. "Do you want to go to camp, Mommy?" she would ask out of nowhere. "I don't want to go without you."

Sheri tried to comfort and reassure Teddi, telling her that she would definitely come, and so would a lot of other people she knew and kids just like her who would be nervous, too. They would love Teddi, too, just like she did, regardless of whether she had hair, tired easily or was afraid.

As the camp's opening date, August 29, closed in, camp organizers moved at a feverish pace. When they talked, the atmosphere became emotionally charged. Gary raised funds while simultaneously educating donors right to the very end. These final days of the campaign found Gary's voice hoarse and his body exhausted. It was all a matter of heart now.

"Vanity has no age," he told audiences, which were growing in number. "The bodies of children with cancer go through a lot of changes: these children get tired, they vomit, they lose their hair, they have excessive bleeding. These children become self-conscious about these things and often withdraw. But at Camp Good Days," he said, smiling, for he knew it was going to happen now:

> *At Camp Good Days and Special Times, such hardships will be the rule, not the exception!...Other children with cancer are probably the only ones who really know what it's like. When my daughter had to go through eight weeks of painful radiation treatment last summer, never once did she meet up with another child. She never had a confidante of her own age who was going through what she was going through, who had the same fears and worries and words. We say we understand, we adults, but we really don't. Not in the same way and with the same words as somebody their own age. The isolation children with cancer have to needlessly endure and what happens to them mentally and emotionally is as debilitating as what happens to them physically.*

The city's afternoon newspaper, the *Rochester Times-Union*, carried an editorial about the camp's opening. Entitled "A Dream Come True," the editorial stated that childhood cancer patients have been a "forgotten group, but no longer, thanks to [Gary] Mervis."

There was only one thing that began to gnaw at the organizers: would the parents of children with cancer actually send them? Used to looking after their children twenty-four-seven, would parents actually let them go? Would they let them travel some two hundred miles for one week with strangers taking their place? These were crucial questions now, and there was nothing to do but hope, pray and try to reassure one another that something so good and important couldn't help but succeed.

Waiting and Letting Go

Gary drove to the campsite on Wednesday, August 27, two days before the camp was to open. Other members of the staff, including safety head Sande Macaluso, were also there. Counselors began arriving, too.

Gary phoned Sheri that night. Like Sheri, he personally was not much of a camping enthusiast. He had not done it while growing up, and he wasn't at all certain he was going to like it now. So far, he told his wife, he still didn't like it much.

"God, Sheri," he told her, "there are all these noises at night. I'm not sure if there are bears outside the cabin—but I am sure there are mice inside!" Sheri laughed.

"I'm going to get my .38!" Gary joked.

"And do what," Sheri joined in, "shoot 'em?"

Sheri drove to the campsite the following morning; Tod, Kim and Teddi were with her. Teddi's anxiety mounted. What would the other children think of her hat? Would the kids like her? What would it be like being around so many children who are sick? Would any of them feel the same way she did about doctors and the disease? She asked if she could stay with her mother, in her cabin, rather than with other children.

Though Sheri didn't let on, she was also nervous about Teddi being there—and what might happen in the week ahead. Had they forgotten something? Something important? Something so vital the camp would have to end early? What if a child died?

Sheri and her staff would be responsible for everything from blowing up five thousand balloons to feeding more than one hundred children,

counselors and staff, as well as guests who were sure to come by, three meals a day.

Sheri, like her husband, was also a little nervous about the camping experience itself. That night, she would shake out her sleeping bag, wanting to make sure there were no mice or other critters inside.

More of the counselors arrived the morning Sheri had come, including Ann Kiefer, who was to be Teddi's counselor that week. Kiefer, articulate and tenacious, kept a journal about her feelings and the experience of that week. One of her entries dealt with seeing Teddi.

> *I had my first glimpse of Teddi. She was smaller than I thought she'd be, but so pretty, with her button nose, long, dark lashes and sweet mouth. She wore a long-billed pink hat to hide her baldness, and that hat, with its ridiculous brim, was like her trademark all week. She disappeared after the meeting with her parents but returned to the cabin later to sleep.*

That afternoon, Doug Brown and Assistant Program Director Jan Bruczicki called all the counselors together and went over their duties and responsibilities. Brown, assistant director of student activities at Monroe Community College, told them that at no time was a youngster to be left unsupervised. That didn't mean hovering over them, but it did mean keeping them within eyesight. Most of the kids, he said, had no experience camping, let alone being around so many strangers. Many would be afraid of not having their parents around should they get sick.

Brown paused. When he spoke again, his voice was intense. "Now pay attention to this: One thing I want to happen tomorrow when the children come is for you to drop everything you're doing and get out there to greet them! I want you to come running! Not just running—but whooping and hollering! The noisier, the better. Those kids are going to know right from the start that they are welcome here and we're here for them." Then he added, with nervous humor, "And that's an order!"

Dr. Klemperer rose to speak. "Welcome to you all," he began, in the soft, low-key way he had. "I just wanted to tell you where the infirmary is—and I also want to tell you not to rush in there every time one of our kids stubs their toe. Nobody would be doing that at a so-called normal camp—and we won't be doing it here."

Other last-minute information and changes were given to counselors and staff. After that, they were free to roam the campgrounds, though most made last-minute preparations for the arrival of tomorrow's

campers. The staff, too, worked to complete last-minute details for the camp's opening.

Margaret Register—known as "Muggs," a name she picked up as a kid—would work at the waterfront that year and be one of the cabin counselors. She looked as young as some of the campers and had their youthful enthusiasm. Though she wouldn't get to know Teddi or the Mervises very well that summer, she would play an important role in Teddi's life later on.

Social worker Polly Schwensen had also volunteered to be a counselor. She was determined to show Royer, and those who thought like him, that social workers could do more than analyze and make recommendations about individual behavior. She believed she could demonstrate that they were caring, empathetic professionals. Polly had a setback of sorts when she introduced herself to Gary, who said he didn't think much of social workers because of his past experiences with them. His remarks only stiffened her resolve to make a difference at Camp Good Days and Special Times.

Skip and Cheryl DeBiase also came. They had become even closer to the Mervises because of Teddi's ordeal and had given up a week's vacation to be there. Cheryl joined Sheri's staff in the kitchen, but Skip, at least in the beginning, had no assigned role. He was uncertain how he could help make a difference.

That night, Sande Macaluso once again drove from the campgrounds to Faxton Hospital in Utica. Sande, responsible for camp security and safety, was a conscientious and very worried member of the staff. If a fire were to break out at camp, or any other such calamity to occur, Sande would feel personally responsible. Strangers had entrusted him and the others with their children. Sande had already checked with the Inlet police and fire departments, even setting up a hotline to each. He traveled and timed the routes they would have to take to the camp in case of an emergency.

The next morning, far from camp, parents got their children ready and drove them to bus departure points in Buffalo, Rochester and Syracuse. Parents and children experienced emotions ranging from terror to exhilaration.

One boy was afraid to leave his parents and board the bus. After being convinced he would be all right, the boy arrived at camp and immediately wrote them a postcard saying he was having a terrible time and to please come and get him. A half hour later, he got Sande Macaluso to fish his postcard out of the mailbox because, as he said, he was having the best time of his life.

Three girls in particular who were coming that morning would play a significant role in Teddi's life. One was Suzie Parker, from Camden, New

York. When she was five years old, Suzie was diagnosed with leukemia. Yet that didn't stop her from taking ballet lessons, being active in school acrobatics and enjoying horseback riding. Laurie Allinger was being driven that morning to the Rochester departure area, as was Laurie Kaleta, known to her friends as "Froggy" because she loved the water so much. Laurie Allinger, diagnosed a few years earlier with bone cancer, had to have her right arm amputated at the shoulder almost immediately. Whereas Laurie Kaleta and Suzie Parker looked normal, there was no hiding that Laurie Allinger didn't have an arm.

The amputation caused Laurie Allinger months of pain and depression. Sometimes kids at school would make fun of her. Whenever she went out, people stared or looked quickly away when Laurie caught them staring. Laurie Allinger and Laurie Kaleta never saw other children with cancer, even though, like Teddi, they had both gone to Strong Memorial Hospital frequently for treatment. They wished they could have met then, so they would have had a friend they could talk to who understood.

Froggy especially wanted to meet Teddi. She had seen Teddi's name, and sometimes her picture, on camp brochures. She had also seen Teddi on television once or twice. Froggy wanted to meet Teddi because, as she said, Teddi had "such a kind face."

The buses filled with children of varying thoughts, emotions and expectations left Buffalo, Rochester and Syracuse and began to head to the campsite. The Buffalo bus had to travel some two hundred miles; the other two bus rides were geographically closer. Aboard each bus was a camp staff member. On the bus leaving from Rochester was the young attorney Tom Gosdeck. He was the young man Gary had found a job for, the one who took care of the camp's legal matters.

Tom said the kids on the bus were quiet at first. Then they got to know one another a little, but it was still quiet. But then, out of nowhere, a kid yelled, "We're going to camp!" And all hell broke loose. Every one of their fears, anxieties and uncertainties came uncorked, and they kept up their racket all the way to the camp. Laurie Allinger remembered laughing and calling out the window over and over again, "Are we there yet? How much longer?"

It was to be quite an adventure. They were going to a particular place they had never been before with people they had never met and with kids like themselves. They couldn't know it, of course, but they were going to a camp that was the first of its kind in the northeastern United States. They also couldn't know, until they got there, that those days, months and sometimes years of being stared at and left out would soon be things of the past.

That morning, before the children were due to arrive, the camp staff, counselors and most others who were there began to gravitate to the playing fields, where the buses would arrive. "We listened," Anne Kiefer wrote in her journal. "We listened for every car or truck that passed, thinking it might be them."

A Dream Is Born

The sun reached high in the noonday sky, and still no buses. The counselors and staff sat down to lunch; it was quiet, almost eerily so. Then, tough Lew Georgione, the waterfront director—old "leather lungs," he was called—thought he heard something. He blew on his whistle. He shouted that a bus was coming.

From every direction people came, only to find that it was a false alarm; there still was no bus. Georgione shrugged his shoulders and tried to look remorseful; Gary threatened to take away his whistle.

The counselors were especially nervous, all sixty of them, roughly equal to the number of campers expected to arrive. They were mostly young and really didn't know what to expect. A few thought it had been a mistake to volunteer. Nevertheless, they tried to busy themselves but couldn't help glancing up after hearing the sound of a car or truck coming up the hill, wanting to be the first to catch a glimpse of the first bus. Though the majority of the counselors were young, in their late teens, there were also parents among them and even grandparents. All had come to serve, and they were already beginning to see that they would find out something about themselves.

They wondered, as did the others waiting anxiously with them, just how many of the children would actually come. They wondered if something might happen that week, something so terrible they'd have to call it all off, the whole effort, never to try again.

Each of them knew that many of the children they were going to meet would be even more anxious. For them, as camp publicist Jack Slattery wrote, "being away from home usually meant a trip to the hospital—meeting a new person usually meant a new doctor or a new nurse." But Camp Good Days and Special Times was about to change all that.

"They're here!" came a voice over the camp loudspeaker, and now they all came running, dropping everything, including their inhibitions. Some stumbled, some fell, but they all got up again, making a beeline for the bus.

"Is all the cheering and clapping really for me? For us?" *Courtesy of the Camp Good Days Photo Collection.*

"Hello! Welcome! Tell me your name!" *Courtesy of the Camp Good Days Photo Collection.*

They whooped and hollered, greeting that first bus from Rochester. They surrounded it from every side, pounding on the metal and the glass windows even before it had a chance to stop. They jumped up and down, clapping and shouting "Hello! We love you!" as if they were meeting the most important people in the world.

For nearly two hundred miles, the children themselves had been giddy with excitement, shouting to one another and from the bus, but now they were silent. Small faces peered from inside the bus. They looked puzzled, unsure what all the excitement was about. Was it—could it possibly be—for them?

Sande Macaluso watched, standing near Skip DeBiase. Both were tough men, growing up in rough inner-city neighborhoods. But neither could stop the tears from falling. Cheryl leaned against her husband, biting on her lip. Muggs Register wanted to climb on board the bus right away and begin hugging the children. She wanted to get on with camp without having to wade through all those awkward wasted moments of getting to know each other. She banged on the bus door until it opened and went inside while the kids were still in their seats. Polly Schwensen, watching Muggs, whispered a prayer that everything would be all right that week, that none of the children would get seriously injured or die.

Crossroads the Clown and a new friend watch as the children get off the buses. *Courtesy of Tony Pierleoni.*

Frank Towner, a college student dressed as a clown named "Crossroads the Clown," blew long and hard on a plastic blue horn. Though his face was reddened and it made an awful sound, he kept blowing on it anyway. Sheri stood off to the side with her family, away from the others. Teddi peered out from behind her mother. To many that morning, the image was that of small soldiers back from a war.

Tod, naturally friendly like his dad, started shaking kids' hands and patting them on the back. He carried bags to cabins and came back again and again to carry more. It also helped his nervousness. Kim, the quiet Mervis who kept a lot inside, felt a terrible pain of recognition rise up in her now. She would say it was one of the few times in her life she would remember feeling extremely upset. It bothered her that she had no way of knowing, before this, just how many children were sick with cancer. Gary was unable to fully absorb what what was taking place before him.

The children *had* come, and Gary, not demonstrative of his emotions in most instances, now began to cheer for the children who had come, for the parents who let them go and for all those who had helped, given and prayed. Tears fell from his eyes, too. Beside him, Sheri cried. Dreams, even the most unlikely of dreams, did, in fact, come true.

Laurie Allinger then came down the steps of the bus. All she could remember afterward was, "They were cheering so much I felt as though I was on top of the world. They made you know they were there to give you something, that you weren't going to be able to lay down and do nothing." Froggy felt both scared and excited. She was anxious to meet Teddi and to get on with the camp, but she seemed overwhelmed by the emotion of the moment, seeing so many others who had gone through what she had gone through. It was such a clear break from the world she was normally in that it was puzzling, even intimidating, at first. Along with the two Lauries, thirty other kids got off the bus, and the hands of staff and counselors kept reaching up to help them, greet them and, for some reason, touch them.

The buses from Syracuse and Buffalo arrived within the hour, and these children were greeted with the same intensity and enthusiasm as that first bus. Suzie Parker climbed down off the Syracuse bus, saying afterward, "There was nothing like it. Nothing in the world like it."

Before dinner that night, while they were all together, the camp had its first mail call. Many parents had written letters during the week so that they would be there when their kids arrived. Some parents were certain their children would be feeling homesick and a letter from home might help.

"There was nothing like it. Nothing in the world like it." *Courtesy of Tony Pierleoni.*

Other parents wanted to stay connected to their children, despite the miles and time between them. It was announced that one little boy had received three letters from home in one day, and the dining room crowd rose as one, offering a thundering, standing ovation on hearing the announcement. Such applause and ovations were common at mealtimes during the week. Every small moment received spectacular attention because every small moment mattered when death was waiting.

At the first camp dinner, after everyone was seated, Gary Mervis was introduced. Campers, counselors and staff rose to their feet again, clapping and cheering. They wanted to say thank you in a big way to the man who had made all this happen, who had brought them together and out of isolation. If ever there was an election with a landslide victory, this had to be it.

Gary slowly rose, waiting for the cheering to subside. He leaned on the table with his hand. His legs felt unsteady as he looked around the room. He took it all in, conscious of the moment and not himself, looking slowly from face to face of the children he had only seen pictures of, friends who had stood by him when the dream was new and the doubters legion.

Gary would bring the house down that night with his promise to the kids that he would wear the hat he was wearing backward and wouldn't shave as long as the sun kept shining. When it did finally rain, Gary shaved his scraggly beard, and the kids thought his hat deserved a proper burial. They took it down to the dock, filled it with rocks and, as the trumpeter played taps, tossed it out to sea.

The first night, Teddi wanted to stay with her mother, but Sheri didn't think it was a good idea. If Teddi was separated from the other children, even at night, she might never feel like she truly belonged there. Teddi would miss those late-night talks when her peers got to know one another, share intimacies and form bonds of friendship.

And this is exactly what happened that first night inside the cabin Teddi was in. Counselor Anne Kiefer was in charge. Laurie Allinger, Froggy Kaleta and Suzie Parker were also in that cabin. It didn't take long for the four of them to gravitate to one another and relate their war stories.

"Did you have radiation?" Teddi asked the three others.

They all nodded. Two of them had gotten really sick, too. Had Teddi?

"Not me," Teddi said. "But I did get awful tired—and my hair fell out!"

They looked at one another. There was a pause, and then Laurie said her hair had fallen out, too. Suzie said the same thing had happened to her.

"Yeah, we love each other. We really do!" *Courtesy of the Camp Good Days Photo Collection.*

A boy in remission enjoying the cool waters of Fourth Lake, free from embarrassment and being stared at. *Courtesy of the Camp Good Days Photo Collection.*

Teddi was warming up now. "Did you ever get to feeling at the hospital like you wanted somebody with you, but you didn't, too? Like you wanted them to hold your hand and not get bored, but not say anything either?"

They all talked about that and about other things they had kept inside. Sometimes what they said was buried so deep, they surprised themselves when they spoke the words. But not everything they feared and shared could be put into words.

"Next to saying goodbye," Laurie would recall, "the hardest thing for me at camp was getting undressed that first night and maybe somebody seeing my scar." She didn't have to worry: everybody had scars, some visible and some not.

Teddi, Laurie, Froggy and Suzie quickly became friends. Laurie believed it was because none of them was really timid or shy, they all liked boys and they all had the same attitude toward their cancer. "We're going to beat this thing," they would take turns promising one another, often in the dead of night, when fears are usually strongest.

After they had time to sort out the whole camping experience, the three of them said that Teddi was the "best" in the cabin, the sparkplug, their leader. "I got kind of down sometimes," said Laurie, "and Teddi was always there, and she would bring me up. If somebody felt kind of scared, Teddi would bring you out of it by saying, 'What's wrong?' She didn't seem scared of anything. She just came out and said, 'What's your name?' She was really outgoing."

Before the four of them did something especially different, like riding horseback or taking a plane ride, one of them might say to the others, "Well, I don't know. I'm kind of scared. I could get hurt." But Teddi would be there—and if not her, one of the others—lending encouragement. "C'mon," she could be expected to say, "We can do it! We've gone through tougher than this!"

Counselor Anne Kiefer recorded in her journal an incident that happened in the cabin one night.

One of the girls in the cabin sometimes had such severe pain she wanted her medication before the necessary amount of time had elapsed. Anne knew it might be harmful if she gave the child the medicine early, despite her pain. One night, as the girl rocked and moaned on her bed, Anne found that Laurie was awake.

"Laurie," she said quietly, "have you ever hurt this bad?"

"You bet your bosoms!" the girl answered. She had been listening for a while now.

"If music be the food of love, play on." —Shakespeare. *Courtesy of the Camp Good Days Photo Collection.*

Anne smiled, wanting to know what Laurie did when the pain was bad.

"I try to do something to take my mind off of it. You know, like watch TV or draw."

Anne took out colored marking pens and papers. Laurie, Anne and the girl worked by flashlight, drawing pictures and coloring them until the pain pills could be administered. Anne and Laurie continued to stay up a while longer, waiting for the girl's medication to take effect.

Sometimes, later in the week, the girl's groaning would take its toll on Laurie. It reminded her of what she had gone through and what, in all likelihood, she would have to go through again. When these fears came, Laurie found herself leaning on Suzie, Froggy and especially Teddi.

By midweek, late one night, while everyone else slept, the four decided they wanted to be "blood sisters." No one afterward seemed to remember who came up with the idea, and maybe that's just as well. They all were eager to do it.

"Here. We'll burn a needle and then stick it in our finger," Teddi whispered—Teddi, the fireball instigator.

Suzie got squeamish. "Well, I don't know," she shivered. "Why do we have to do that?"

Ropes course: courage anyone? *Courtesy of the Camp Good Days Photo Collection.*

"It's to seal our friendship," Laurie explained. "We do everything together, and we even talked about being like real sisters. Now come on guys, let's be blood sisters."

Suzie still hesitated, and Teddi took the needle and poked her own finger first. "Piece of cake," she said. Teddi took Suzie's hand and steadied it before poking the needle into her finger.

Then, the four touched fingers, their blood mixing together. "All right," they exclaimed. "That does it."

A voice pleaded with them to be quiet. They giggled and, before turning in for the night, agreed on a toast. "To health and liberty," they said, together.

Good Days

Skip had gone out to the dock alone that first evening. He needed to pull himself together from the emotion of the day. He looked around him, admiring the sunset, the thick pines surrounding the lake and the calm waters. He was still trying to think of something he could do that would be useful when it suddenly occurred to him that the one thing he knew well, and could teach the kids, was how to fish. Any kid, thought Skip, loved to fish. Skip went to town to buy some bait only to be told that the lake was dead.

Acid rain had killed it. There were no fish in the water, people said.

Skip drove back to camp and went out to the dock again. He looked over the edge into the water. "It can't be," he said to himself. "It's too beautiful."

Skip drove into a different town, near a different lake, and bought fishing poles and other gear. He found a kid selling worms and bought all he had, twenty dollars worth.

It was nightfall by the time Skip returned to camp. Others were in their cabins; he could hear people talking in the dining hall. Skip knelt on the dock, emptied the carton of worms, and began cutting about a dozen of them in half. He threw these pieces into the water. "*E nomine Dei*," he whispered. It meant "in God's name."

The next morning after breakfast, Skip handed out fishing poles to the first dozen or so kids walking out of the dining room. Most of the kids had never held a fishing pole before. "Here," Skip said, sticking a pole into one hand and then another. "Let's fish."

One of the adults stopped him. "You know the lake is dead, why do you want to get their hopes up?"

"This lake can't be dead," Skip kept saying to himself. *Courtesy of Tony Pierleoni.*

"It's sick, yeah—but I don't believe it's dead," Skip answered, continuing to hand out fishing poles.

Skip taught those who needed help, which was most of the kids, how to bait the hooks. He taught them how to use a reel and cast. He helped those having difficulty casting the line. He took hooks out of sneakers, jeans and even the wooden dock itself.

The first fishing lines were in the water for only a few moments when a child began shouting for Skip's help. He had a "big one," the kid screamed. It wasn't big, but that didn't matter to Skip. After all, it was a fish. A sunfish. And in a few minutes more, the other kids on the dock were catching fish, too. Skip nearly burst into tears every time a fish landed on the dock. One girl was so excited and proud she kept the fish she caught on a string in the water the whole week, showing it to anybody who walked by.

A typical day at camp started with reveille at 7:00 a.m. A polar bear swim immediately followed this, for those who dared. It was a suitable name, given the cold early morning Adirondack waters. Lew Georgione noticed that while only a few tried the swim early in the week, their numbers had grown by the week's end.

There was a flag-raising ceremony at 7:45 a.m., followed by breakfast and then sick call and cabin cleanup. After that, campers spent an allotted amount of time at woodworking, arts and crafts, fishing, archery, boating, swimming, horseback riding and playing "new games"—games that were fun but noncompetitive. There was quiet time after lunch and room for special events later in the afternoon. Dinner, a flag-lowering ceremony and nighttime activities followed in that order. Lights out was set at 9:30 p.m.

Some things were typical for kids at any camp, cancer or not, such as writing home. Postcards, almost all written to Mom, were probably the same anywhere. One such postcard read, "Dear Mom, I miss you. I fell out of bed. I love you." Another child wrote, "Dear Mom, Today I got E [a backward "3"] letters. I went swimming. I didn't get tired on the way." And on still another postcard was written, "Dear Mom, I am having fun. The first day we got here we went swimming. I like it here a lot. Nate." Then, in case his mother couldn't remember what he looked like, her son drew his picture at the bottom of the note.

Aside from the fact that there was a daily schedule of activities and that the kids wrote and received letters from home, nearly everything else at Camp Good Days and Special Times was atypical. In fact, the camp

Flag raising, 7:30 a.m., Camp Eagle Cove. *Courtesy of Tony Pierleoni.*

seemed every bit like the day set aside as "Backward Day." That day, people dressed backward, walked backward and tried to do everything else backward. It was an apt metaphor for the camp itself, with dependent kids acting independent; kids who were "different" now all looked the same.

Camp had its own unique cast of characters. Big Lew Georgione worked the kids hard in the water, trying to get them to learn how to swim. Sometimes the kids, legs kicking, would look up at Lew for a tidbit of recognition, a small crumb of approval.

"I know I'm pretty!" Lew would growl back. "But pay attention to what you're doing!"

Another time, while checking cabins and tents one night, he poked his flashlight into Counselor Mike Menz's tent. "You awake, Mike?" he asked. Georgione never learned how to whisper, and Mike was startled. "Okay," Lew said, "you can go back to sleep now."

Late in the week, people decided that safety chief Sande Macaluso needed a night off. Usually, he stayed up at night making sure the children and others were safe. Nurse Practitioner Mary Ellen Dasson and others told him to go into town for dinner and that they'd stay on guard.

It took some convincing, but Sande went into town with lawyer Tom Gosdeck. When the two returned, they were surprised to see Nurse Dasson nervously pacing back and forth in front of her cabin.

"What's the matter?" Sande asked.

"There's a bat inside my cabin."

"Okay," he said, "we'll take care of it. Be right back."

Tom and Sande went to their own cabin. Once the door was closed, Tom asked, "How the hell do you get rid of a bat, chief?"

"Damned if I know," Sande answered.

They were laughing as they searched the cabin for something that might help them get rid of the bat. They found a ball of string and a broom and took it back to where Dasson was waiting.

"What's the ball of string for?" she asked.

"I don't know," Sande said. "Maybe I'll lasso it!"

All of them were laughing now, and then Sande and Tom crept to the cabin door on all fours. Sande opened the door quickly, throwing in the ball of string. "There," he said, pulling the door shut.

"I love you, too." *Courtesy of the Camp Good Days Photo Collection.*

Tom was confused. "What do we do now, chief?"

Sande looked at him nonplussed. He nodded in the direction of the broom leaning against an exterior wall. "I did my part. Now it's up to you to do yours!"

At midweek, female counselors raided the men's cabins. It was partial payback for the night male counselors had growled and scratched at their cabins pretending to be Adirondack bears. The next morning over the camp loudspeaker came the messages, "Will somebody please return Judge Bonadio's shorts!" This was followed by, "Attention, Mary Ellen, we have your bat."

Humor was an important part of camp, and much of it had to do with camp founder, Gary Mervis. For example, he asked one kid if he was having a good time. The boy answered that he was.

"Let me know if you're not okay, Johnny," Gary said.

The kid nodded. "I sure will, Mr. Mervis."

"Yeah, you let me know," Gary told him. "And if you're not, I'll send you home."

The kid grinned from ear to ear. Gary had become a hero to these kids.

Humor at camp seemed a way to ease doubts and pain and even change one's perspective. At times, it seemed to give campers and counselors alike a kind of spiritual second wind to reenter the world they found themselves in. Humor was fundamental to courage.

Gutsy Laurie Allinger learned how to excel at archery that week even with one arm. She learned to hold the bow with her toes. Ricardo Venegas, from Syracuse, couldn't even hit the archery target that first day, but by the end of the week, he walked off with the grand prize for excellence.

Mark Dillon, handsome, soft-spoken and affable, was one of the best-liked kids at camp. One of the local television stories about camp humorously depicted Mark missing swing after swing of softball pitches thrown him. Mark, a good athlete, smiled and never told the reporter about the rod recently put in his leg because he had broken it.

One of the special activities for the older kids at camp was an overnight canoe trip to an island out on the lake. The eleven-canoe expedition was turned back once because of a sudden, massive downpour. But when the rain subsided, they set out again, and all of them made it to the island. Once there, they gathered all the dry wood they could find, made a fire to cook with and pitched their tents. That night, after eating, they sang songs just like they would do at any other camp.

If the personal strength and camaraderie gained from this experience weren't enough, Bello Snyder told them later in the week that a group of his

Gutsy Laurie Allinger rides the wind. *Courtesy of the Camp Good Days Photo Collection.*

Being with others going through the same thing was a new experience for most of these kids. Here, Laurie Allinger, far right, swaps war stories with new friends. *Courtesy of the Camp Good Days Photo Collection.*

kids earlier in the summer, kids without cancer, couldn't make the strenuous trip in a canoe, and he had to take them out to the island in a motor boat. Word got around camp quickly and brought smiling pride to campers and counselors alike.

Laurie, easily identifiable now not by her loss of an arm but by the bandana and mini-cowboy hat she loved to wear, spotted Dr. Klemperer standing on the beach looking out over the water. She came up beside him.

"Can I ask you a question?"

Klemperer turned. "Sure, Laurie."

"Doctor, is there going to be a camp next year?"

"I sure hope so," came his response.

"May I come?"

Klemperer nodded. If there was proof that the medieval attitude of people toward children with cancer needed changing, she was standing beside him. Syracuse's Jim Hajski, one of the tallest kids at camp, was also proof positive. Jim loved basketball and seemed to play it at camp almost nonstop. He never talked much. He also wore a bandana and hat to cover

up his surgical scars. "It's nice to be out here," he said, "and not feel like a freak."

The people in Inlet and around Fourth Lake were slowly beginning to find out about Camp Good Days and Special Times and the special children in their midst for a week. Out boating or water skiing, they would make a special pass by the shore and wave or blow kisses. Inlet's fire department came with its truck, sirens blaring and lights flashing, and took the children on a wild ride through country roads. A man who owned a custard stand gave free ice cream cones to each of the kids. "I saw their faces," he said afterward. "That was enough of a reward for me."

The kids were thrilled at being able to go to the Enchanted Forest or for a hike up a mountain trail. A large sightseeing boat took them around the lake; a ski lift took them up mountains; they rode horses in the valley; and an amphibious plane took batch after small batch of them soaring through the sky. Sheri thought Teddi was having the time of her life. Her nervousness about coming ended the second day. She took off her hat and didn't care who saw her bald. The print and broadcast media, when it came to camp, often sought interviews with Teddi.

Sheri thought her daughter answered the reporters' questions like a pro. Dr. Klemperer, watching the attention Teddi was receiving, said Teddi did not act like "a reigning queen" and that there was "a modesty to her, a sense of humor and common sense that was really nice to see."

Though Teddi seemed to shed her nervousness, Sheri wasn't always able to let her own fears go. In some ways, she was more anxious with Teddi not being at home. Sheri would check on Teddi at night to make sure she wasn't in any pain and was getting enough rest. She would give Teddi a kiss in the morning, at noontime and before bed. This routine of affection did not go unnoticed by Teddi's blood sisters and other girls in the cabin, all of whom missed their own moms. And so, before long, Sheri was kissing each of them morning, noon and night. It wasn't totally selfish on her part. By caring for them, she felt her own hurt and worry ease some.

Early one morning, as Sheri looked out over the lake, she noticed Teddi going in for the polar bear swim. Afterward, at breakfast, Sheri asked Teddi about it. She knew jumping into cold water early in the morning just wasn't Teddi.

"I've got a boyfriend," she told her mother, eyes beaming. "And he goes swimming in the morning." Teddi knew how protective Sheri felt. Teddi paused, leaned forward and, in a loud whisper, told her mother, "I go so I can grab him!"

"This is great fun!" *Courtesy of the Camp Good Days Photo Collection.*

Early the next morning, Sheri watched again, but this time Teddi stood on the shore, a blanket wrapped around her, watching. The third morning, Teddi didn't show up on the beach at all.

"What's the matter between you and Marvin?" her mother wanted to know.

"Nothing," Teddi answered nonchalantly. "He's interested in me without my going swimming."

Sheri laughed. "Good for you. Good for you, Teddi."

Though Teddi went through nearly a half dozen boyfriends during that one week of camp, blond-haired, blue-eyed Marvin remained special to her. Sheri was amazed at the boy's politeness. A year older than Teddi, Marvin held doors open for her. He asked her to the camp's formal dance and held her hand that night. "Do you want some cookies, Teddi?" he'd ask and go get them for her.

The children at camp were divided into different cabins, named after Indian tribes. Boys and girls from the same tribe did many of the same activities together. One night, as Sheri was walking back from supper, she spotted Teddi ahead of her. She was walking with a boy, and it wasn't Marvin. When Sheri passed the same cabin Teddi and the boy had just passed, she heard a voice from inside say, "We better get out there right away, men. One of those Oneidas is stealing our woman!"

Teddi in her
unofficial
role as
advisor to
her father!
*Courtesy of
Dick Sroda.*

Sheri looked around. Woman? There wasn't any woman around but her. "Naw," she thought to herself. "They can't be talking about my daughter." But when the boys piled out of the cabin and chased after Teddi and the other boy, she knew it had to be true. The next morning, Teddi ran up to her, all excited with the news. "They're fighting over me, Mommy. Isn't it wonderful—boys are fighting over me?"

Counselor Anne Kiefer picked up another side to Teddi that week, one that may have gone unnoticed by others. Near the end of the week, Kiefer wrote in her journal:

> *I sat next to Teddi, who was very quiet. I could think of nothing to say to draw her out that would not seem false or hypocritical, so I left her alone with her thoughts. I guess I could have teased her out of her mood, but sometimes teasing takes a nasty turn. She was already impressing me as being introspective, a little aloof, maybe even a little depressed.*

Anne thought Teddi may have been somewhat envious of her sister, Kim, whom Anne described as "an exceptionally pretty thirteen-year-old." Though Teddi idolized Kim, self-consciousness about her own looks—despite the attention she was receiving from boys—may have had an effect. Anne also speculated that Teddi was having trouble separating her desire to be just another camper from the attention afforded her as being the camp's inspiration.

As the week drew to a close, many began to sense how hard it was going to be to leave. It came out in odd ways those last few days: a boy suddenly stopped talking to a girl he was trying so hard for so long to impress; a girl suddenly bursts into tears at dinner because she made the mistake of passing the salt and not the pepper. It got harder and harder to sing "Kumbaya" around the campfire at night. Words such as, "Someone's crying, Lord" took on new meaning.

There were other songs, too, that could almost break the heart. Beautiful nine-year-old Jennifer Masters stood center stage on Talent Night and belted out the hit song from the musical *Annie*. "Tomorrow! Tomorrow! I love you, tomorrow!" No kids knew how much the word "tomorrow" meant like the kids joining in to sing the final chorus with her.

SPECIAL TIMES

Suzie Parker remembered that they stayed up all night that last night at camp, talking about all they had done and the boys they liked best. It was as though they wanted to get things right—the details and the exact words—to remember it for the long, uncertain days ahead. To them, it was a great harvest, the best they had before getting sick, and it would nourish their souls when winter was at the door.

The next morning was chaotic and intense. Clothes had to be found, sorted and put in the right camper's bag. Each of the campers had to be put on the right bus. And all this and more had to be done before the buses were scheduled to leave. Delays would make parents at the other end of the bus ride worry unnecessarily. They had already taken the biggest gamble in their lives.

Suzie hugged Teddi long and hard; tears ran down her cheeks. She even hugged Tod, too, that day, even though Tod had put rubber mice and a rubber snake inside her sleeping bag. She hugged Gary Mervis, as well, whom she said had become like a father to her. She called out to Sheri, "See you next year!"

Laurie Allinger didn't want to leave at all. It was terribly difficult for her to see the buses come, for it truly meant the end of things. She was crying when she said goodbye to Teddi. Though some told her not to cry, Laurie looked around, and it seemed everybody else was crying, too.

They cried not only for what they were leaving but also for what awaited them. At most camps, kids are sad because they may not see their friends for another year. At Camp Good Days and Special Times, the campers knew that they or their friends could die before another year passed.

Teddi held on to her emotional self. "We'll see each other next year," she told Laurie. "We'll see each other again."

Teddi's words made Laurie cry even harder. "Here's Teddi again," thought Laurie, "just like always, trying to bring me up." And then she whispered in Teddi's ear, "It was the best time in my life."

Teddi started to cry, too, when Marvin boarded the Buffalo bus. She waved and kept blowing him kisses.

Sheri, watching, thought Teddi was getting carried away. "Teddi—slow down," she said, putting her arm around her daughter. "Just what have you and Marvin been doing anyway?"

"We haven't been doing anything more than you and Daddy," Teddi answered.

"And what's that?" Sheri asked, much too loudly, nervously wanting to find out what her daughter meant exactly.

A camper needing help with goodbye. *Courtesy of the Camp Good Days Photo Collection.*

"You and Daddy kiss and hold hands, don't you?"

Sheri nodded, her calm returning.

"Well, that's what we've been doing," Teddi added, turning and continuing to blow Marvin kisses. Then she stopped and looked up at her mother, "There's nothing dirty about kissing, is there?"

Sheri told her there wasn't. Then she blew a kiss to Marvin, too. The two laughed, but the thought of Teddi holding hands and kissing a boy was too much to contemplate at the moment.

Gary drove home with Doug Brown. Together, they analyzed the positives and negatives of what had happened that week and talked about what they might do differently the following year.

Sheri, Tod, Kim and Teddi rode home together. Kim stared out of the window; she'd had a great time, met some boys, made new girlfriends and had become an honorary aunt to little Jenny Masters—the girl who sang "Tomorrow" on Talent Night. Kim had also initiated the "tuck in" ritual at camp. Elder kids tucked the younger ones into bed and gave them a goodnight kiss. On the way home, Kim remembered feeling emotionally "full."

While Tod slept, exhausted by the experience, Teddi wrote feverishly. Like most kids, she loved to get mail and was now writing letter after letter to her "blood sisters," the new people she had met and especially to Marvin.

Sheri was pleased Teddi had made some new friends; it was what she had wanted ever since that terrible night Kim went to Chrissy's house, leaving Teddi behind. It was wonderful, too, thought Sheri, that Teddi had gotten a boy's attention and that she had been able to experience the feeling of first love. She pictured Teddi blowing kisses to Marvin. This time, Sheri smiled.

Sheri also recalled a recurring exchange between her and her daughter, wondering if it would happen any more.

Teddi would ask, "Mommy, am I going to be beautiful?"

"Well, Teddi," Sheri would answer, "you're very cute. Very cute."

"But I don't want to be cute," Teddi always complained. "I'd rather be beautiful. Kim is beautiful, but I'm only cute."

"Yes, that's true," Sheri would say. "But I think you're charming, too."

"But I want to be beautiful," would always be Teddi's closing line.

Maybe now, thought Sheri, Teddi would understand that her personality is what made her beautiful. Teddi had indeed learned at camp that summer that boys liked her and others liked being around her, not because of the way she looked but for who she was. Her baldness and lack of a wig made that unequivocally clear.

Skip went down to the dock late that afternoon, the camp nearly empty now. Busy as always, Cheryl was attending to some last-minute details when Skip told her, "Don't come to get me. I'll be back when I'm ready." Cheryl saw how sad he looked.

A boy and a girl and a first-time kiss (maybe). *Courtesy of the Camp Good Days Photo Collection.*

Skip sat at the dock's edge by himself. He thought about that week and about John Davis, a wisecracking, troubled kid from the inner city. They'd had a rocky beginning but left as good friends. Memories of John made Skip laugh while tears also fell from his eyes.

John had put shaving cream in Skip's pillow, sprayed Skip with whipped cream and even bombed him with water balloons. One time, after he had taken a group of campers out to an island in his boat, they realized that John was missing. They searched all over for him. Skip saw a couple picnicking, and they said they hadn't seen the boy.

Just then, Skip noticed that their picnic basket began to rise in the air. He followed the line to the fishing pole he had given John, who was up in the tree using it to reel in the basket lunch.

Later, after camp was over, Skip would call John on the phone, and they would talk. Sometimes Skip would drive to the boy's house in a troubled part of Rochester, pick the boy up in his flashy yellow Corvette convertible and take him to lunch or back to his own house for dinner.

Skip had been so busy teaching other kids how to fish, bait their hooks and take those same hooks out of the fish, sneakers and dock that he didn't spend as much time as he would have liked with Teddi. He had made her come out to the dock and fish at least a few times, even though he was aware that she was more interested in boys than fishing.

"You know," he told her, "the reason you're out on this dock with me is so I can keep you away from that kid. What's his name? Marvin? I see you two sneaking in the bushes. I better not catch you!"

Teddi would blush.

"Hey," he continued, "what kind of a name is that anyway? Marvin. Is he Italian? Ask him if he knows how to make spaghetti. What are you going to do with a guy who doesn't even know how to make spaghetti?"

Still reminiscing, Skip flashed back to that afternoon in the hospital parking lot when Gary was crying and he had to leave the hospital himself when Teddi came back from surgery. He looked at the water again. "They said you were dead but you weren't," he told the lake.

Skip got up from the dock. As he walked back to the campgrounds, he wondered if autumn would be a hard one on Teddi and the kids at this special place. He hoped that each would carry the warmth of a special time well into winter.

THE SOUND OF THE SECOND SHOE

Autumn was warm that year. Teddi went to school. She became a cheerleader for one of the Vince Lombardi teams even though her father coached the team Tod played on. It made for lively dinner conversation—which team was better and how terrible the referees had been.

Despite the daily demands in their lives, the Mervises tried to find time for Kim and Todd. They strained to resist the natural tendency to give the

In remission, Teddi becomes a cheerleader against her father's team.
Courtesy of the Mervis Family Collection.

majority of their attention to the child most in need of it. Still, they secretly knew that when Teddi talked, seemed different or needed something, they were a little more concerned, a little more attentive.

Teddi continued writing letters to friends she had made at camp, her blood sisters and Marvin. In one letter, she invited Marvin to come to Rochester to see her.

Sheri took the phone call late one Friday afternoon. It was Marvin's mother. Her son was on the train to Rochester, and it was due to arrive at 7:30 p.m. Sheri told her that would be fine, hung up the phone and asked Teddi if there was something she had forgotten to tell her. Teddi shook her head no, she couldn't think of anything, and then Sheri reminded her about Marvin's visit. "Oh, I didn't think he'd really come," she answered, smiling. Sheri shook her head. "It's a good thing we're going to be home this weekend."

Throughout that autumn, Teddi continued making suggestions to her dad about how the camp could be improved. And Teddi continued to talk to both of her parents, and anyone who would listen, about her experience at camp, what had happened and who said what to whom. Why wouldn't she? It was the most exciting time of her life.

Sheri listened and smiled, feeling so hopeful that sometimes she couldn't believe Teddi was really sick at all. The child's November check-up was encouraging; Dr. Salazar noted that Teddi was "doing very, very well." Her hair was growing back, which lifted her spirits. Though she still had some lack of coordination in her left hand, she did not seem to be favoring it at all.

Despite these and other positive developments, the dark circles around Teddi's eyes persisted, always a concern to her mother. Sometimes Teddi's eyes looked glassy, and to look at her, she seemed far away. There were seizures, too. They never lasted long, but they wouldn't stop either.

Sheri seemed as though she was in a constant state of worry. Teddi had a sore throat, and she worried if somehow it was related to the tumor. She worried when Teddi had Novocain at the dentist's office and when she had X-rays taken. Hadn't Teddi had enough radiation?

None of the doctors speculated about when the tumor might start growing again or how much time Teddi actually had left. And neither of her parents opened the door to such matters. The two took care of the doctor's appointments and got the required tests done on time. But other than that, they just watched and waited, wondering, as it were, when the other shoe would drop.

It was a dreary, desolate January day when Teddi went with her dad to Dr. Salazar's office for another CT scan. After telling them both that the test

results were good, Salazar told Teddi to go on ahead, and he put his arm around Gary. "I don't want to get your hopes up," said the doctor. "But 80 percent of the recurrences take place within two years. In April, it will be two years. If she makes it to then, she has a good chance of beating this thing."

It wasn't long after, however, that the number and severity of Teddi's seizures increased. Sheri was alarmed. After consulting with Dr. Nazarian, Teddi's pediatrician, Teddi received a larger Decadron dosage. It didn't help. "She's getting worse," Sheri told her husband. "We should take her in to see the doctor."

Gary so badly wanted April to come and go first. "She's the same as she always is," he would answer. "Let's not go looking for things."

Finally, Sheri insisted that something had to be done. "You've got to take her in," she pleaded. "Something's bothering her."

Dr. Salazar seemed troubled by the fact that Teddi's tongue deviated significantly to the side. He immediately asked for a CT scan, and by the time he got it back, Dr. Nelson had also arrived. They found a large cyst on the tumor but weren't sure if there was regrowth of the tumor itself. They could not be certain unless another craniotomy was done.

Dr. Nelson initially opposed the idea of more surgery. He felt it was too close in time to the previous operation. Dr. Salazar, on the other hand, thought that a second craniotomy might make another round of radiation successful.

Gary listened carefully, his emotions swirled. He concluded that radiation had worked pretty well before, and maybe, just maybe, combined with new surgery, it would work again. "I have to ask Sheri first," he told them. "Could somebody call?"

He wanted to explain, but Teddi was there, eyes straight-ahead and listening, always listening.

It was four o'clock. "I think you better come down here," Salazar's assistant told Sheri.

Sheri sat with Gary, Teddi and the two doctors in Salazar's office. She could see how tense each face looked. Gary turned to Sheri and told her about the cyst and the reasoning behind a second operation. Dr. Nelson explained that he would try to remove the cyst in the second entry and try to get out as much of the adjacent tumor as possible. Salazar said that when Teddi was ready, he would try localized radiation. Chemotherapy was also an additional therapeutic possibility.

Gary asked Teddi if she was willing to go through more surgery. Sheri was watching Teddi as her husband talked. Teddi held Teddietta tightly. The more she hurt, the more that raggedy bear hurt. Then, for some reason unknown to

the others, Sheri put her fingers to her lips and began to nod her head slowly up and down. She closed her eyes, not wanting to cry anymore and not wanting the others to see her cry anymore either. Sheri knew—she had a mother's instinct—that things would go badly and that, at the end of it, Teddi would die.

Gary finished what he had to say to Teddi. She told him that if he thought it would help, she would do it.

Teddi was readmitted to Strong Memorial Hospital on January 18, 1981. The admitting physician's report said Teddi was weak on her left side, she couldn't raise her arm above her shoulder and she had poor use of the fingers on her left hand.

After being admitted, Nurse Anne Cameron came by to see Teddi. Anne maneuvered to get Teddi placed on the pediatric floor rather than on the adolescent floor. Her age, eleven, would normally put her on the latter, but Anne felt that the change would make it emotionally harder on Teddi. The child wouldn't know anybody and would have to meet—and come to trust—new people all over again.

Anne had followed developments in Teddi's case since their first meeting. Teddi had been written about in the newspapers, and Anne had seen her on television. Teddi was often laughing and appeared happy. But Anne knew Teddi's entire tumor hadn't been removed, that it was the kind that was deadly and that, someday, it would begin growing again. Anne assumed primary nursing care (PNC) for Teddi, meaning that she would be in charge of all aspects of the child's care. Such an approach gave patients and families a primary contact person, one they could come to know well and rely on. This medical professional also would be able to give a sense of permanence in a system where new nurses and doctors come and go, making hospital stays nerve racking and worrisome.

There was, however, a big emotional risk for the primary care nurse; such emotional intimacy was often harder than the shift in, shift out approach. A relationship could form between nurse and patient, making the pain personal should a patient die. Barb Fredette and Sally Masten, providing secondary nursing care, also became involved with Teddi's case and the Mervises. The introspective Barb Fredette said that love often developed in such relationships and that foregoing the pain also meant missing the love.

After successfully getting Teddi placed on the pediatric floor, Anne went into her room and introduced herself to the Mervises, explaining what her role was and the floor routine. Anne would recall how utterly tired Sheri looked, like somebody who seemed to want the whole sorry business done with once and for all.

It was often difficult for primary care nurses, even ones as open and thoughtful as Anne, to get to know their patients well in the beginning. Parents tended to speak for them. But Anne found quiet times to be with Teddi, and they built a strong and trusting nurse/patient relationship. This quickly turned into an older sister/younger sister type of bond.

Teddi told Anne about Teddietta and how Teddietta had been with her since she was a baby. She told Anne about all the other teddy bears people had given her. She showed Anne a picture of her dog Sweet'ums, too.

"Everybody says she's ugly, but she isn't. You don't think so, do you, Anne?"

Anne couldn't keep from laughing. "I'm sorry, Teddi," she answered, looking at the picture again. "She really *is* ugly!"

Teddi laughed, too. Later, she told Anne about Marvin and the boys at camp who had fought over her, the ones who still wrote to her and wanted her to write back. She told Anne about Skip's son, too, who always flirted with her—and how she sometimes flirted back. Anne and the other nurses took great pleasure in kidding Teddi about which one was her "boyfriend of the day."

Becoming close to Anne made a difference for Teddi as the date for surgery drew near. Anne came in often, even on her days off. She tried to choose her words carefully, watching Teddi's face for any hint of fear or self-doubt. If it seemed Teddi didn't want company or to talk, Anne sat with her, holding the child's hand in silence.

"The pre-operation shot is going to sting, Teddi," Anne explained.

"Why does it have to hurt?"

Anne didn't answer the question and instead moved on to other matters.

"The doctor has to give you the shot in your thigh because they find that's the best place for children to absorb the medication that makes them drowsy. That way you won't feel the pain later in surgery."

"They do that so I can go to sleep and not feel any pain, right?"

"That's right," Anne soothed.

"My dad told me. And I was in here before, so I kind of remember what it will be like."

"There'll be some pain after," Anne told her.

"I know, just like before. But after awhile I'll be all right."

Anne went over the operation procedures with Teddi a few more times, explaining what would happen and how it would be done. She couched her words so as not to arouse new fears and tried to directly respond only to what Teddi truly wanted to know. She found that talking too much, or talking only about what adults considered important, could be overwhelming and push a child even further into him- or herself.

The night before surgery, before her mother and father left, Teddi told them she was afraid, but she also said she wanted to have the surgery over with so she would be able to be well and feel good again. Teddi wanted to know if her parents would be there in the morning before surgery. They promised they would be and kissed her goodnight.

The next morning, Gary was running a little late. He kept forgetting things, like a man who subconsciously doesn't want the day to begin. Sheri waited in the car, beginning to panic, blowing on the horn. She felt an almost desperate need to see Teddi before the surgery began. She wanted to see Teddi alive. As Gary sped to the hospital, Sheri kept looking nervously at her watch. Gary dropped her off in front of the building and went to find a place to park. Sheri hurried inside to Teddi's room and found her on a gurney. Sheri delayed the orderly and some of the staff until Gary had a chance to see Teddi, too.

Sheri didn't wish her daughter luck that morning. She said, instead, that she would be there when Teddi came out after surgery. "I love you, honey," she whispered close to Teddi's ear. Secretly, Sheri didn't even think Teddi would survive surgery a second time. She didn't tell her husband or anyone else because she didn't want to add to their worries. But she had the same feeling she had had a few days before when she saw that the seizures were more frequent, violent and longer lasting than before.

Gary understood how serious the operation was going to be. He had taken medical books out of the hospital library and studied the procedures. He had raised questions with both Drs. Salazar and Nelson. Still, he was trying to hang on to hope. "What if?" he kept telling himself. "What if it's just a cyst and not a regrowth and they're able to get it all out? What if? What if? What if?"

Dr. Nelson entered the operating room briskly focused and somewhat hopeful. Teddi had been thoroughly anesthetized and was in a deep sleep. Her head had been purposely turned to the right and the previous incision exposed. Nelson helped prep and then draped Teddi's head. Deftly, he reopened the old incision. He turned down the scalp flap and then removed the sutures. This exposed the dura, the tough outer membrane enveloping the brain. Cutting it, Nelson saw that Teddi's brain was extremely "tense," meaning it was stretched tight. He opened and hinged the dura.

Dr. Nelson saw the cyst and asked for a needle. He drew out approximately twenty-two cubic centimeters of a yellowish fluid, and Teddi's brain immediately went slack. The cyst had definitely increased pressure on the brain. The surgeon probed further, able to examine the tumor itself. It was yellow and covered with blood vessels. Its color and

consistency told Nelson that the tumor had gone from intermediate to high grade in terms of its malignancy. For the next several hours, he used suction to try to get out some of the tumor. But several large arteries fed into the tumor, making suction difficult and dangerous. Doing as much as he could with suction, he then tried to remove still more of the tumor by actually cutting into it. He thought if he got out as much as he could, it would ease the pressure on Teddi's brain. By the looks of it, though, the tumor would continue to invade Teddi's motor area. The blood vessels began bleeding profusely and he stopped. He had done as much as he could without risking Teddi's life. He asked for a biopsy.

Dr. Nelson straightened his back, which had become knotted and stiff. He looked at the clock. Nearly seven hours had elapsed. The bleeding was stopped, and he closed the dura with a silk suture. He then connected the craniotomy flap with a number twenty-eight stainless steel wire. Nelson sutured Teddi's exterior skin. It would have been quicker and easier to use staples, but they carried the risk of infection.

As he was finishing, the biopsy report arrived: the tumor was high grade, just as he thought. It was further defined as a glioblastoma multiforme. Such rapid change in a tumor usually meant an extremely poor prognosis. He shook his head. He thought that Teddi would have twelve, maybe eighteen, months to live. He didn't tell those working with him what the report said. He could tell by their faces that they already knew.

Meanwhile, Polly Schwensen, the pediatric social worker at Strong who had challenged Dr. Royer when he visited Rochester and who had volunteered at that first season of camp, sat with the Mervises while Teddi was in surgery. Polly remembered afterward that Gary told her it was the hardest time in his life. Polly didn't say anything but knew there would be more times like this for him in the future.

Polly took Kim for a walk that morning. Later, she would do the same for Sande Macaluso and Judge Tony Bonadio. Both men were extremely shaken; neither could believe Polly went through this time and again. They had come to know Polly at camp. "Is this what you do? Is this it really?" they asked. "We had no idea."

Sheri sat in the special waiting room Polly helped obtain for her. It was private and could be used only by one family at a time. Sheri began knitting from the time she entered the room, seldom looking up. But after six hours of waiting, she broke down completely, sobbing and seemed unable to stop. The others—Cheryl and Skip, Judge Bonadio, Irene and Bob—saw her and tried to comfort her, but nothing they said seemed to work. The women

tried to console her by touching and stroking her, struggling all the while to control the emotional tornado lurching up inside each of them. Sheri knew. Deep down she knew. She knew Dr. Nelson's findings were going to be bad, but the waiting had become unbearable.

When Dr. Nelson called the Mervis waiting room, Sheri was still crying and shaking uncontrollably. All she wanted to know at this point was whether Teddi was alive. It didn't matter if Nelson had removed all or even a little of the tumor. It didn't matter if Teddi had a day, a week or a year more to live. All she wanted was to see her daughter alive one last time.

Over the phone, Dr. Nelson told Gary that he had taken out the cyst and some of the tumor but that there was still more left, a lot more, and it had threaded itself into other parts of Teddi's brain. He said he would be up to talk to them later.

"She's alive," Gary told his wife, holding her close to him now. Suddenly shaken by the fact that Nelson hadn't come up personally to tell them about the operation, he turned to a resident physician and asked why.

The resident physician left the room and returned, moments later, with Nelson. He didn't explain why he had not come before and said again, though this time more briefly, what had taken place in the operating room. All the time he talked, Sheri watched him closely, perhaps to discern whether everything was being disclosed, perhaps to find a grain of hope. She felt overwhelming gratitude that Teddi hadn't died on the operating table. Yet a part of her sorrow now was for the defeated look in the doctor's eyes.

Starting Over

Teddi was put in Strong's pediatric intensive care unit.

"Do you know who you are and where you are?" Nurse Anne asked, her face close to Teddi's.

Teddi tried to open her eyes, but they were badly swollen. "I'm Teddi," she managed. "And I'm at Strong." It was pretty remarkable, given the amount of anesthesia she had been given, the invasive nature of the surgery and the fact that her brain had been exposed and cut into.

"Good," Anne told her. She then told Teddi to rest, and the child immediately fell asleep again. Teddi slept fitfully that first and the next few nights, becoming tearful at times because of the pain. The bandage on her

head had to be replaced often due to the bleeding, and changing it caused her more pain.

Family and friends were anxious to know what happened, and Polly—thank God for Polly—was there to tell them. As delicately as she could, she said the tumor was back and growing. Surgery had gotten some but not all of it out. The tumor had become too entangled with Teddi's brain. She would need radiation, maybe chemotherapy, and her situation—Polly paused then, momentarily unable to continue—would deteriorate. Difficult as it was, she retold the story to members of the family and the close friends of the Mervises. Like repeating the same prayer over and over again, some of the sting left with each repetition of the words but the reality remained.

Immediately after surgery, Polly noted in Teddi's chart that Gary "plans to do as he has done in the past, search for other medical answers." She also noted, "The family is obviously and understandably upset."

If these were hard days and nights for Sheri, Gary and other adults in Teddi's life, it was compounded for Teddi's siblings. It would take Tod and Kim months, even years, to make sense of what was happening and to be able to deal with their own fears and other emotions.

The day after surgery, February 13, Teddi was taken out of the intensive care unit and put in a private room. She complained of headaches and abdominal pain. Her eyes were repeatedly checked for any deviations, just as they had been after her previous operation. The incision in Teddi's head, according to her medical chart, seemed to be healing well. About 4:00 a.m., Sheri called the hospital to check on how Teddi was doing. Neither she nor her husband slept well.

Polly came by the next day to discuss her role with the Mervises. Sheri said, "If you could stop by periodically, we'd like to talk to you about how we're doing. There'll be a lot we will be dealing with and maybe we could talk about that."

Polly wanted to know if they were generally satisfied with Teddi's care thus far.

The Mervises thought this admission had gone well. "We're able to relate to the doctors and that feels good," said Gary. "Sheri and I both appreciate the openness and frankness of the doctors." The Mervises told Polly that they would like a straightforward, honest approach with respect to Teddi's care, and Polly passed this information on to the floor's medical staff.

Teddi's eyes remained swollen, but she was capable of walking and did so, with help. She also got about with the use of a wheelchair. That night,

after everyone left, Teddi called Anne into the room. "I think I'm having a seizure," she said. "Will you hold my hand?"

Anne sat down beside her.

"I'm not always sure whether a seizure is just ending or starting."

"Does that scare you?" Anne asked.

Teddi tried to nod her head, but it hurt too much. "Yeah," she said softly, "I can't control my arm."

Anne squeezed her hand and stroked her arm. "I'll stay until it passes."

The two of them waited quietly in the darkened room. Dozens of get-well cards had been tacked to the walls. The table and windowsill were dense with potted plants and flowers. Bears and other stuffed animals, which continued to arrive, were put in any available space. The sound of Teddi's breathing in the dark room told Anne the child was asleep. Anne bent down, kissed Teddi softly on the cheek and quietly left the room.

The next day, the fourteenth, Teddi made a breakthrough of sorts. The swelling around her eyes had gone down considerably, and she felt alert and energetic. The change put everyone in good spirits, including her father. "If you told me she would look this good a week ago," Gary told Anne, "I would have thought you were crazy." He rejoiced, "I'm feeling really good now!" But his happiness was short-lived.

Dr. Nelson brought up another CT scan done on Teddi. "It shows," he told the Mervises, "that there's about a 70 percent reduction in the mass effect." This was mainly due to the cyst. Nelson paused, the hard part was coming up. "Unfortunately, the scan also clearly shows plenty of residual tumor on all margins of the resection. It's my judgment she'll still need ancillary therapy."

Because Teddi again had to have radiation therapy, she knew the operation had not gone all that well. "They didn't get it all, did they, Mommy?"

"No," answered her mother. "They had to leave some fringes."

"Will they do anything besides radiation?"

Sheri said she didn't think so.

Later that day, Gary met with Drs. Nelson and Salazar to talk about the next round of radiation. Gary said he wanted to explore the possibility of chemotherapy as well, which involved the use of powerful drugs. The particular drug chosen would have to conform to the nature and location of Teddi's tumor and be a drug with some success in the treatment of a glioblastoma multiforme tumor in children.

The medical record being kept on Teddi had grown long. The medical personnel were now starting volume two. Teddi's record contained

medical terms, prescriptions and hospital shorthand difficult for a layperson to understand. The content was devoid of more human kinds of insights or revelations.

The days, months and years—written numerically, separated by slashes, over and over again—began to wear on the soul, making one crave both the look and feel of words such as "November" or "December." With the words came images: the new flowers of spring, the pretty weeds of summer, the fall colors and pumpkins. Without them, there was a sterile feeling. But on that particular day, February 14, another nurse entered Teddi's life. From the medical record, it was plain she would be different. In Teddi's chart that day, Valentine's Day, Nurse Sally Masten had drawn, in red pen, a tiny heart.

From February 15 until Teddi was discharged on the eighteenth, she showed remarkable improvement. She slept well at night and was alert each day. Her spirits were good. Despite sustained weakness in her left hand and several brief episodes of hand twitching, Teddi's wound healed well, and she looked forward to going home.

Polly Schwensen observed in her own official notes that Teddi had many visitors, including her aunt, grandparents, friends and siblings. "Tod and Kim worked with Teddi on a puzzle. Then they all watched TV together. People took turns reading Teddi jokes from the newspaper." Polly also noted that Teddi's "dad was in good spirits" and that he had been doing extensive speaking on behalf of the camp.

Before Teddi's discharge, the Mervises and Dr. Salazar developed a re-radiation plan for Teddi. It was to begin the following Monday, and she was to receive 150 rads per day for five weeks. The entire right upper quadrant of Teddi's brain was to be radiated.

Teddi couldn't return to school after surgery. Her re-radiation therapy was to begin, and it would later be combined with some form of chemotherapy. For these reasons, instead of returning to school, Teddi would require a tutor.

The Pittsford School District called Mrs. Karen Lenio, certified to tutor grades one through six, and informed her that a sick child was in need of her services.

"What's wrong with her?" Karen asked.

"She has a brain tumor," came the reply.

Karen Lenio, a patient woman with children of her own, accepted the assignment. After making arrangements with Sheri, Karen drove over to meet Teddi and her family.

Karen was nervous but wouldn't let it show. Though having a great deal of experience tutoring, she always wondered if she and the new family would

get along and feel comfortable around one another. Karen considered it a privilege to be invited into someone's home and be the sole provider of a child's education.

Karen wasn't told much and didn't know what to expect. Would Teddi be withdrawn? Would she be apprehensive about having a visitor, especially a teacher? What would Teddi look like? Would she have scars or be deformed in some way? Perhaps physically handicapped? She wondered further if Teddi would be eager to learn or incapable of it. Would she be able to keep up with her class and advance into the seventh grade?

The afternoon Karen arrived, Teddi and Kim were on the couch watching their favorite show, *General Hospital*. They giggled and agreed that Karen could have picked a better time to come! Though neither child noticed, Karen felt relieved. The family was friendly, and Teddi didn't seem at all embarrassed by her baldness or the fact that she hadn't put on her wig. "She's a pretty child," Karen thought, "and a spunky one."

Teddi, along with her parents and Karen, decided on a teaching schedule that consisted of one and a half hours per day on Monday and Wednesday and two hours on Friday. At their first meeting, Karen was impressed by Teddi's commitment as a student. She accepted her homework assignments without complaint, always did them on time and often asked for more. Upon seeing Teddi's work ethic and her brightness, Karen decided she would try to keep Teddi up with her class.

From then until the end of March, Teddi began re-radiation treatments. Dr. Salazar noted, toward the end of those treatments, that Teddi continued to have weakness in her left arm and left hand. He also showed the Mervises a new CT scan indicating there had been a decrease in the tumor size, as well as the swelling around it, compared with the CT scan taken prior to the initial re-radiation.

Dr. Salazar noted, in his March 31 report, that a meeting had been set up with Dr. Klemperer to decide what kind of chemotherapy Teddi would require. Even though the radiation treatment had been intensive, the tumor still remained. Salazar recommended chemotherapy as a way of killing it entirely.

A new, largely experimental drug called cisplatinum was being tested at Georgetown Medical Center. It showed some promise in the treatment of tumors in children, and Gary had been following its developments with interest.

"I LOVE YOU ANYWAY"

Gary viewed the next stage of Teddi's treatment with cautious optimism. He wanted Dr. Klemperer to take charge of Teddi's chemotherapy treatment. He trusted Klemperer. Both he and Sheri had spent time with him at the camp, watched him with children and listened to his views on how children with cancer ought to be treated.

Dr. Klemperer never let on, but one area of the human anatomy that troubled him most was the disease and treatment of the brain. He believed the mind separated humans from other life, and jeopardizing its full functioning, or losing that faculty altogether, caused him a great deal of anxiety. "Yes, I'll do it," he told the Mervises, keeping his reservations to himself. Teddi and Sheri, who were also present, were as glad as could be about his decision. Dr. Klemperer said he agreed with Gary that cisplatinum was the most effective form of chemotherapy for children with brain tumors.

"Cisplatinum does have nasty side effects, however," Klemperer said. He believed in being honest with patients and their families. "In addition to nausea and vomiting, Teddi may lose her hearing. Her kidneys could also be permanently damaged." He stressed to them that there was no guarantee, even after all the harsh side effects, that the tumor's growth would be halted.

That afternoon, the four of them agreed they would proceed with cisplatinum treatment until there was evidence that the tumor was growing again. If growth resumed, it would mean that the drug wasn't working, and the administration of it would cease immediately. Moreover, if the drug or its consequences proved too difficult for Teddi, termination of the treatment would also be considered.

During the conversation that afternoon, Dr. Klemperer deliberately used the words "dying" and "death" instead of holding out false hope or using euphemisms such as "passing on" or "leaving." Klemperer thought that honesty, hard as it was at the outset, was the truest path to emotional healing.

A little more than a month elapsed before Teddi began her chemotherapy treatments. Anne Cameron had talked to Teddi about cisplatinum's effects on another child Teddi knew. LaVerne Haley had been to camp the previous summer. Anne knew LaVerne had suffered from extreme nausea and vomiting from taking the drug. Teddi nodded without saying anything.

Before cisplatinum was administered, other procedures had to be initiated. Teddi was given the first of many IVs containing medicine to help prevent or reduce nausea and vomiting. She was given another IV to make her sleep

during the ordeal of taking the drug. The night before treatment began, Teddi was hydrated. When no one else was in the room, Teddi said to her mother, "Either you get better or you die." There was a long pause as Teddi, looking directly at her mother now, said, "I'm not getting better, am I?"

Sheri was indirect in her reply, but the real answer hung in the air like a dark cloud. "Honey, we're still trying. There's always hope, and we keep looking. You've had two major operations, and it takes a lot out of you."

"I'm not doing good, Mommy. I'm not well," was Teddi's reply.

The following morning, and for nearly two days, cisplatinum went into Teddi slowly, drop by drop, from yet another IV. Gary and Sheri were pleased, after the first day of treatment, because there were no adverse reactions to the drug—no nausea or vomiting—though Teddi did act a little disoriented.

After the second day of treatment and after her parents and other visitors had left the room, Nurse Barb Fredette went to check on Teddi. Barb found her crying, and she knew Teddi didn't cry often. Barb thought Teddi was sensitive to how it hurt others, especially her parents, when she cried or complained. If a nurse was in the room when she cried, she would make them promise not to tell her parents, and in most instances, the nurses complied.

To Barb, Teddi seemed to be the kind of person who kept a lot of her personal feelings inside. Though Teddi had a smile when there was company, alone, she was more subdued and reflective.

"What's the matter?" Barb asked, hoping she could be of help. Teddi said she didn't want to bother Barb.

"You're not a bother to me," Barb said, taking Teddi's hand. "I'm interested in knowing what's wrong so I can help you."

"I'm afraid," Teddi said. She didn't look at Barb but instead continued to stare at the ceiling. "I don't like being sick, Barb," she said.

Barb let a few moments pass before she asked Teddi what frightened her.

"Everything," Teddi replied.

Barb waited, trusting that patience was better than probing. Children often showed more faith in silence than adults.

Teddi then revealed her fears, one by one, before moving swiftly to the point. While she thought her sister and brother and her friends would be all right, she was worried about her parents. She worried about hurting them.

Barb wasn't sure what Teddi meant, but the child grew quiet and began to withdraw, so Barb let her go, believing there would be another time to talk about it, that the heart of a child lets hard things out in trickles rather

than a torrent. Teddi's hand relaxed in Barb's as she drifted off to sleep. Barb remained in the room a few moments longer, until she regained her composure and could approach the next patient with cheerfulness and vulnerability.

Barb, like Sally Masten, knew Teddi's primary nurse, Anne Cameron, well. They had all been classmates at D'Youville College in Buffalo. Though Anne took to the Mervises quickly, Barb and Sally weren't certain if they were ever going to warm up to them. Both were Teddi's secondary care nurses. Sally came on board when another nurse withdrew from Teddi's case. Sally described the Mervises, and especially Gary, as a "challenge." At that point, Gary was playing an active role in Teddi's care.

Sally's view of Teddi matched Barb's more than it did most others. She didn't see the "corker" that her parents and friends described. For her, Teddi was a shy, mostly withdrawn child who preferred to stay in her room rather than wander the hallways or go to the playroom to be with other children. She saw a child in considerable physical and emotional pain.

Teddi had four "courses" or "cycles" of cisplatinum, beginning in May and ending in mid-July. Her second course, in late May, resulted in serious new developments. Sally Masten reported that Teddi's seizures had changed and were more strange and serious than before. Sally also noted that Teddi was losing hearing in her inner ear.

With her third course, and in spite of the fact that a repeat CT scan showed that the tumor was "much less prominent," Teddi's physical condition deteriored with terrible speed. Her suture looked discolored, the scalp itself had become tighter or, medically speaking, "more tense." The medication made Teddi talk oddly at times, like someone disoriented. Sudden and sometimes violent muscular contractions occurred in her left leg.

By mid-July, the cisplatinum had taken a serious toll on Teddi's body. Often nauseated, she vomited frequently. Her face was gradually becoming disfigured, and she complained about her inability to sleep. Unable to walk unless someone helped her, she soon was unable to do even that. At home, she stayed in bed most of the time. According to the medical record, Teddi could no longer hear "the ticking of a watch or whisper." The awareness heightened among those closest to her that the deadly tumor was growing.

Though her physical condition declined throughout her treatments, Barb was witness to Teddi's courage. "Most of us can get through chemotherapy the first time," she said. "But it's hard to come back knowing what it's going to be like. Yet when Teddi came in for treatment with that determined

look on her face, she took it time and time again like a brave little trooper." Everybody was feeling miserable at this point, including the doctors. The cisplatinum had resulted in blown veins; the increased Decadron dosage caused her to become "morbidly obese." The doctors could not find a vein in which to stick a needle for an IV.

Strong Memorial Hospital's policy is that a doctor had only three tries to get an IV in a vein and, failing that, someone else had to try. "Three times and you're out!" Barb remembered Teddi saying.

But there were times when Teddi's courage faltered. Anne Cameron remembered how painful it was for Teddi to step on the scale at each hospital admission. Before her last cisplatinum treatment, Teddi had stepped on the scale and watched Anne move the "weight" further and further to the right. "I'm fat and I'm ugly, aren't I, Anne?" she couldn't help saying.

No one present could answer or respond honestly, so they chose silence.

Sally Masten thought that Teddi was becoming more and more afraid, especially as the seizures continued with more frequency and ferocity. The medication and fatigue were also making her terribly disoriented, and this frightened Teddi. She was not able to determine if a seizure was just beginning or about to end. Anne and Barb noticed how increasingly withdrawn she had become. All Teddi's chatter about her boyfriends and Marvin was at an end now, as was the teasing by the nurses. Conversations slipped into phrases, and phrases gave way to one-word questions and responses.

A major downside of primary and secondary care nursing was that Anne, Barb and Sally had become close to Teddi, and the latter's deterioration and impending death took a large emotional toll on them. Good friends, they tried to comfort one another when the hospital nights seemed unbearably long and their courage thin. After Teddi's fourth and last cisplatinum treatment, the hospital chart read that, while the cisplatinum had apparently decreased the size of Teddi's tumor, the swelling around the brain had increased.

It was also noted that:

> *Teddy's* [sic] *father tells me that she knows she has cancer, a serious disease, but the family has not specifically dealt with death with Teddy* [sic]. *The Mervises prefer to maintain an optimistic approach while she is undergoing her difficult treatments and wish not to dwell on the subject of death, saving all her energy for her treatments.*

While a patient at Strong Memorial Hospital would have primary and secondary nursing care from the same people, physicians were a different matter. In Teddi's case, Drs. Nelson, Salazar and pediatrician Lawrence Nazarian were her continued consulting physicians. But because Strong was a teaching hospital, attending physicians rotated.

The purpose of having resident physicians rotate was so that they would gain experience on different floors and sections of the hospital, with different kinds of injuries, illnesses and diseases. The drawback was that patients and their families sometimes felt intruded upon by strangers and sometimes even lacked confidence in a new resident, worried that he or she wouldn't fully understand the patient's medical past and might even make a crucial, even life-threatening, mistake. It was an emotional burden on patient and family alike: they would have to be more vigilant, and they had to carefully size up each new doctor.

The rotating physicians used words in Teddi's medical record that represented either their lack of closeness to her or the empathy they had for her. Some misspelled "Teddi," using a *y* instead of an *i*. Though true, a doctor for the first time wrote that Teddi was "obese." One resident seemed touched by Teddi's circumstance. "It should be pointed out," he wrote, "that a grade IV astrocytoma's peak incident is 45–50 and is rare below the age of 30, making Teddy's [*sic*] plight all the sadder."

Teddi's awareness of her condition came about when the cisplatinum treatments ended.

"I'm going to be sick again, aren't I?" Teddi asked, struggling to find and even say the words out loud. And she asked it of the one person, other than her father, she wanted to hurt least.

"Oh, Teddi," said her mother, "you know I wouldn't let anything bad happen to you."

Teddi, perhaps for the first time, was firm in her response. She said, "You know that's not true. You know you can't get rid of this cancer."

Sheri didn't say anything or move.

Teddi, noticing, went over to stand by her mother. Sheri began to tremble. Her daughter knew she was going to die.

Teddi leaned into her mother.

"That's all right," Teddi murmured. "I love you anyway."

DECLINE

That spring, Teddi and and her mother visited the DeBiases. Teddi asked if Skip would put a movie in the VCR for her to watch.

"I've got just the perfect movie for you," he said and put on *The Muppet Movie*. He began to leave the room, but Teddi called him back.

"Come here and listen for a minute," she said. "I learned the words to this song in school."

Skip knew "The Rainbow Connection," too, and knelt beside Teddi and began to sing along with her. They had reached a point in the lyrics that said, "Have you been half-asleep, and have you heard voices? I've heard them calling my name. Is it the sweet sound that calls the young sailor? The voice might be one and the same."

The words, Skip would say later, hit him "like a runaway train."

He had not heard those words in the same way before and wondered if Teddi wanted him to know that she had accepted death. He got up after the song was over and left the house. Sheri thought it strange for him to leave without saying anything and wondered if he was mad about something. Skip could never bring himself to tell her what had happened. After that time, and at different moments, Teddi talked to Skip more and more about "not being around anymore."

Teddi talked to Cheryl about these things as well. One time, she told Cheryl how great she thought heaven would be. Cheryl wasn't exactly sure what the child meant.

"Because I'll be pretty again," Teddi said. "I'm going to have all the boys I want. My hair is going to grow back. And I'm going to be *so* happy."

In some ways, the campaign to raise funds for the camp's second year was a little easier. At least Gary didn't have so much explaining to do about who he was or what the camp was about. Many had heard of him and the work he was trying to do on behalf of children with cancer. The media had picked up and followed the story. The camp's first year had been an unmitigated success, and word was spreading. That fact alone made it easier to secure financial support and rouse a supply of much-needed volunteers.

The high hopes regarding Teddi's schooling obviously eroded. Karen Lenio still came to the Mervis home, and Teddi kept trying, but returning to school was no longer an option.

It hurt Teddi. She wanted so much to be able to go into seventh grade. There were horror stories, which Teddi repeated, about seventh graders being shut away in their lockers for the whole year!

That spring, before the end of the term, the elementary school Teddi would have been attending arranged a visit to the new school. There would be an orientation program, as well as a chance to meet some students in the upper grades. Teddy wanted to go.

But when the time came, Teddi wasn't able to do so. She had kept up with her homework, sometimes refusing to sleep or to rest in order to do so. But physically, going would be too hard on her.

Sheri planned a party for Teddi on her birthday, June 27. One of the people invited was Teddi's "blood sister" Laurie Allinger. The invitation said there would be pizza and that they'd all go out to a movie afterward. She called Sheri to say she would be coming.

Laurie arrived, and she and Teddi were glad to see each other, though Laurie was stunned by Teddi's appearance. Teddi led her to her room, where she explained there were exactly 187 bears and other stuffed animals. Laurie's gift, much to her own embarrassment, was a small bear wrapped in a shoebox. But mostly, Laurie felt a terrible sadness. Laurie's mother had told her that Teddi was not doing well, but Laurie hadn't really heard her mother. She was too consumed by the excitement of seeing her old friend. But there was no denying what Laurie saw. She had seen Death's slow arrival too many times to not know what was going to happen. Laurie held back her tears as she helped Teddi open her present. But she cried afterward while eating her cake at the far end of the table.

It was a hard summer for Teddi's sister, Kim. An active thirteen-year-old, she looked forward to being with her friends. But Kim, along with Sheri, was about to take major responsibility for Teddi's care. Kim watched her sister, read to her and helped her to the bathroom and back. She was Teddi's near-constant companion. Later, Kim would feel bad about becoming irritated with Teddi at times, frustrated by her sister's demands and her own feelings of being tied down.

Sheri would also have a hard time of it that summer. Teddi asked more questions and seemed afraid of the word "cancer." So when Teddi asked about it, her mother would say, "You have a brain tumor, honey." Though she knew she was softening the truth somewhat, she also felt that Teddi could not be at a camp for children with cancer and not know. Teddi fell one day, fracturing her arm. Along with other challenges, she would also have a cast on her arm for the second year of camp.

Both frustrated and worried, Sheri brought Polly Schwensen in for help. Polly, alone with Teddi, verbally walked Teddi through her fears and insecurities. Some of it was hard for Polly to hear, especially about the boys

from the year before seeing Teddi now, the way she looked, fat and disfigured. "They will laugh at me," Teddi said.

Polly let the girl talk without interrupting, offering encouragement with a nod of her head or by squeezing Teddi's hand. When she felt Teddi had emptied herself of her pain and torment, Polly began by tackling the easiest fears, the ones that could be dealt with practically.

"You liked arts and crafts last year," Polly said, "and you can spend a lot of your time doing that this year. For sure it will be hard getting around, but there are plenty of strong, willing counselors at camp who would be eager to help. I mean, after all Teddi, that's what they're there for," Polly said. "And they know, and everyone knows, how much you've done for camp."

Teddi's other feelings and fears were more difficult to address. Both Polly and Sheri, in the days ahead, told her that many of the people at camp—campers, counselors and staff—would be glad to see her anyway, that her true beauty was on the inside. Teddi never responded to these and other sentiments.

THE SECOND CAMP

Former campers and new ones alike were excited about being able to go to camp that second year. Suzie Parker felt the bus ride was like "leaving one world and going into another." Veteran campers lessened the anxiety of new campers. Laurie Allinger told a little girl who sat nervously next to her, "Don't worry, you'll be all right once you get there." Most of the counselors were back. They broke in the greenhorns and gave the arriving campers the same jubilant, enthusiastic reception of the year before.

Two people were critical for Teddi at camp that year. One was Polly, selected to be the head counselor of Teddi's cabin. Polly felt as though she had gone from "a peon at the camp the year before to Queen of the Counselors." Muggs Register would also be important to Teddi. Like Polly, she had barely come to know Teddi at the previous camp. Muggs, arriving a few days before the campers, noticed Teddi one afternoon off in the distance. She was sitting in her wheelchair while the adults around her talked to one another. Even from a distance, Muggs could see how much Teddi's condition had worsened and moved away to cry, by herself,

Gary welcoming a returning camper to the second year of camp. *Courtesy of the Camp Good Days Photo Collection.*

for Teddi and for the campers who would soon see Teddi and likely know she was going to die.

Muggs sought out Polly. "I'll take care of Teddi," she said matter-of-factly. Polly wasn't sure what Muggs meant. "One-on-one you mean?" Muggs nodded yes. Though most never knew, the twenty-year-old college student was battling Hodgkin's disease. There was a lot of spunk inside Muggs. "She'll need plenty of looking after."

Polly nodded, "Thanks."

Muggs smiled and walked away.

Nurse Barbara Fredette came to camp for the first time that year. Whenever she saw kids in the hospital, they were sick, and she wanted a chance to be with them when they felt and looked better, when she could be with them more as a friend than a nurse.

The kids she knew were glad to see her, too. When they got off the bus, they ran up to hug her, squealing with delight to see her in blue jeans and a sweatshirt rather than hospital garb. Some even kidded that they were going to get back at her for all the needles she had stuck in them. They would keep their promise, putting rubber snakes in her sleeping bag, engaging her in pillow fights and waiting for her to walk below the second-floor windows of the main cabin in order to bomb her with water balloons.

Irene Matichyn also showed up for the first time that year. It had taken some doing to get her to volunteer, and that mostly came from Skip. He talked to her throughout the year about going, walking her through her fears and the feeling of not being able to be of much help to the children.

But she had come. And when the children got off the bus, she was prepared to greet them with wild abandon. She had been a high school cheerleader and was known for being a kind of "rah rah" person politically. But what happened next hit her hard, like a punch in the stomach, taking her breath away.

She couldn't speak or move; one by one, the children slowly climbed off the bus. Some were bald, one was blind, a few were on crutches, many looked terribly emaciated. Laurie Allinger then climbed down from the bus, and for an instant, Irene saw a tall, beautiful, athletic girl with a winsome smile. But Laurie turned just then, just enough for Irene to see that the girl didn't have an arm. Irene began to lose her self-control. "This is crazy," she thought to herself. "Life is crazy. How could God do this?"

"Dear God," she cried, "how did this happen?"

Skip, watching her, came up beside her. Irene's knees buckled, and Skip helped her to the bleachers a little distance away. All the while, he talked to

"I'm ready," said the boy. "Mom packed everything." *Courtesy of the Camp Good Days Photo Collection.*

her. "These kids are here to have fun. And we're going to let them have fun. You and I and everybody else here. Period. We're going to make them laugh."

Irene looked up, and though Skip's words were tough, tears were in his eyes, too. "Trust me," he told her. "After a day, you won't even see them as having cancer."

Irene was shaking her head, like she didn't believe him. "Skip," she said, "I don't want to do this. This is crazy. I've got enough pain in my own life—I don't need any more."

Skip held tightly to her arm. "You get this out right here," he said more firmly. "Get this out. Don't feel sorry for them. You only have to do one thing: make sure they have a hell of a good time. That's it. And you're the kind of person who can do just that, Irene."

Later, Irene dove into the camp's activities with the same spirit that she showed in other endeavors. She volunteered to participate in the banana-eating contest, was a major instigator of flour and cake wars and even abandoned putting make-up on each day. There was no self-consciousness. Each night, she went to bed utterly exhausted.

Most of those who came to camp that second year, veterans or novices, were uncertain how to respond to Teddi's condition. Her blood sisters, all in good health, came by to talk with her each day either in Teddi's cabin, at dinner or during some of the camp activities. But Teddi couldn't hear very well. Laurie was too embarrassed to shout and walked away at times, knowing that Teddi hadn't heard much, if anything, of what she said. Teddi spent a lot of time in her cabin, away from the others, saying she was too tired to participate. Sheri thought maybe Teddi's medication was making her more lethargic than usual. Changes in dosage were tried but didn't seem to help much. Often, the camp relied on counselor Jim Menz, a strong and likeable college student, to carry Teddi when she wanted to go somewhere. Nobody was really sure, even her parents, if Teddi simply didn't want to be seen or was too in pain from memories of the previous year, most likely a little of both.

Muggs went over to Polly one morning, near the flagpole, during flag raising. "I need to talk with you," she said. Before Polly could respond, Muggs started to cry.

She told Polly she was physically tired and emotionally mixed up. She wanted to be with Teddi, to help and to cheer her up, but sometimes she just wanted to be alone or laugh or be with others. She knew Teddi was dying and, "Oh God," didn't want her to die. She also thought that, because Teddi was in such terrible pain and the small details of daily life had become so difficult for her that—dare she even say it?—death might be a welcome sort of thing.

While the others were at breakfast, Polly and Muggs walked in the woods. Polly later said that Muggs "cried and cried and cried," that she felt guilty and could not find any peace.

Other campers tried to get Teddi involved in some of the activities. She shook her head no. Some of her friends invited Teddi to town. But she shook her head no again.

"We can wheel you, Teddi," Muggs offered.

"But I'm too heavy," Teddi answered.

"We'll take turns," said Polly.

Teddi refused. Later, Muggs, Polly and Teddi were alone in the cabin and heard a commotion outside. The cabin door swung open, and a bunch of boys and girls came inside singing, "We love you, Teddi! Oh yes, we do!" over and over. It gave Teddi all the encouragement she needed to go into town, and so she did.

Skip would see Teddi at times and think she was having flashbacks from the year before. Sometimes when he was out on the dock alone, he would remember how they had sung "The Rainbow Connection" together that spring afternoon and how the words about a voice calling her name nearly broke his heart.

What Teddi could "see" in memory would have to compensate for her steadily declining vision. On the beachfront one night, Sheri said, "Look at the sunset, Teddi. Isn't it beautiful?"

Teddi strained to see but told her mother it was mostly gray to her.

Believing in God's goodness had also become extremely difficult for Teddi. One afternoon, as Sheri and Irene were wheeling Teddi over a hill, the wheelchair got stuck.

"Why does he hate me?" Teddi suddenly began to cry. "What did I ever do to him?"

It was a warm, sunny day, and around them, children laughed and played. Irene moved behind the chair so Teddi couldn't see her. She was angry with God, too.

Sheri struggled to free the chair. "God doesn't hate you, honey," she said, frustrated by the rock and the statement. "He loves you."

"Why is he picking on me then?" Teddi wanted to know. "Why me? Why me?"

Teddi's emotions seemed to bounce back and forth between anger and acceptance that week, a recognizable stage in the dying process. Nurse Barb spent a brief moment with Teddi one afternoon. She sat with the girl beneath a tall pine tree at the water's edge.

"They're having fun, aren't they, Barb?" she said, able to hear some of what was going on around her.

Barb looked at the kids, smiled and said yes, the kids were having fun.

"It's sad that so many of them are sick, isn't it?" Teddi added. "But it's okay, they're having fun."

Barb, a quiet person, nodded agreement without saying anything. She squeezed Teddi's hand to assure her that she was a good person and had spoken the truth. Barb was content to sit with Teddi, listening to the sound of the children playing and the waves lapping on the shore.

Finally, Teddi said, "You know Barb, I know I'll be okay, but I'm worried about my parents, if they are going to be all right."

It was the second time Teddi had said this, and Barb thought she was talking about her own death. She was going to ask Teddi what she meant when some other children came up to kiss Teddi and then scurry away. Barb waited, but Teddi seemed far away, and Barb let it go for a second time.

Late in that week, the entire camp went to Lake Placid. Teddi went on the bus. All had a good time. But it was a very hot day, and as they were about to head back to camp, Nurse Barb fainted. She and Teddi returned to camp with Gary in the van.

When Barb awakened, Teddi's arm was around her. She was also holding Barb's head, looking at her and smiling.

"Hi, how are you feeling?" Teddi asked.

"A lot better, Teddi," Barb answered, "now that I'm next to you."

Teddi beamed. "I feel a lot better with you next to me, too, Barb." Then Teddi said, "I love you, Barb. You can tell Anne that I love her too, even though she didn't come to camp this year. I love both you nurses. And Sally. I love my daddy, too."

Gary, listening, began to smile.

Teddi yelled to him, "I love you, Dad!"

Gary was laughing now. "I love you, too!" he called back to his daughter. And for the next several miles, Teddi and her father exchanged "I love yous" with each other.

On the last night of camp, there was a softball game, and Teddi sat in her chair at the field's edge, watching. Well before the game was over, she told Polly that she wanted to go back to the cabin.

"Let's go for a walk instead," Polly said. "Let's go out on the dock for awhile, okay?"

The two of them sat on the dock in silence. It was twilight now, and the sounds of children in the distance were but echoes.

Then a flock of squabbling, rowdy ducks broke the silence and their thoughts.

"Oh, you want to feed the ducks, Teddi?" Polly asked excitedly. That was something they could do.

Teddi said she'd like that, and Polly ran to the dining room for some bread. She broke it up for Teddi to throw in, which she could, a little, with her right arm, the good one. The ducks cut through the water toward Teddi and the bread, making the two friends laugh.

Polly didn't think Teddi had much fun that week, but now, with the beauty of the night, the happy ducks and the content look on Teddi's face, everything seemed all right with the world. Teddi said she'd have to go to the bathroom soon, and Polly nodded yes, she knew about that. Polly wanted to extend this happy moment longer and told Teddi she was going for more bread.

Returning, Polly broke up more bread for Teddi to throw into the water. The ducks began their splashing and squawking again. Teddi, ever patient, finally couldn't hold it in anymore. She said to Polly, "This is really fun. But I *really* do have to go to the bathroom!"

Polly raced Teddi back to the cabin in the wheelchair, both of them laughing so hard that they ended up in tears.

Skip improved and expanded his fishing operations at camp that year. No longer did the children have to fish from the dock; he brought his boat to camp and took them fishing in deeper waters. Skip held a variety of fishing contests, and on the last night of camp, he distributed awards.

A young boy named Chuckie Altamara became one of Skip's steadfast fishing companions. He was in a wheelchair but fished whenever he could. Chuckie also liked to go on the boat

Another fisherman is born. *Courtesy of the Camp Good Days Photo Collection.*

when Skip hunted for small pan fish, which provided so much fun for the campers. Often no bigger than minnows, these fish always seemed hungry.

The fishing contest held on the last day of camp was for the person who caught the biggest fish. Despite the fact that Chuckie fished way more than the other kids, he didn't catch a single fish that day. At supper, he was, initially, crestfallen. But then, like many kids with cancer, he pulled himself together.

Chuckie could walk, with great difficulty, without the aid of his wheelchair. That night, he wanted to make an attempt to walk from the front door of the dining hall to his table beside his counselor, Phil Rivaldo. Rivaldo worked at Xerox Corporation and was one of the funniest of all the adults at camp. Chuckie asked Phil if it would be all right. Though ready to help if Chuckie fell, he told the boy to "go for it."

Staff and counselors began to notice, and the room soon became quiet. All eyes were on the boy. Some held their breath, some crossed their fingers and some prayed. Chuckie slowly, and a bit unsteadily, made it to his place at the table. The dining hall erupted. People banged forks, pounded their feet, clapped, cheered and cried. At Camp Good Days, the small things were sometimes big indeed, and what the world considered big didn't seem to matter at all.

After supper, awards were presented. One award, presented by Skip, was for the person who caught the biggest fish that day. As Skip talked, he could see Chuckie, cap on, lower his head. After giving out all the awards for the contests that week, Skip said he still had one more, a special one.

"You kids go out there on the boat and catch those fish, but I'll tell you something—there was somebody who was out on the water first and who found them for you. It's hot out there, and finding those fish takes a lot of time. Sometimes you even miss a lot of camp activities. So this year, to my special fishing guide, I'd like to present a new rod and reel to Chuckie Altamara."

Chuckie slowly began to raise his head. It was totally unexpected, and he couldn't be sure he had heard right. With Skip walking toward him, the dining hall once again erupted in cheering and noisy bedlam.

Phil Rivaldo sat down next to Chuckie, after others had stopped by to congratulate him.

"I don't know what else I can do for you, Phil," said the boy, "for all you did for me this week."

Phil pointed at the boy's sneakers. "See those?" he asked.

"Yeah," Chuckie answered, somewhat confused.

"What you can do for me is wear them out by next year at camp, okay?" Chuckie smiled and promised he would. It was enough for Phil, even though he

knew Chuckie wasn't going to make it for very long. Soon after the camp ended, Chuckie's condition worsened. Teddi would often ask about him, and Cheryl DeBiase thought it might be a good idea to get the two children together.

"How about you two come over here for lunch," Sandy Altamura, Chuckie's mother, offered.

Teddi said to Chuckie when they saw each other, "So what's your biggest complaint?"

As autumn slipped by that year, Teddi asked less and less how Chuckie was doing. Although snow was on the ground, sometimes in large mounds, when Skip visited Chuckie, leaning against the wall beside Chuckie's bed was the new rod and reel. Chuckie died that November. But nobody had the heart to tell Teddi, even when his mother came to visit. That spring, the kids at Chuckie's school raised more than $10,000 to donate in his memory to Camp Good Days. At the time, it was one of the largest single donations to the camp.

On that last night of the second week of camp, Skip saw Irene standing by herself by a huge Maple tree.

He took her by the arm. "Come," he said, "walk with me." They walked on the beach for a short while, and then Skip stopped. Irene stopped, too, and looked at him.

Friends forever. *Courtesy of the Camp Good Days Photo Collection.*

"Well?" he asked.

Tears formed in Irene's eyes. "You were right. Make 'em laugh. And I did make 'em laugh, didn't I, Skipper?"

"How do you feel?"

"I can't describe it," she told him, feeling herself beginning to tremble.

"Now you understand," he told her.

Yet Irene couldn't find the courage to stay for the final goodbyes of camp. "I escaped," she said, "in the dead of night."

That second camp farewell was even more overwhelming than the first, and a lot of it had to do with Teddi. Her blood sisters came by, one by one, to give Teddi a hug. "See you next year!" they said loudly, so Teddi could hear them. Laurie was the last to say goodbye. "You're going to be here next year, right? Right, Teddi?" Laurie repeated, like someone insisting on an answer or not wanting to hear one at all. She wanted to hold on with that goodbye, perhaps even though it was a hopeless hope.

"I'll be here," Teddi told her, managing a smile.

Barb kissed Teddi goodbye. "I love you, Teddi," she told Teddi. "Thanks for taking care of me."

"Thanks for taking care of *me*, Barb," Teddi answered.

There were no boyfriends waving back at her this year. Muggs had her own car and was one of the last to leave. She didn't remember saying anything important or special when she said goodbye to Teddi. Muggs knew Teddi wouldn't be back the following year. She hugged Teddi and said, "I'll see you later." Once in the car, Muggs would cry on and off on the way home.

As Autumn Approached

Karen Lenio, Teddi's tutor, had followed developments at that second year of Camp Good Days and Special Times in the newspapers. The stories sometimes carried Teddi's picture, and Karen could see Teddi's steep decline. Karen would help out at times in the fall, even though her teaching credentials were only good for grades one through six. Nobody seemed to mind, not even officials at the school.

Karen and some of the other teachers thought it would be good for Teddi to attend seventh grade, knowing it probably wouldn't be for long. Despite Teddi's self-awareness of her own appearance, when told of the plan, she was exuberant.

"First," she announced to her mother, getting a head of steam. "I'll go to English class."

"Whoa," said Sheri. "Now let's talk this over."

"What's there to talk over?"

"Do you think English class is a good idea, Teddi?" her mother asked. "I mean, you can't see to read and you can't hear all that well."

"Then I'll sit in the front of the class." But Teddi hemmed and hawed momentarily. "I know what," she said, "I'll take a tape recorder to class."

"If you take that class and a lot of others, how are you going to get around? Get from class to class I mean?"

"My friends will push me."

"Suppose they aren't going to the same class as you are?"

Miffed, Teddi said, "Well, we'll work things out, Mom."

Teddi was to have a day nurse beginning early that September when Kim was at school and her parents at work. Sheri wanted to know what the nurse, whose name was Laurie Freeman, was going to do with Teddi at school all day.

"Who knows," Teddi shot back, "maybe Laurie needs some more education!"

Sheri wasn't trying to discourage Teddi from going to school, she just knew Teddi's physical needs and limits. Sheri was also against getting Teddi's hopes up, only to see them dashed. She had seen the emotional devastation it caused her daughter to believe one thing, only to have it taken from her. They had all thought, and passed it on to Teddi, that maybe this surgery, this radiation, this chemotherapy would do it, cure her, save her life. And each time, Teddi had only gotten worse.

The Mervises, with Karen as a consultant, decided that Teddi would start with one class—art—and if that went okay, more courses might be added. The consensus, including Teddi's vote, was that she should have a tour of the school, the one she had missed the previous spring. Soon afterward, Teddi, Laurie, Karen and Sheri arrived at the school after classes had been let out.

Most of Teddi's teachers, knowing she was coming, had waited. What surprised everyone, however, was how many students also waited. They heard Teddi was coming and wanted to meet her. Karen would remember that when the tour ended, there was quite a procession of students and teachers behind them.

Even after Teddi started school, students would stop her in the hallway to introduce themselves. They offered to help with her wheelchair or homework. Some would stop by art class, knowing she was there, just to say hello or to ask how she was doing.

Teddi hadn't lost her perspective despite all the attention. For instance, one boy, also in a wheelchair, came by to talk one afternoon. Wheelchairs can be extremely uncomfortable, and when he left, Teddi said to her nurse Laurie, in a too loud whisper, "I wonder if his keister gets sore, too!" Teddi laughed, in that infectious way she had, sending Laurie and others close by into fits of laughter.

That autumn, it became increasingly difficult for Karen to find schoolwork Teddi was physically and mentally capable of doing. Teddi's eyesight further declined, and sometimes Karen was forced to put a single math problem on an entire sheet of paper in order for Teddi to see it. For a while, Karen made posters of information Teddi needed to know. Teddi tried. She kept trying. At one point, she was ahead of her class in the number of book reports required of seventh graders. But that didn't last long.

Karen had grown close to Teddi, just like Teddi's nurses at the hospital, and it was as hard for her as it was for them. To cope with the sadness, Karen kept a journal. As autumn passed and Christmas approached, Karen wrote:

> *Teddi was trying as hard as ever but was extremely confused, vague, forgetful and distracted. She isn't sure what day it is, what time it is, nor whether or not she has eaten lately. She is worried about everyone, and is out of control on such things as going to the bathroom...I see blue hospital baby pads under her. She gave a blood-curdling scream from the bathroom with Laurie (the day nurse) and whimpered her way down the hall. It is heartbreaking. My dear Teddi...may tomorrow be better, please Lord.*

Knowing the end was coming, that fall, the Mervis family went out of their way to make things as interesting and comfortable as possible for Teddi. Sometimes, they would make a big thing out of watching TV on Saturdays or when there was a special program, so that Teddi had something to look forward to. They bought Walt Disney movies for her and made a fuss about making popcorn and getting ready, just as though they were going out to a movie.

Other times, they would help Teddi into her favorite brown chair, put her feet on the hassock so she was comfortable and bundle her chilly body with blankets and pillows. They would sit next to her and read. Sheri couldn't read long without her voice getting hoarse, so that task largely fell to Gary. He would buy books or borrow them from the library. There was a story about a blind girl confined to a wheelchair, another about a girl who fell in love for the first time and another about God. Teddi wanted to keep up with her book

reports, and even though she couldn't read them anymore, her dad would read them to her. Then, together, they'd work on the book report, talking it over, laboring over each sentence Gary wrote. Both complained to Karen once how she only gave them a B when they thought they deserved an A!

A terrible dread began to find its way into Sheri's heart. She thought Teddi needed to talk to somebody who knew about religion, a priest or somebody like that, in order to find a measure of peace before she died. Sheri felt that deep inside Teddi was spiritually troubled. Sheri also feared that if she died without being baptized, she might go to that place between heaven and hell Christians call limbo. If that happened, she thought, Teddi might have to stay there for eternity without seeing God and without seeing the people Teddi loved. There would be no way, if this happened, for Sheri to ever reach Teddi.

There was a shy and watchful man who sometimes came to family court where Sheri worked. Though having spoken to him only briefly when he came, she had come to like and respect him. Dave Ambuske was an advocate for children, heading up the Rochester chapter of the Society for the Prevention of Cruelty to Children. He was also an Anglican priest.

Ambuske had strong, independent opinions about his calling that the Mervises would find out about later. As a worker-priest in France, he had come to believe that a cleric must not remain isolated or aloof from the harsh realities of the world but participate in them fully, embracing and experiencing the same pain, fear and anguish that existed in the daily lives of those who came to him for counsel and comfort. He also believed that honesty was a prerequisite in all matters of faith, even if a child was involved—and even if the child was dying.

Father Ambuske's life had been nudged in the direction of Teddi's life before Sheri asked him for help. It began during one of his church services when a parishioner wanted the congregation to pray for a sick child. Over the weeks, the parishioner added more and more detail about the child before they prayed. One time, it was said that the child had a brain tumor. One morning, before the start of the service, Father Ambuske saw the woman who asked them to pray and asked her the child's name. "It would mean so much more to us," he said.

"It's Teddi," she said, and from that moment on, Ambuske's church prayed for a child named Teddi.

Sheri talked to the priest late one autumn afternoon, and they sat next to each other on a wooden bench in the back of the empty courtroom. Sheri would look over at him only twice in the brief, somewhat awkward, conversation. Both times, she wanted to be sure of his reaction. The first time was when she had finished telling him what had happened to her daughter.

The second was when she asked him if he would be Teddi's priest. "It won't be for long," she told him softly before turning away.

"Of course," he answered. "I would be glad to come."

A New Friend

Father Ambuske drove to the Mervis home for the first time, anticipating what it might be like. He had consulted the medical library about Teddi's particular form of cancer. He learned its nature, manner of growth and the possible side effects of surgery, radiation and chemotherapy. From what Sheri had told him, Teddi had not said yes or no to his coming, and he wasn't sure whether Teddi wanted to talk to him at all. "Maybe she'll be so depressed—or angry—I won't be of much use to her. Maybe she won't want to talk about her own death."

As he pulled into the Mervis driveway, his perspective returned. "Whatever happens," he told himself, "she's still just a kid. In spite of everything happening to her, she has the same attitudes and needs as any child." Father Ambuske was straightforward and direct; so was Teddi.

After introducing himself, he asked Teddi if she would like some time together each week when it was only the two of them in the room. "This will be the time that's reserved for just you and me, and you can say anything you want, and I won't tell anybody afterward if you don't want me to. And if we don't have anything to talk about, then it'll be our quiet time together."

Teddi said that would be fine with her, except she wondered if Sweet'ums, her pet bulldog, could also stay.

This made Father Ambuske laugh. He told her he liked bulldogs. "But you know what, Teddi," he added, "I like horses even more."

Teddi liked horses, too, and Father Ambuske showed her pictures of the two he owned. "This one is named Minerva," he said, "and that's Cassie, for Cassiopeia."

Teddi thought their names were funny.

"They're named after Greek goddesses," the priest explained. "Minerva is the goddess of wisdom, and Cassiopeia is the rocking chair goddess in the sky. You can see them both in the stars."

They talked about goddesses and horses, and then there was an awkward silence. Father Ambuske nodded at the door, asking Teddi if it was all right to shut it. Teddi told him, "Yes, that would be all right."

Father Ambuske's Holy Cross Anglican Church, Webster, New York. *Courtesy of Deedee Carey.*

He returned, sitting on a chair next to her bed and, as gently as possible, asked how she felt about being sick. The question triggered an immediate emotional reaction in Teddi.

"You know," she said, "everything is always so nice for everybody. I feel sorry for myself that I'm sick and there's so much to do and I can't do it."

Father Ambuske moved the box of tissues closer to her.

"I want to know why, Dave," she said. "Why me? Let's have some answers to that question."

Ambuske felt his years of theological training and experiences as a priest had to be distilled into a brief, clear, honest response that a child could understand and find comfort in. "Well, I'll tell you something, Teddi," he answered, leaning close to her and taking her hand.

"I believe something, even though I can't prove it. A lot of religion, a lot of things connected with God, requires our belief. It takes faith because we can talk to God all we want, but we don't always get answers. And sometimes the answers we get, or think we get, are not the answers we want."

Teddi watched his eyes carefully and waited as Ambuske continued. "It takes a lot of faith," he said. "Faith is what it's all about. I always believe that people like you get sick because there is a very special reason. And I think God picks certain people that he feels can accept that sickness and

can do things with it and not just sit around and feel sorry for themselves all the time."

Teddi asked him questions about faith—what it meant, how it applied to her and what he meant when he talked about God's will. They talked about the fact that Teddi spent time thinking about other children with cancer.

She corresponded with some, she told him. And she talked to more on the phone.

"There," Father Ambuske said, "see, you're doing just what I've said. You're thinking about others. You're accepting your sickness. You're accepting the other person's sickness, but you're living as normal a life as you possibly can. I think that's the way we should live our lives, even though we know we're going to die."

Some moments passed. Father Ambuske purposely didn't say anything, wanting to wait to see if Teddi had more questions for him. He didn't like the word "die" still lingering in the air.

She didn't seem to have anymore questions, and he continued in what he was saying. "In one sense," he said, "you're very lucky because you know you're going to die. I don't know and most people don't know. I could walk out of here and drop dead. But you know you're sick and you know it's the kind of sickness that, in the end," and here he paused, even though he didn't want to. "At the end of the sickness is death. That there's no cure."

He stopped, concerned about the effect his words might have on Teddi.

"I know."

"Did you tell your mother that you know?" he asked.

"No," Teddi answered.

The priest wanted to know why.

"Because I don't think she could take it," Teddi told him.

Even if he wanted to hold back, Father Ambuske couldn't. "You're telling me you know you're going to die?'"

Teddi answered yes, that she knew.

"But why are you telling me, Teddi?"

"Because you're supposed to know about these things, aren't you, Dave? You're a God person."

Ambuske, surprised by her response, said it sounded as though she had been giving a lot of thought to such matters. Teddi remained silent.

During the next several visits, the priest came bearing jokes. If he forgot and used something he had said before, she would promptly jump in. "C'mon now, Dave," she would tell him, "You said that before!"

Father Ambuske told her how sharp she was and shared stories about the traveling he had done both in the United States and abroad. Teddi liked these

stories, perhaps because it was something she would never be able to do. They talked about horses more. And they talked about God and about death.

Teddi seemed to get around to the tough theological questions before their time together ended. She asked questions that the priest increasingly had to answer with words such as "mystery" and "faith."

On one visit, Teddi asked what death would be like for her.

Father Ambuske was grateful he had done his homework and had asked his doctor friends about it. "First," he said, "there will be some difficulties. You're going to lose your hearing a little more. And you'll probably lose your eyesight."

He went on slowly, evaluating her each step of the way, gauging how his words might be affecting her. He said, "you're not going to be able to get up much. You're going to have to stay in bed when it gets closer and closer."

"What's next?"

"Next," he answered, hesitating. He wanted to be honest, but honesty was pretty hard sometimes. "Next, it will probably be a coma, Teddi. Most likely you'll go into a coma and go to sleep that way and die. It's not going to be painful for you, then, all the pain will be behind you."

On his next visit, Teddi's theological question for the day was about heaven. She wanted Father Ambuske to tell her what it would be like. Would, for example, God be an old man with a long beard as pictures showed him?

"Heaven will be a surprise," he said, smiling, having come to know how much Teddi liked surprises.

But she had one for him, too. A big one. "I'll find out the answer to that question, and some others, before you will, won't I Dave?"

He nodded his head. "You probably will, Teddi."

Dave broke the silence that followed. He asked Teddi if she would give God some messages from him. He talked about his mother. He told her things he wanted to know about God. When he was done, she told him she would take what he wanted with her when she saw God.

Autumn came early that year. In fact, it had come far too early for those who had experienced long northern winters. On one cold afternoon, as Father Ambuske was about to leave, Teddi asked, "What will happen when I die, Dave? Here, I mean?"

Father Ambuske took off his heavy winter coat and returned to the bedside chair. He told Teddi that there would be a funeral and that everyone would bring Teddi's body into the church. Then, they would pray over her body. He also said it was customary for the priest to talk about the person who died. "It's called a eulogy, Teddi. And after the eulogy, there will be more prayers and some music maybe."

"And there will be lots of people there," he said, attempting to lighten the burden of what he was saying. "Lots of people will come because they love you and your family."

"In the church, Dave?" she wanted to know. "They'll come to the church?"

"That's right, Teddi, people will come to the church, and I will probably say a few words about you."

Teddi scrunched her shoulders and clasped her hands. "And?" she said, waiting.

"And?" Dave repeated, uncertain.

"And what will you say about me?"

"Oh, I'll tell them what a wonderful person you are," he said. "How you did things for others. How you dealt with your suffering without complaining. I'll tell them about your love of animals and your love of people. I'll tell them about some of the things we talked about—I mean, if that's okay with you."

She told him it would be all right. Teddi would break the silence this time.

"Do you remember telling me about how you saw the Sistine Chapel, Dave?" she began. "And how there's the picture of God and his finger is touching Adam's?"

Father Ambuske nodded.

"I'd like to feel that I was like that. That I touched a lot of people."

"Oh, you have," Father Ambuske said enthusiastically. "You have, Teddi. With the camp, you've touched a lot of people. Not only the kids but all the people who know about it and helped it along."

The sudden rush of good feeling was once again followed by what seemed like an even louder silence. It was now dark in the room, but neither seemed to notice or care.

"Will you be sad, Dave?" Teddi asked. "Will you be sad when you talk about me?"

In all the time he had been with her, the priest never cried. He turned toward the window and then back to her. "Of course I will be sad, Teddi," his voice faltering and just above a whisper. "I love you and will miss you very much. So will everybody who knows you."

"I don't want you to be sad, though, Dave," Teddi said almost matter-of-factly. "If you cry then so will my mom and dad. I don't want them to cry. It's not like goodbye. I don't like goodbyes. I'm leaving one side and going to another, aren't I, Dave? So it's more like hello than goodbye then, isn't it? For me it's more like hello."

The priest, having been comforted himself, said, "You're right. Of course you're right, Teddi."

She told him, toward the end of another time together, that she wanted her funeral to be a happy time.

On every other occasion when he left, Dave would try to leave Teddi smiling. He would call her "Lizzie" or pick out other names. That day, as he left, and all the days he had with her after that, he would always say, "I'll see you later, pretty lady."

"Pretty lady?" Teddi asked the first time he said it.

"Yes," he said. "'Pretty lady.' Because that's what you are and that's what you'll always be to me."

Teddi didn't understand. "But I've lost my hair," she said. "And you know I've got a scar."

"That's not you," said the priest. "I see what you are on the inside, the *real* you, the you that will live on forever and ever."

HOPE RETHOUGHT

The next visit Dave Ambuske paid to Teddi Mervis began with a request. She asked if she could be baptized.

Though pleased, he wondered if Teddi thought baptism might somehow cure or transform her physical appearance. "You'll be a child of God," he told her gently, "but you might not notice any physical change."

She nodded. "I know, Dave," she said, "but I would like to anyway."

That evening, Teddi talked over being baptized with her parents. They were happy for her and approved. Yet they also wondered, as had the priest, whether Teddi wanted to be baptized because she believed doing so might somehow alter her fate. Later, Teddi asked her mother if she would dial the DeBiase number. Cheryl answered.

"I'm going to be baptized, Cheryl," Teddi exclaimed. "And I would like you to be my godmother."

Cheryl was grateful the conversation was taking place on the phone. "I'd be happy to," she said quickly and then covered up the receiver.

"Can you put Skipper on?" Teddi asked.

Any phone call, given Teddi's condition, was cause for concern in the DeBiase household. Skip had come into the room immediately after he heard the phone ring. He feared for the worst. Cheryl handed him the phone. "Teddi's got something to ask you," she said and left the room.

Teddi told Skip about wanting to be baptized, and tears formed in his eyes. Thoughts of the last rites, a Catholic sacrament for dying persons, formed in his mind. Teddi asked him to be her godfather, and he said yes, he'd be honored.

"I'll be almost Italian now, won't I?"

Skip could hear her trying to muffle a laugh, but he wasn't into the humor of the situation. "You'll be what's called my *comare*," he told her, "and that's as close as you can get to being family without being blood."

Before bed, Sheri told Teddi it was customary, with baptism, to pick a new name. It seemed as though Teddi had been expecting the question, for she answered straight away, that she wanted the name "Angelina." In Italian, the name meant "little angel." Her mother had no idea where she came up with that specific name, but many of the Mervises' friends were Italian and used to kid Teddi that she looked more Italian than any other nationality. Now, when they heard the name she picked, they would tell her she belonged more to them than to her own family.

As the date for the baptism approached, Teddi became increasingly excited. She even had a hard time taking her customary afternoon naps. She helped her mother, as best she could, make a cake for the event. She and her mother laughed because of the difficulty Sheri had in trying to get the entire name "Elizabeth Angelina Mervis" written on top. Teddi picked out a new white dress for the occasion. With her eyesight failing, she asked her mother a few times if she could feel the material.

On the day of the baptism, Sheri put pink ribbons in her daughter's wig. As she folded and tied them, she asked Teddi a question that had been bothering her ever since she learned that her daughter wanted to be baptized. "Do you expect the baptism to change you in any way, Teddi?"

Teddi, whose voice was low and halting at that point, said she didn't expect anything to change in regard to her body or the tumor. But she did say, "I'm just so excited about doing this. It's more exciting than Christmas!"

Sheri smiled. She was convinced that it wasn't just having a party, getting gifts or expected miracles motivating Teddi. Sheri was grateful she had invited Father Ambuske into her daughter's life. Teddi had God, and God would be welcoming her into his kingdom.

As family and close friends arrived on the day of the baptism, they remarked to Teddi, and to one another, how radiant she looked. Photographs of the event confirmed her beaming face. It seemed as if something peaceful and good was happening inside her. In terms of the stages of dying, Teddi seemed to have reached the final one: acceptance.

"C'mon everybody," Teddi called out in the noisy room. "Let's get this show on the road!"

Father Ambuske explained that Teddi would have to repeat what he said. He then turned to Teddi's parents and to those who had come and gave a description of what was to follow and what it symbolized. Turning back to Teddi, he asked if she was ready.

Teddi wanted to know if she was to repeat what he had just said to everyone, and that made everybody laugh. Before beginning, Ambuske felt a deep and abiding friendship with Teddi, and it mostly had to do with her sense of humor. Christian theologian Reinhold Niebuhr had written of a close relationship between humor and faith—while humor dealt with the immediate ironies of life, faith dealt with the ultimate ones.

Those gathered watched quietly and intently. Some, like Irene Matichyn, moved to the back because she didn't want Teddi to see her face. At the end of the brief ceremony, everyone clapped their approval. Gary uncorked a bottle of champagne. As glasses were being poured, everyone present took turns kissing Teddi, telling her how lovely she looked and how beautiful the ceremony had been. Each person also brought a gift for her. Teddi, like most children, loved opening presents.

Irene had been near the end of the line, and now it was her turn to kiss Teddi and give her the gift she had brought. It wasn't even wrapped. She handed Teddi what the child had often said she loved—a large bag of cashew nuts. "My dad will eat them, too!" Teddi said, making Irene laugh.

"No. Oh, no," Irene responded. Her father wasn't to have any.

Skip was the last to present his gift. Though the others were milling about, the room grew silent as Skip placed a gold necklace in Teddi's hand. It had a heart, an anchor and a dove.

"It's from Italy," he told her, and she smiled. He said the heart stood for love because she was the kindest person he had ever known. "The anchor is faith," he said, "and your baptism is proof of that."

He held the dove now and realized he should have thought about what he was going to say next. After a beat or two, with the room growing totally silent, he told her, "The dove is for hope, *comare*." He had put hope in an altogether different place now, and it wasn't for Teddi. "You've brought more hope to kids than anybody I know."

After the baptism, Father Ambuske continued coming by for his weekly visits with Teddi. When Teddi was feeling well, they would chat and discuss their heavy theological questions. When Teddi was in pain or moody, he sometimes sat there holding her hand, praying for her and for children like her.

Teddi was no longer able to walk or stand by herself. Her weight continued to climb. The optometrist told Sheri not to be optimistic about Teddi's eyesight improving. Before long, he said, Teddi could be blind.

Teddi with her family shortly after her baptism. *Courtesy of Kevin Higley.*

Teddi's pediatrician, Dr. Nazarian, came by the Mervis home and wrote in his report that Teddi "gets depressed." He also commented that she has "some good days."

Father Ambuske was concerned about Teddi's impending blindness and wanted to prepare her when the time came. On his next visit, he asked if she would mind closing her eyes. Ambuske then began to describe what the sky looked like outside her window, the shade of blue and the shapes of the clouds. He described what the trees looked like and what the wind was doing to the leaves. When he had finished, he asked Teddi to open her eyes and compare what he had said to what she could see.

"You have an advantage over many blind people," he told her. "You know what things look like, and what color is, and you can remember all of that."

That day, and on the visits that followed, the priest kept working with her, identifying colors and holding on to the images he described for her. He also showed her photographs of her siblings, her parents, other loved ones and one of himself.

On a cold, crisp autumn day, Ambuske knocked on Teddi's door at their scheduled time, went in and, like always, greeted her. She was somewhat reticent, however, in murmuring her hello. The afternoon sun had set, and Ambuske reached to turn on her bedside lamp. But something made him stop. He knew she was blind.

"You can't see me, can you Teddi?" he said. She didn't answer.

"Can you see anymore?"

"No, no, I can't, Dave," she whispered and began to cry.

And so Father Ambuske, from that day forward, described the world in colors and shapes and the images that still remained in her memory. He would tell her how the sky looked, and the trees and how the wind whipped the snow.

A favorite question Teddi had for the priest at the outset of each visit from that time forward was the color of the suit he was wearing.

"It's the brown one," he might say.

And Teddi might pop back at him, "Oh, no, Dave, you wore that suit last time. Not too much now." And the priest would be cheered.

Sometimes, some of Teddi's old sad questions returned. "Why me?" she'd ask, and Father Ambuske would patiently start at the beginning, with the answers from the day they first met.

Blindness and her strong medications combined to make Teddi more disoriented and afraid. Caring for her also was becoming increasingly difficult and fatiguing. Teddi wouldn't know what time it was and would call out for help in the middle of the night. When Sheri or another family member got up and went to her room, Teddi sometimes forgot why she had called them. More often than not, when she called out for help, she just wanted to be turned; her back, arm or leg ached from being in the same place for too long.

Tod would come by before school and call into the room. "Hey, Teddi, what are you doing in bed again?"

"Hi, Dad," Teddi would sometimes answer.

Those times, wise guy Tod would sit on the bed next to her without saying anything. Teddi, who could tell by the weight it wasn't her father, would reach out and try to poke Tod. "Oh, Tod!" she'd say. "You're such a joker! You're always trying to trick me!"

Late one afternoon at the end of November, Sheri was seated beside Teddi, looking through a magazine. Teddi seemed to be troubled by something. "What is it?" her mother asked. Teddi told her that a little boy had come into the room and wanted to play.

"Where is he?" her mother wanted to know.

"Over there." She pointed to a corner of the room farthest from the door.

"What's he wearing?" She asked, and Teddi told her the boy wore a nice shirt and a pair of pants.

"Oh, okay," Sheri said matter-of-factly. "If he wants to play, he can stay and play."

The next day, around the same time, Teddi said the boy was back again but that some other boys were picking on him. "Mommy!" Teddi yelled. "Quick! Help him!"

Sheri scolded the boys. "You bad kids get out of here and leave that little boy alone."

Teddi thanked her mother. "They were going to hurt him," she said.

"We're not going to let anybody get hurt around here." After a pause, she asked Teddi if she knew the boy's name. Teddi said she didn't but would ask him the next time he came.

A few days later, Teddi called her mother into the room. She said the boy had come back and that she had asked him his name but had forgotten it. "Well, you think about it," said Sheri, "and let me know when you remember." Her mother added, "Why don't you invite him for spaghetti the next time he comes by? Everybody loves spaghetti."

It was two days before Teddi said the boy had returned. She looked sad. "What's the matter, Teddi?" Sheri asked.

Teddi was slow in her reply. "He's waving for me to come with him," she said. Sheri asked if he was a nice boy.

"Oh, yes," Teddi smiled. "He's very nice. He has a very kind face." Sheri asked if he had told her his name yet.

"Yeah, he did," said Teddi, but again, for the life of her, she couldn't remember.

Teddi couldn't see the tears running down her mother's cheeks. Sheri seemed prepared for what came next. She leaned close to Teddi's face. "Teddi," she said, "is the boy's name Jesus?"

Teddi became excited, nodding her head up and down as best she could. "That's it, Mommy! That's his name! How did you know?"

"I was just guessing, honey," her mother said.

There was a long pause; Teddi appeared as though she was already with the boy. And she was the most peaceful Sheri had ever seen her. "Teddi," she said, and waited.

After a few moments, Teddi asked what was the matter.

"Teddi," her mother said, "nothing's the matter." And then, Sheri later said, she spoke the hardest words of her life: "If you want to go with him, it'll be all right."

III
Of Death and a Dream

"They've Come for Teddi"

A few days later, Teddi asked her mother to box up and put away all her teddy bears. Sheri wanted to know why.

"I'm too old now," Teddi said.

Her mother tried to convince her to keep them out. "You've got so many, and you love them so much."

"I know, Mommy, but I'm too old now."

Sheri wanted to know if they could put shelves on the wall and put all the bears on them.

"They'll be in Kim's way," Teddi told her.

Around and around they went, until Sheri finally gave up and said she would find some boxes and put away the bears.

It was December now, and though it didn't seem possible, Teddi's condition continued to worsen. Sheri called the hospital and had them deliver a bed, which was put in the living room. Sheri also talked with Teddi's pediatrician, Dr. Nazarian. She told him that Teddi was undergoing personality changes; she was crying and complaining more and also calling for Sheri for no apparent reason. She explained that Teddi slept a great deal and seldom left her bed. Dr. Nazarian came by to examine Teddi a few days before Christmas, and according to his notes, he thought Teddi was "having a good day." He also wrote:

She cannot see, but she hears and understands fairly well. She answered my questions with one or a few word answers. She told one joke in somewhat halting, sometimes indistinct words. She ate pancakes and sausage, slowly, when fed by the nurse Laurie Freeman. She seems to drift into a quiet almost sleep-like state quite often, but will then suddenly make a clear request. After going to bed, she cried out frequently for her mother. She screamed when we tried to take her blood pressure and said it hurt a great deal.

Friends came by to see her during the holidays. The camp had planned for a Christmas party, and at first, Teddi didn't want to go. She was practically immobile at that point and could barely stay awake. Her back and bottom hurt considerably, even when she was in her wheelchair for a short while.

Teddi hurt so much that, soon after the camp Christmas party started, she had to lie on her sleeping bag in a corner of the room. Muggs Register came and lay down beside her. Muggs stayed there until the party was over.

Campers came over to say hello to Teddi, most knowing to speak loudly close to her. Counselors, one by one or in groups of twos or threes, came by to wish her a Merry Christmas. Teddi's blood sisters told her gossip and pretended that she wasn't any different from the first year at camp, when they were all well together. Some, like Nurse Barb, started to tell her something mundane but became too overcome with grief to continue and rushed her goodbye before hurrying away.

One of the most troubling developments when the party ended was that Teddi never truly believed she had been brought home. She would plead with her mother to take her home, even though she was in the hospital bed in the family living room.

"When are we going home? Please take me home. If I'm really a good girl will you promise to take me home, Mommy?"

It pained Sheri. "But you are home, Teddi. Please believe me." Sheri would make Teddi feel her bed, the bears and the faces of friends and family.

After several days of insisting she wasn't home, Sheri dressed Teddi and took her for a ride in the van. They drove around before returning home. "There," said Teddi's mother, "we're home now." She shut off the engine. "Feel the first step to the house, Teddi?" she said, helping her inside. Once inside, Tod was waiting with an armful of her favorite bears. "See, Teddi," he said, putting the bears in her hands and next to her face, "here's your bears. Now you've got to be sure you're home."

No matter what they tried, Teddi believed she had left home for good. One last time, on Christmas Eve, as the family was putting up the tree, Teddi

asked if she might go home by Christmas. Father Ambuske thought maybe her spirit had already left and, for Teddi, only an unfamiliar body remained. She was transitioning to another home.

The day after Christmas, the Mervises inquired about hospice care. This provides the opportunity for terminally ill patients to die at home, around loved ones and in an environment familiar to them.

Teddi was sleeping even more than usual at this point, and when Dr. Nazarian visited in mid-January, he believed that Teddi was "becoming more somnolent [sleepy] and withdrawn." She did have a good day now and then, but they were less and less frequent. People came by to say goodbye without using the word. Other than that, word also spread that her death was imminent. On one of Teddi's good days, Karen Lenio came by. Her journal entry for January 15, 1982, reads:

> *She was awake today. Hooray! Not comfortable, not chatty, but AWAKE. She knew I was there, she knows I love her, she repeated, "I love you, too." That's all I hoped for in a way of conversation. I could rub my lips over her cheek and touch the fuzzy top of her head…And I could smell the powdery sweet smell. Like a baby. A visit for all the senses.*

On January 18, Teddi's parents came home for lunch, as they had started doing every day. The number of Teddi's seizures had increased and were harsher than they had ever been. Dr. Nazarian recommended increasing her medication. That was tried, but it didn't yield any positive results. Nazarian recommended that Teddi be taken to the hospital by ambulance right away.

Betty Scobell, Teddi's favorite next-door neighbor, was standing by the sink that afternoon and saw the flashing red lights reflected in her window. Her husband came into the room. She saw tears in his eyes.

"What's the matter?" she asked.

He shook his head. "They've come for Teddi. It's an ambulance."

Betty looked at the clock. It was 5:00 p.m. She was sorry it was suppertime because a lot of people would be coming home from work then. They would stare at what was happening. "The Mervises don't need that," she told herself.

Sheri rode inside the ambulance with Teddi; Gary followed from behind, in a car driven by home care nursing supervisor Angie Mastrodonato.

Tod was at wrestling practice when he saw a policeman enter the room. The coach pointed at him, and the cop began walking toward him. "Oh, God," thought Tod, "I'm really in trouble now. What did I do?"

The policeman was a friend of his father and had come to tell Tod what had happened and to take him to the hospital. Tod said afterward that the news about his sister was worse than any trouble he could have gotten into.

When the ambulance arrived at the hospital, Teddi was immediately given an IV of Valium to help control the seizure activity and what the doctor's report described as "other movements of agitation." Teddi had a fever. She was also put on a respirator. The doctor recorded in his notes that "the parents at this point seem near the breaking point." The final words in his report that day were: "end stage tumor."

After reporting for work, Nurses Anne, Barb and Sally came by to see Teddi. Once so terribly pretty, her bloated frame, blindness and inability to hear made them all very sad. Even more so, Teddi didn't know who they were anymore.

Teddi slipped into a light coma, only occasionally crying out "Mama" or "Dad" that evening and early the next morning. Her seizure activity continued despite dosages of phenobarbitol. The side rails on her bed were left up and padded.

There was little left for doctors, nurses and science to do. The medical personnel and the Mervises agreed that the purpose of this hospital admission was to control possible infection and to make Teddi's stay as comfortable as possible. The hope now was that she would be able to return home to die.

But her condition worsened. She had difficulty swallowing her own saliva. She was incontinent and needed diapers. When her fever shot up, which it did often, Teddi was wrapped in a cooling blanket. Her left hand looked grotesquely deformed.

After Father Ambuske left, giving Teddi her last rites, Sheri was alone with her in the darkened room. She put her face close to her daughter's and whispered, "I love you, Teddi."

Then, in her last lucid moments on earth, Teddi whispered back, "I love you."

Waiting

Teddi, for a short while, responded to words called into her ear with only a grunt. Sally Masten, the small, gutsy nurse who had lost her fiancé to cancer and still continued to work with cancer patients, recalled how devastating it was for her one day when she went into Teddi's room and found Sheri saying over and over again, "Are you all right, honey? Do you hurt?"

Gary stayed with Teddi around the clock that first week. Sheri, his friends and the medical staff had to insist he go home for some much-needed rest. Yet even at home, of course, his thoughts remained with Teddi. Watching NBC's *News Magazine* one morning, he learned about an organization in Phoenix, Arizona, called the Make-a-Wish Foundation. It was exclusively for terminally ill children, providing money and logistical support to fulfill the last wish of a dying child. Gary began to wonder about setting up something similar in Rochester.

At the hospital, Kim and Tod had a difficult time those final days. Kim, never much of a talker anyway, was mostly silent when she visited. Tod, however, talked to Teddi about how he was doing in wrestling and what Teddi's friends were up to at school. One night, when Teddi was worse than usual, Sheri told Nurse Barb she would like to stay late. Barb volunteered to take Tod home. As they left the hospital, Tod put his hand on Barb's shoulder. She turned and could see he had tears in his eyes. She felt he probably didn't want her to see him like that but didn't want to turn away either. "Is Teddi going to die tonight?" he asked.

Barb wasn't expecting the question. She told him she didn't know. On the way home, Tod talked virtually nonstop, mostly about small matters. Barb glanced over at him from time to time. When oncoming headlights washed across his face, she could see how anxious he looked. She thought he was talking so much and so fast in order to not cry.

Tod said that through Teddi's long ordeal, he still believed that the "good Lord would come through"—change things and save his sister's life.

Laypeople, as opposed to most medical personnel, generally believe that someone in a comatose state can still hear. And so those who loved Teddi and came by for a visit talked to her, even though she could no longer respond, even with a groan now.

Father Ambuske still talked with her, telling her what the sky looked like and how the trees were barren of leaves but not life. "Looking at them," he said, "with their dark wet bark, it almost seems as though their souls are revealed." He knew telling her that he was wearing his blue—and not his brown—suit might get a rise out of her. Gary's brother, Bob, would sit alone holding Teddi's hand. He didn't say much, except for hello and goodbye, but felt unspeakably sad to see his niece's life slipping away. He knew how Gary felt, and if something like that happened to one of his kids, he told his wife it might just be over for him.

Barb Fredette saw the Mervises leaving one night. Both were sobbing, and Barb wondered if that night was Teddi's last. The child moaned almost constantly, and it seemed as though she was in a great deal of discomfort.

Barb gave Teddi the maximum pain medicine prescribed. She stayed late in the room, even after her shift was over, holding Teddi's hand, thinking the Mervises would not want Teddi to be alone if she died.

Barb thought about God and grew angry. The death of children seemed a horrible fate. But Barb knew that what kept her going, and what made her stay with Teddi even now—when hope was lost—was that she had known love. She was loved for what she did for others. That past summer, when the sun was hot and the air thick, Teddi Mervis had told her so over and over again in the back of the van on the way back to camp.

To Skip DeBiase, those weeks when Teddi was in a coma were the worst in her entire sickness. "There was a point," he said, "where nothing but despair existed." Sometimes, when he became upset or overly angry about something, he knew it was because he felt frustrated that there was nothing anybody could do anymore. There was nothing he could do. "We're taking our frustrations out on each other," he said to his wife once. "You can't hit God. My arms are too short to box with God."

Polly would come to Teddi's room, sit and hold her hand. She would talk to Teddi, too, despite the fact that some of the doctors said the patient was a "vegetable" now. Polly would become angry with the doctors when they didn't come into Teddi's room anymore. They said it didn't matter.

Gary tried to keep his own spirits up. He told Polly during this period that while he thought Teddi was doing poorly, he didn't think she was at death's door. Sheri was of a different opinion. She told Polly about her conversation with Teddi and the little boy named Jesus who had come. Polly agreed that Teddi was likely asking her mother's permission to die. Sheri felt this was the last part of the illness and hoped for a peaceful death.

Father Ambuske and his congregation continued praying for Teddi. On these occasions, the priest would tell his parishioners how the child was doing. Sometimes, after the service, the parishioners would ask if it was a good sign that she was still hanging on. "No," he would tell them, it wasn't a good sign. "Hope of her recovering is lost." And then he usually added, probably more for himself than others, "But it shows you the strength of this child, doesn't it? She's very, very strong-willed."

Teddi's breathing became more labored. Suctioning was necessary to clear her throat of a white mucus. Teddi exhibited less and less body movement. Dr. Nelson's examination showed her reflexes were gone, reflecting the tumor's almost complete involvement with her brain, that it had entangled the brain and was now squeezing the very life out of it. "Terminal stage," he wrote in Teddi's medical record for the day, "high liability for aspiration."

On February 3, just after midnight, Gary came out of Teddi's room in a panic. "Barb," he yelled, "something's wrong with Teddi!" Another nurse and a doctor rushed to Teddi's room with Barb. "This is it," she thought to herself. Upon entering, Barb put the bag used to stimulate breathing over Teddi's mouth and pumped it a few times. Teddi's breathing was restored. It was the third time Teddi had to be manually revived.

Word reached Laurie Allinger that Teddi was in a coma. She called Suzie Parker in Camden, New York, and they cried together on the phone. Laurie went to the hospital to see Teddi, but when she got near the room, she saw Sheri come out crying heavily. Sheri passed by Laurie without noticing her, and Laurie couldn't bring herself to see Teddi. She left the hospital without seeing Teddi alive again.

Muggs Register remembered Gary asking if she would stay in Teddi's room. He had to make an important phone call. Gary was adamant, at that point, about not wanting Teddi to die alone. Father Ambuske told the medical staff on Teddi's floor to please call him if death was clearly at hand, but his message got buried in a pile of notes, records and folders and was lost.

No matter how much each of them loved and cared for Teddi, those who waited and prayed feared that Teddi would die on their watch. Would they be able to handle it? Could they have done something to keep Teddi alive? Would they be blamed?

Anne Cameron didn't know if she could bear it and asked Polly to pray that Teddi wouldn't die on her shift. Skip DeBiase felt that each of them, with each visit, were playing an emotional kind of Russian roulette.

Afterward, some talked about being in the room alone with Teddi and looking up anxiously when the child suddenly gasped for air. They would stare steadily and long to see some trace of movement in the white sheet draped over Teddi's body. Sometimes their eyes would play tricks on them, and they would have to get up and check with a hand on Teddi's pulse, putting their heads close to Teddi's mouth. Who would be in the room when Death came, like a cool breeze rustling papers and making the curtains tremble? Who would be the one to see Teddi die?

One afternoon, as Sheri and Anne talked, she asked the nurse what happened to the body when somebody died in the hospital.

"We clean them first," Anne answered, and before she could say more, Sheri interrupted.

"Do they have clothes on?" Anne didn't have the heart to tell her that the body normally went downstairs to the hospital morgue naked, in a plastic bag.

Sheri kept pausing, as if trying to catch her breath. And then she asked if Teddi could go downstairs to the morgue wearing a nightgown.

Anne promised that Teddi would.

A Child Dies

It was unusual for a child in a coma to moan, but Teddi did so periodically. It was troubling to nurses and visitors. Was she moaning because she was in pain? Was it because she was trying to shake herself awake? Did she want something? Want to *say* something? Nurse Sally Masten, disturbed about the moaning, asked a resident physician what he thought was going on. He shook his head. "Nobody knows," he answered.

After a few more days, Teddi suddenly stopped her moaning. Barb was on duty and decided to call Gary and Sheri at home to tell them about it and that Teddi seemed to be resting peacefully now. The Mervises were grateful for the news.

Sally Masten assumed a larger role in Teddi's care; at that point, it mainly consisted of turning and changing her periodically and putting Vaseline on her lips so they wouldn't dry up, crack and bleed. Sally also made sure the curtains were open. Despite the fact that Teddi couldn't see, Sally hoped Teddi might feel the sun's warmth and maybe even tell when day had turned to night.

The precariousness of Teddi's life began to unlock some of the anger and resentment that had been stored away inside her parents. One time, the Mervises returned to Teddi's room after going out for supper only to find Teddi had wet her diapers and her bed was soaked. The Mervises couldn't know it, but Nurse Sally had left the room just moments before, and Teddi was fine. Gary buzzed Nurse Masten into the room and chewed her out for a lack of attentiveness toward his daughter.

Sally didn't say anything. She listened, all the while changing Teddi's diaper and bed. Gary, uneasy about what he had said and how he had said it, tried to joke with Sally. "Gee, Sal," he said, smiling, "and here we thought you were a good nurse."

Sally would have none of it. She stopped what she was doing. "Gary," she said, trying to remain calm, "don't joke with me. I'm very upset." She told them both that when she finished, she would like to speak with them in the conference room down the hall.

Sally was direct with the Mervises. "I think we've got to adjust this right now," she said. "I love both of you, and I love Teddi. And if this isn't adjusted right now, it will cause bad feelings on both our parts. I know you're ticked at me, and I am also ticked." Gary, still trying to smooth things over, said they weren't all that upset.

Sally stuck to her concerns. "You *were* ticked, Gary," she said. "And I want you to know I give myself 100 percent to Teddi. If you don't think that's good enough, then by all means look into getting another caregiver."

Gary told her that he and Sheri were both there to make certain their daughter got the best care possible, and if they thought anybody was giving less than that, they would certainly look for a replacement. Gary's anger subsided. He knew Teddi's nurses were special. And he told Sally that he and his family loved her and that they thought she was a very good nurse. He said they were "just very upset when we came back and found her like that."

Sally said she understood, but she told them they had to understand she "knew exactly where they were coming from." The Mervises looked at each other, unclear about her meaning. How could she possibly know? Sally told them about her own losses. Her father had died of cancer. And then, less than five months later, her fiancé died of Hodgkin's disease. "I know how anxious you are," she said, her own painful memories rushing to the surface now. "And I know how you want to do everything you can. I understand your frustration, but you must trust other people, too. And that includes me."

Though sometimes difficult to take, Sally's courage and honesty were qualities the Mervises really did admire. They told her they would try to trust more. And, as Sally predicted, the three of them seemed to move even closer in their understanding and affection for one another. At times, this came out in the form of humor, proof that it was the best medicine.

One particular running joke involved the taking of Teddi's temperature. Sally would put a thermometer under Teddi's arm, chat for a few minutes and then leave the room to take care of another sick child. Moments later, she would return and try to remove the thermometer without anyone noticing. Invariably, one or both the Mervises would clear their throats and, with a smile, ask if Teddi's temperature was okay.

The closeness between Sally and the Mervises manifested itself in other ways, too. One time, Sally came into the room only to find Sheri standing over Teddi, crying. Without saying a word, Sally put her arm around Sheri and wept with her.

Dr. Nazarian, Teddi's pediatrician, was coming by nearly every day now. An energetic, sensitive man, he had grown fond of the Mervis family, most

especially Teddi. He felt a responsibility to provide Teddi with optimal care, even while she was in a coma. Yet because the child lingered for as long as she did, he saw how it began to wear on others. Conflicts arose, and tempers flared.

The Mervis family, especially Gary, were increasingly anxious about the details of Teddi's care. He was worried the medical staff viewed Teddi's condition as hopeless. And would that mean giving up on Teddi's care? Gary insisted on seeing daily copies of Teddi's medical reports.

His request irritated the hospital staff members, who felt he didn't trust them. Moreover, with Teddi's life so tenuous, Gary also insisted that everybody be on the same page regarding resuscitation efforts. He wanted to make sure that if Teddi's breathing stopped, medical personnel who were on duty would not let her die without trying to revive her. Gary explained these and other concerns to Dr. Nazarian. Gary didn't mention to him, though Nazarian already knew, that he was still searching for a new cure, discovery or way to prolong Teddi's life. Nazarian felt as bad for Gary as he did for Gary's daughter.

But having experienced such situations before, the doctor let two criteria guide him: first, he weighed whether a proposed treatment or course of action would actually help Teddi or if it would cause her increased discomfort and be an inappropriate intrusion on her personhood; the second thing he weighed was whether plans or promises of future actions would hasten or retard her decline, even though her life at this point was measured in days and maybe even hours.

Nazarian also believed in honesty. He wanted to make sure the Mervises understood that this was the final stage of Teddi's illness and that, in all likelihood, she would not regain consciousness. He also told them that, given Teddi's medical needs at that point, she would probably have to stay in the hospital rather than be able to return home.

Sheri wanted to know what was happening to Teddi on the inside, and Nazarian said, "As far as we can tell Teddi's in a dream state. Perhaps she is even seeing and hearing images and sounds in her mind with a clarity denied her by her failing senses when she was last conscious."

Gary said again he wanted the medical staff to make an honest effort to revive Teddi if she stopped breathing. He told the doctor that Teddi was trying so hard he believed she ought to be helped. He didn't want a respirator used to revive her, or a "full code," just a modest attempt. If her heart stopped, Gary wanted them to try CPR or maybe some drug to try to stimulate it. Teddi should also be encouraged to breathe manually, Gary said, through the standard rubber bag used for this purpose. Nazarian supported

Gary's reasoning and wishes, assuring him that these would be written into the hospital record so there would be no misinterpretation or mistakes.

Sheri, agitated, voiced her desire to be notified immediately of any change in Teddi's condition. Dr. Nazarian assured her that this would also be relayed in writing to the medical staff. Their meeting was drawing to a close, and the doctor listened as both Gary and Sheri expressed their hope that Teddi would continue to live. Yet they also acknowledged what a terrible emotional and physical toll it was all taking on her, along with those who watched and waited.

Before he left, Dr. Nazarian repeated what he had told the couple before, that he would put their concerns and recommendations in writing for the medical staff. He said he would forward a copy to them. Finally, he asked for their patience with the healthcare professionals involved in Teddi's care. The focus of their study and training, he told them, was to keep people alive. With death waiting, they sometimes appeared to lack purpose and became frustrated.

Nurse Sally Masten saw Gary come out of Teddi's room after the meeting, Sheri followed a few minutes later. Sally was close by, and Gary began walking toward her. She was surprised she hadn't noticed before how worn out he looked. His voice sounded hoarse, like somebody who was going to cry or had just stopped. "I want to do everything I can for my daughter," he said. "I want to make sure that everything is tried in case she isn't going to die."

Sally nodded. "I understand your hope" was all she could manage before leaving him in the hospital hallway, shattered and alone.

One of the things Dr. Nazarian concluded in his notes of the meeting was that the Mervises were the kind of people who took the negative and tried to make something positive out of it.

Nazarian's assessment was borne out in a press conference called by Gary for the following morning.

Come Saturday Morning

Teddi Mervis was one of western New York's most carefully watched stories, so the press conference was covered fully by the local television and radio stations and print reporters from daily and weekly newspapers. Many of the people involved in Teddi's care, along with some of the children and their families on the pediatric floor at the hospital, watched.

Gary announced the establishment of the Teddi Project. He had met with the board of directors for Camp Good Days and Special Times, and it had approved of a special fund to give terminally ill children a last final wish. The board, on the recommendation of one of its members, unanimously voted in favor of naming this special fund after Teddi Mervis. Gary spoke without notes, talking with only a hint of emotion. He explained, "The family of a terminally ill child is dealing both with emotional frustration and economic pressures. They really don't need the additional frustration of knowing it is beyond their wherewithal to do something special that their child might want at the end." Gary wanted these people to know there would be a fund ready to help in such circumstances. It was the least the living could do, he said, for those whose lives were so tortured and brief. Gary concluded saying the Teddi Project would be a "living memorial" to his daughter.

Teddi developed phlebitis because of the presence of the IV tube in her left ankle. After several attempts, the IV was successfully inserted into a vein in her wrist. She seemed to slip into an even deeper coma now. Her breathing became more irregular, with long gasps between breaths. The moaning had returned.

Dr. Nelson explained the results of another CT scan that had been taken. "The tumor is now massive," he told the Mervises. "It occupies about three fourths of Teddi's right cerebral hemisphere." A few days later, Gary suggested to Dr. Nelson that they try an "external ventricular drainage" or shunt. Gary thought it might relieve some of the pressure on Teddi's brain. He saw Teddi grimace a few times and, at one point, even flash her eyelids. Gary thought these, combined with the moaning, were signals that she wanted something done.

Nelson listened to Gary's recommendation thoughtfully. Before offering an opinion, he talked to Gary about the risks and complications, as well as other options, including doing nothing. He finally said he agreed with Gary about a shunt being able to relieve some of the pressure on Teddi's brain. He also said that, with Gary's approval, he would perform the procedure himself if it was what Gary wanted done.

The next morning, while getting dressed, Gary looked through his dresser drawer for a handkerchief. He took one with him to the hospital every day now. He found the one Teddi had given him for Christmas and hoped it would bring her luck. He smiled but didn't say anything that morning, when he saw Dr. Nelson just before he performed the shunt procedure. He was wearing a tie Teddi had given him for Christmas. In surgery, Teddi's head was prepped and draped for the surgical procedure. Nelson made an incision

into the old scar, as far as the bone. He then drilled a hole about a quarter of an inch in diameter into Teddi's skull. Almost immediately, fluid rushed out. The shunt would drain the entire day.

Once over, it seemed that Teddi's coma lightened some. Tod was alone with her when she opened up her eyes for a few moments. He told his sister that he loved her, and he would reveal, later, that he also told her goodbye.

Suctioning was now used to remove increasingly large amounts of green bile that was forming in Teddi's lungs. Teddi's respiration returned to being labored. She even gurgled at times, as though she was trying to catch her breath. Because Teddi's improvement was minimal after two days, Dr. Nelson recommended that the shunt be removed. The Mervises delayed a few days more because Sally Masten reported that Teddi had opened her eyes.

Anne Cameron wrote "Happy Valentine's Day" in Teddi's medical chart. That day, the Mervises threw a pizza party for the children and staff on Teddi's floor. Sheri had also made little bags of candy hearts and brought dozens of homemade cookies. After kidding Gary that each of the nurses wanted a dozen roses for Valentine's Day, they were delighted when Gary came to the party carrying a bouquet for each of them.

In those final days, Irene Matichyn brought her mother to the hospital. The woman wanted to see the child that called her "Baba," which in Ukrainian meant "grandmother." After they left Teddi's room, Irene's mother started to cry. Irene told her, "If you break down, I'll clobber you." In halting English, Baba looked up and said, "I no cry for Teddi. I cry for the mother."

Late that night, it was just Irene and Sheri in Teddi's hospital room. Sheri told her friend she sensed their friends were feeling guilty that even though they loved Teddi, they were also glad it wasn't their child dying. Irene's eyes welled up with tears. Truthful to the point of sometimes being blunt, Irene said, "I would be lying to you if I said I would rather it was my little girl lying there."

Meanwhile, Dr. Nelson was testing the medical waters for further consultation on his own. He called specialists at the University of Maryland to inquire about hyperthermia as a possible treatment for Teddi. It was a relatively new technique of reducing tumors through the use of heat. But specialists did not recommend it in Teddi's case. Nelson also called Dr. Charles Wilson at the University of California Medical School in San Francisco. He asked his colleague about further surgery for Teddi. Wilson urged against that, too.

It was February 24 now, and Teddi was still hanging on. Nurse Barb took Anne aside that night, before switching shifts. Barb said she couldn't help it but was becoming anxious. The doctors didn't know how or even why Teddi was staying alive. "Do you think there is much time left for Teddi?" Barb asked. She didn't know if she could hold on much longer. Anne didn't answer, just hugged Barb, who began to weep.

The next afternoon, February 25, with just Sheri in the room, Teddi cried out "Mama" several times. This unnerved Sheri, who jumped out of her chair. But no matter what she said or did to comfort Teddi, her daughter did not respond.

On Friday, February 26, at 4:30 p.m., Polly Schwensen came by to see Teddi before leaving work. She was in good spirits. After the usual greetings and Sheri's comments about Teddi's condition, Polly told her that she had just come from being with a mother who had lost her daughter to leukemia, and the woman's faith had made her remarkably positive and accepting. Polly hoped that would be of comfort to Sheri.

Sheri listened, nodding her head. "Chuckie Altamara's mother came by this afternoon and said something similar. 'Don't worry, it will end. For awhile, you'll wake up in the middle of the night with this terrible ache in your heart, but you just call me then. I don't care what time it is. Call me.'"

Sheri left Polly alone in the room with Teddi while she went to make a phone call.

Sheri and Gary were awakened the following morning by the sound of the phone ringing. They knew what it was even before answering. Afterward, they drove to the hospital together, just like they had so many times before—just like that first time, which seemed a million years ago now, when they had followed behind the ambulance thinking maybe Teddi had had a petit mal or an allergic reaction to something like a cat.

The policy at Strong Memorial Hospital is that nurses involved in primary care are notified before coming to work if their patient dies. Anne thought the policy wise, that it was easier to deal with such news when still at home. Anne got dressed and went to the hospital. Having arrived before the Mervises, she went into Teddi's room. Her eyes filled with tears. Teddi looked peaceful, and Anne continued in her prayers for the child, the parents and her nursing buddies.

"I know you're well now," she whispered, close to Teddi's face. "You've always been a special person to me." She leaned down and kissed Teddi for the last time.

Anne went to her desk and called Barb and Sally. She got Barb on the phone first. All Barb had to do was hear Anne's voice, and she let out a small moan. She knew what it was about.

"I don't have good news," Anne said.

"It's Teddi, isn't it?"

"Yes."

Barb cried. Anne told her they would talk later. She needed to get a hold of Sally.

Barb sat down at her kitchen table, her bathrobe on, and cried by herself that morning. Somehow, even though she knew it was coming, she still wasn't truly prepared for the reality of it—as if humans ever could be. The three nurses—Anne, Barb and Sally—prayed especially for Gary that morning. They felt Teddi's death would be hardest on him and couldn't fathom how he was ever to let go of his little girl.

Anne was at her desk when the Mervises arrived. She saw them go into Teddi's room, huddled together, looking utterly broken. Anne called Dr. Nazarian and told him about Teddi's death. Anne let the Mervises be alone with Teddi for some time before deciding to join them.

She got up slowly from her desk. She told herself not to cry. Anne stood toward the back of Teddi's room for a few moments, waiting for an appropriate time to let them know she was there. Both were leaning over the bed, touching Teddi's face. Anne quietly slipped her arms around both, crying along with them. After a few moments, Sheri asked Anne for the details of how Teddi died. "Were the agreed-upon procedures followed?" she wanted to know. Anne said she had checked before their arrival, and the procedures had been diligently followed. Sheri asked other questions, and Anne answered as best as she could; out of the corner of her eye, she could see that Gary was sobbing and holding on to Teddi.

Dr. Nazarian came down the hospital corridor. Naturally, he didn't like these occasions, especially when it had to do with a death of a child, but he also felt that it was during times like these that parents needed their doctor most. To shore himself up, he reminded himself that Teddi was no longer suffering now. He was also grateful Teddi had died at the hospital rather than at home, so the Mervises would feel comforted by the knowledge that the necessary medical remedies had been implemented. Nazarian entered the room quietly and stayed with the Mervises without speaking. He took turns holding one and then the other Mervis and, like Anne, cried.

Anne called Polly to tell her Teddi had died. Polly felt relieved. Everything had worked out, she thought—her conversation with Sheri about the mother who had lost her daughter, Chuckie Altamara's mom coming by and even the prayers that Teddi wouldn't die on Anne's shift. But soon enough, on a walk by herself, she came across the morning paper. Its headline blared, "12-Year-

Old Teddi Mervis Dies of Brain Tumor." Polly bought the paper and stood there in the snow, reading down the page. She lingered on a quote from Gary.

"No matter how you plan," he said, "It was still something to have that warm body there. You could talk to her—and whether she could hear us or not in the last few weeks, we don't know. But you could hug her and squeeze her—and now she's gone." Polly cried, for the first time that morning, still standing in the same place, on the cold city street, with a gentle snow beginning to fall.

All Irene Matichyn said on the phone that morning was "Skipper, honey," and Skip knew Teddi had died. Irene said the Mervises were heading home from the hospital. Skip hung up the phone and turned around. His wife was standing behind him. Cheryl lowered her eyes and left the room.

As Skip drove his wife, Cheryl, to the Mervis home, he talked out loud, mostly to himself, not expecting an answer. He said "all those macho things" he had learned growing up, about men not showing their emotions or crying. He pulled into the Mervis driveway and stopped before turning off the engine. "I don't know what we're going to find when we get there," he said. "And I don't know what kind of an ordeal this is going to be. But God knows it can't be any worse than what they've already gone through." He looked over at his wife. "Somebody's got to be strong. Let Gary not be and Sheri not be. You will be and I will be."

Cheryl was half listening, knowing her husband was trying to fortify himself for the ordeal ahead. She felt numb. She panicked for a moment, thinking maybe they shouldn't have come, that the Mervises would want to be alone. "I don't care," Cheryl said to herself. "I really don't care. I need to be with them. They may not need me, but I need them."

Betty Scobell had called the hospital each day after the ambulance had come for Teddi to find out how she was doing. That morning, a neighbor from across the street called her. "Is everything all right with the Mervises?" the neighbor asked, knowing that Betty was a good friend of the family.

"I don't know," Betty answered. She hesitated, "Why do you ask?"

"I saw the Mervises leave about a quarter to seven," said the neighbor.

Betty called the hospital and got the news about Teddi's death that way. She watched as cars pulled into the Mervis driveway and parked up and down the street throughout the day. She wanted to wait until Gary and Sheri were alone before she and her husband paid their respects.

When Irene Matichyn arrived at the Mervis home, she started out by being confident and strong. She went in without knocking and saw Tod and Kim watching TV. She learned Sheri was in her bedroom. Hearing Irene's voice,

Gary looked up, and Irene went over and kissed him. "I'm going to make some coffee," she said, "and look—I've got some of your favorite doughnuts."

Sheri entered the room, and Irene kissed her. "I'm sorry, honey," Irene said to her friend.

"What can I do? I'm here to cook. To clean. What do you want me to do?"

They sat down and drank coffee in the kitchen instead. Irene tried to keep the conversation upbeat, like keeping a balloon in the air, but Sheri started recounting that morning's details, trancelike, almost unaware of where she was and with whom she was speaking. Sheri tried to recall how the phone call came, what was said and what she and her husband said to each other—how she and Gary had gone into Teddi's hospital room to be able to touch her one last time. "Oh, Anne came in," Sheri said, interrupting herself. "Anne was there, I almost forgot." Painful as it is, even seemingly so unnecessary, we deal with trauma through its every specific detail.

With trauma, we seem to want to recall every detail, fit it into an understandable pattern. We want order, rationality and meaning where there is only chaos and a few meager answers.

Irene was nodding all along but had a difficult time remembering their conversation later. All her energies were focused on not wanting to break down in front of Sheri. If she did so, Irene would feel too guilty afterward, venting her own pain after all that Sheri had gone through. One piece of the conversation did stay with Irene, however. She remembered Sheri telling her that she didn't think Gary really believed Teddi was dead until he saw her. Then, she added, he held on to her and cried and didn't seem as though he was going to let go.

On the surface, Tod and Kim appeared to be taking the news well. But later, Kim said that morning and the mornings immediately following were like a dream. She knew what was happening, and she talked and listened and even cried, but somehow, she felt detached from it all.

Tod seemed to hold up well. On the morning of Teddi's death, when he found a quiet moment with his mother, he had asked, "Mom, do you think I could be one of Teddi's pallbearers?"

Sheri nodded but wondered how he had learned about something like that without ever having been to a funeral. In actuality, Tod had seen a funeral in a movie and learned that the people who carried the casket were considered to be very dear to the person who died.

Sheri was taking a shower when the DeBiases arrived. Cheryl took Kim and Tod into the kitchen so Skip could be alone with Gary. He went to where Gary was seated, took his friend's hand and kneeled next to him.

Gary looked into Skip's eyes and started sobbing. With Skip, he could let go. "Gary," Skip said, "she was strong."

"She was, wasn't she?" Gary nodded, trying to get a grip on his emotions. Skip agreed, "She certainly was a fighter."

That made Gary cry again. "But she couldn't beat it, Skip. She just couldn't beat it, could she?"

Skip squeezed his hand. "Listen, Gary, she made life a lot more worth living for a lot of people."

Sheri entered the room. Cheryl was in the doorway and remembered how calm Sheri looked. But she knew her friend well enough to see—in her eyes, the stiffness of her body and the way she held her head—that Sheri's heart was broken.

Anne Cameron came by the Mervis house after her shift was over. She brought Teddi's personal effects and a paperback book Gary had left at the hospital. Gary said he had something for her and momentarily left the room. When he returned, he gave Anne a stickpin inscribed with the words "The Teddi Award." It was a camp medal for valor in the fight against cancer above and beyond the call of duty. "If anybody deserves this award," he said, "you do."

Phones rang elsewhere throughout the city and beyond, carrying word that the beloved Teddi Mervis had died. Laurie Allinger stopped crying long enough to call Suzie Parker.

"What are we going to do without Teddi," she asked Suzie. "What are we going to do *at camp* without her?"

"We'll do what we always do," Suzie said. "We'll carry on."

That was the first time Laurie Allinger wondered if there would be a camp the following year now that Teddi had died, but she kept it to herself. She wondered if there would even be a Teddi Project anymore now that its inspiration was gone.

Muggs Register—in her dorm room at the State University of New York, Geneseo, in the small town of Geneseo, New York—felt somehow defeated when she hung up the phone that morning. On the drive back to Rochester, her thoughts turned to camp and the time she had huddled next to the deaf and nearly blind Teddi on the floor at the camp Christmas party. But even that long drive to Rochester wasn't long enough to recall all the memories she had about Teddi, and she considered that a good thing.

Drs. Omar Salazar and Martin Klemperer were no longer working in Rochester but were called and told of Teddi's death. They were sad but relieved that Teddi's terrible ordeal was at an end and the strain on her

parents and friends was also finally over. They wrote personal notes to the Mervises, trying to console them from far away.

Dr. Nazarian came by the Mervis house around noon that day. He sat at the table with the Mervises and talked about Teddi, her personality and great courage. The talk turned to religion, and Dr. Nazarian, a physician with faith, shared his deep-seated belief that he thought this life was a prelude to a better one. "Somebody like Teddi," he said, "has moved on to another realm. The more living and working I do, the stronger my faith becomes."

His faith did not negate his conviction, however, that the optimum medical science and technology available had to be employed. And though his faith was strong, he had never tried to force it on others. But he didn't feel it inappropriate to talk about his faith when asked, and the Mervises had done so.

Father Ambuske came to the house, and because of him, the mood and even some conversations began to change. The mood became lighter; laughter was heard more often. It was unnoticeable at first, but then, all of a sudden, a change had come. Gloom and despair was balanced by the part of Teddi that people remembered as funny, insightful and loving. The room grew quiet when the priest told about the time Teddi had cautioned him about wearing his brown suit too often and about her insistence that Sweet'ums the bulldog remain in the room during his weekly visits.

Before leaving, he shocked the Mervises when he told them, privately, that Teddi had planned most of her funeral. This surprised and, in some ways, saddened the Mervises. Father Ambuske, explaining some of the major points of the ceremony, asked if it would be all right if he proceeded according to her wishes. Both parents nodded their approval.

"There's one more thing," Father Ambuske said before leaving that day. "We'll need a larger church. I don't think my church will be able to accommodate the number of people who will probably come."

After Father Ambuske left, Sheri left Gary to the newcomers, who were arriving steadily now, to make arrangements for Teddi's coffin and burial. Deep down, she also knew that as tough and scrappy as her husband could be, such matters would crush him.

Sheri met with Mike Falvo, the newest son to enter his father's undertaking business. This funeral and family were special to Mike. He had been a counselor that previous summer at camp. Later, Mike would recall how strong and direct Sheri was on that visit.

"No embalming," she told him. "Her body has been tampered with enough." She told Mike she wanted Teddi to have "a simple wooden coffin so that it

would decompose as quickly as possible—along with Teddi's body." Sheri hesitated, trying to regain her focus. "Her soul is with God now."

She told Mike she wanted the wake to be for just one day and wanted a closed casket. She said she wanted a funeral stand by the casket and for Teddietta and a letter Teddi had written to her dad on Father's Day that year to be put on it. Sheri said the letter would be framed and brought to him later that afternoon. She handed him Teddietta.

"What shall I do with the wedding band?" Mike asked.

Teddi had taken Gary's wedding ring off one day. She didn't offer an explanation, and the two had forgotten about it. Sheri told Mike to leave it in the casket with Teddi. "Tod wants you to put this in with her, too," Sheri said. She handed him Tod's St. Michael's medal. Michael was the patron saint of the underdog.

"Don't Hang On to Goodbye"

There were only a dozen or so simple bouquets around and above Teddi's casket. Instead of flowers, people were encouraged to make contributions to Camp Good Days and Special Times. The donations from Teddi's funeral and other such funerals over the years are a reflection of people's changing attitudes toward childhood cancer.

People trickled in. Nurses Barb Fredette and Anne Cameron arrived early. They saw the Mervises but found themselves unable to speak when they reached them. All they could do was hug them. Sheri had some tissues and said, while handing them over, "You'll probably need these this afternoon." Nurse Sally Masten arrived shortly afterward. Finding herself angry with God, she had been praying to her father and her fiancé, John, that morning, for help. She asked them to "take care of Teddi." When she reached the Mervises, she stuck out her hand to Gary. "I hope you remember that I know what you're going through, and I wanted to say I love you, Teddi and Sheri."

Tears fell from Gary's eyes. "We love all you guys," he said haltingly, "and we don't know what we would have done without you."

Polly Schwensen arrived, thinking about what had happened that day at work. A doctor had come up to her and said, "Did you see the papers where Mr. Mervis thought Teddi could still hear him in a coma?" Too angry to respond, Polly turned and walked away without saying anything. But Polly was warmed by the fact that throughout the afternoon and evening,

Gary, though constantly surrounded by others, wanted her to stay close by. Spotting Polly, Gary would come to talk with her whenever there was a break from those who came to offer their condolences to him and the family.

The nurses, Polly and even some of the doctors felt it necessary to attend the wakes and funerals of children they had provided care for. They learned that it was better, in the long run, to come than to stay away. Seeing the children dead and struggling with their grief alongside the families brought closure. In order to move forward and not be weighed down by the past, they needed closure.

Polly knew that going to funerals was her way of knowing that a child was truly gone. Otherwise, she'd still think, in her heart that "they were still all out there somewhere."

Betty Scobell and her husband, Jim, arrived, followed by Irene Matichyn. Betty, battling her own cancer, waited in the long line to shake Gary's hand. "She's gone," Gary said, shaking his head.

Betty had tears in her shiny blue eyes. "Maybe we can't see her, but she'll never be gone, Gary."

Irene hugged Gary, trying to console him. Irene refused to cry. She turned to Sheri. "I'm so glad you didn't wear black," she said. "Teddi would just love the way you look. Teddi always liked it when you looked beautiful, and you do." Irene didn't go to the coffin to pray but instead worked her way to the back of the room to chat with a few others and to watch. She needed an escape route in case she broke down.

Mike Falvo, the young funeral director, spotted Muggs Register and came over to her. Muggs had noticed how hard he seemed to be trying, that he really was concerned about the job he was doing.

"I don't know if this is the best time to tell you this," he said to Muggs, and then unraveled a story about a close friend of his who had just been diagnosed as having Hodgkin's disease. Mike said his friend was depressed and afraid.

"Sure," said Muggs, knowing what he wanted before asking, "I'll be glad to talk with her." Mike thanked her, saying that it meant a lot to him. Muggs thought to herself, "Teddi's gone, but it's not over. There are still a lot of other people to worry about."

Skip DeBiase watched from a wooden folding chair, his wife beside him. The number of people pouring in amazed him. Among them were politicians, lawyers and doctors. There were policemen who came in uniform and women who came from work with their briefcases. Camp counselors arrived in groups of twos and threes, and some came alone. Mike and Jim Menz—two strong, gentle brothers who had such a good time with the kids at camp that somebody told them they ought to be charged for going—walked

in the door. They felt as though they had lost a sister. It was bitter and cold outside, and yet the large funeral home overflowed with mourners.

Skip watched as the children from camp arrived, nervous looks on their faces. The crowd noticed them too and grew quiet. They made room for the children to reach the Mervises and Teddi's coffin. As if there had not been enough sadness and tears, seeing them with their amputated limbs, canes and crutches, pale faces and wigs made some, like Skip, gasp. "Life doesn't get much harder than this," he thought. Like Laurie, Skip realized that camp had brought them together, and because of that, they were going to see a lot of death.

After the campers passed by the coffin, Skip and a few of the counselors got them together in an adjoining room. The kids were quiet and sad at first but lightened up some as Skip regaled them with stories about fishing hooks getting caught in the trees and spaghetti served up as worms to blind-folded nurses. "Blasphemy," he said, shaking his head, "using spaghetti that way." Skip noted that every one of the children with cancer who left that night said they were going to miss Teddi. He thought it the greatest of tributes, coming as it did from Teddi's peers.

Throughout the wake, Sheri continued to making final arrangements for Teddi. She saw Karen Lenio and took her aside. "Your son's picture is in there with Teddi," she said, nodding in the direction of the casket. Eric Lenio had sometimes come with his mother to see Teddi. "Teddi liked him very much," Sheri said.

Cheryl DeBiase was about to leave the funeral home when Sheri stopped her. "Being so close to Teddi," Sheri said, "is there anything you'd like to put in the casket with her?"

Cheryl thought for a moment. "How about Teddietta? Are you going to put her in there?"

Sheri shook her head no. She couldn't let go of Teddietta too.

"Well, Teddi will need a stuffed animal with her," Cheryl said. She left and came back with a stuffed donkey she had bought for Teddi. To Cheryl, it was a symbol of Teddi's stubbornness. "When you were stubborn, you were very, very stubborn," she thought, remembering those endearing times when Teddi's strong will showed itself. The stuffed donkey, along with letters from each member of the DeBiase family, was put in the casket with Teddi.

CHERYL HAD A HARD TIME sleeping that night. The funeral was the next morning, and she tossed and turned for most of the night. Whenever she did fall asleep, it wasn't for long. She would look at the clock, afraid she would miss Teddi's funeral. It took forever for morning to come.

"There's one other thing," Father Ambuske said. "We'll need a larger church." Teddi's funeral was held at St. Thomas Episcopal Church, Rochester, New York. *Courtesy of Deedee Carey.*

Skip looked in the mirror as he shaved that morning. He stopped for a moment, trying to remember what it was like the first time he was a pallbearer. His eldest son was going to be a pallbearer that morning, and he wanted to know if he had forgotten to tell him anything.

As Irene was getting ready, she wondered if she should wear her false eyelashes that morning. She had not cried since Teddi died. She was glad, at that point in the day anyway, that Teddi was no longer in pain. Many a night she had driven home from the hospital saying, "When is it going to end? Godamnit, this is enough." Irene put on eyelashes, feeling hard and angry inside.

Laurie Allinger was ready that morning long before her ride was to arrive. Laurie was afraid she would "do something stupid" at the funeral and embarrass herself and the others. When one of her grandparents had died a few years before, she had laughed throughout the entire funeral service. "If I get stupid, just bop me on the head," she told the person driving her.

Barb Fredette and Anne Cameron arrived about twenty minutes before the funeral started and were lucky to find seats. St. Thomas Episcopal Church, though larger than Father Ambuske's church, filled up quickly. Ushers began setting up folding chairs on each side of the aisle and along the back. The

line would extend, once the funeral started, down the church's front steps and into the street.

Barb looked around and saw kids from the hospital and camp. Some saw her and managed a smile; a few waved. It made Barb cry, thinking that Teddi had brought so many wonderful people together. Anne was not the type of person to cry in public, but when she got a glimpse of the way the Mervises looked, she leaned against Barb, her heart hurting.

Sally Masten was having a miserable time waiting for the funeral to start. Unlike many of the others, she was not glad Teddi's suffering was over—she was angry that it began at all. A familiar hurt returned, and she almost left. Polly Schwensen, an Episcopalian, felt good being in a church of her faith. Then she glimpsed Kim, sitting in an aisle seat next to the casket, and she suddenly burst into tears. She could deal with almost anything except watching children struggling with the death of other children. Dr. Nazarian attended the funeral. He hoped the Mervises shared his conviction that Teddi was in a better place. He hurt some for the family, too, knowing of their pain. And then, he hurt for himself, realizing he was going to miss Teddi.

Skip DeBiase sat near the Mervises, fuming inside because a television crew had come in and was setting up its cameras. He thought it an unbelievable intrusion into a private moment and felt himself start to get up. He waited, instead, to see if Gary was going to give him a cue to throw them out. When none came, he turned his thoughts inward. For some reason, he couldn't stop going over the words from "The Rainbow Connection." He didn't cry, though, until he saw his son walk down the aisle as a pallbearer. He wanted to get up and leave then, but his wife and three children were beside him. He stayed for them, knowing they needed him. Skip later said he knew a good eulogy was given that morning because so many commented on it afterward, but he couldn't personally recall a single word.

Cheryl DeBiase held on to her six-year-old daughter's hand. That morning, the child insisted she be allowed to go to the funeral. "I gotta do my respects," she said. "Teddi was my friend, too."

Cheryl saw the pallbearers come, all young, all handsome. Her own son was among them, the one who had flirted with Teddi, the one who told Teddi that he was going to be her first date. "Boy," Cheryl thought, "I bet you feel like a big wheel now with all those big, handsome boys around you."

Barb, who had stopped crying, fell into deeper sorrow when Tod passed. "He was trying to be so brave," she thought. Laurie Allinger was experiencing strange sensations and delusions. She imagined monsters coming out of Teddi's casket. She remembered Tod going by, carrying his sister. "He sort

of looked at me like 'don't cry' because I was crying so hard. But I couldn't stop no matter what anybody said or did."

Anne Kiefer caught a glimpse of Gary's face as he turned toward Sheri, and in that instant, she realized that the separation from Teddi was real now. Anne was about to cry but sensed somebody from behind was watching her. She turned and saw a child from her cabin at camp. She was crying but extended her hand to Anne, who held on to it throughout the service.

Not all of the Mervises' many friends or those associated with Camp Good Days and Special Times came to the wake or the funeral. Some people couldn't, or wouldn't, deal with the loss and drifted away, not stopping by, calling or writing to extend their condolences, never acknowledging their relationship with the Mervises or the camp again.

It was a very simple, almost stark, service that morning. Beginning with a few brief formal prayers, Father Ambuske took a few notes to the pulpit with him. He paused. He could hear the wind blowing outside and the muffled sounds of people crying and comforting one another. There were coughs, some sneezed and some couldn't quite settle down.

He whispered a small prayer for himself, and to Teddi. He asked for her help and for the courage not to cry, just as he had promised her. "Oh God," he intoned, "whose beloved son did take little children into his arms and bless them, give us grace, we beseech thee, to entrust this child Elizabeth to thy never-failing care and love."

Ambuske felt his heart pound and paused. It looked like something he was supposed to do, so nobody noticed how anxious he was. He looked out over the great crowd—the powerful and small children; mothers and fathers, including the Mervises; and the host of friends who had come. He thought of Teddi saying she hoped her life had been like the picture of God touching Adam's finger in the Sistine Chapel, that she had touched a lot of people. Father Ambuske fought the urge to cry, realizing that she had indeed touched the hearts of so many others.

He began:

> *Teddi Mervis asked me some of the most difficult questions I've ever been asked. I told her, when she asked to be baptized, that she would now be a child of God. But then she wanted to know if there were other children of God and I told her yes, and some didn't have a priest or rabbi to be with them, but if they did the right thing then they were children of God, too. Teddi said—Teddi wanted to know why, if there were so many children of God, there was so much trouble in the world too!*

With that, Father Ambuske heard scattered chuckles from the crowd. He continued, telling them that Teddi had asked him that if all religions were supposed to love one another, then why didn't they? He said she had often made him answer her questions with words such as "mystery" and "faith" and that he told her he didn't know the answers to all her questions.

"'I'll probably know some of these answers before you will, won't I, Dave?' she told me, and I said she probably would."

He talked about some of the other things she had said and realized, at that point, that he was no longer referring to his notes. He was talking with the same ease and peace that he had when talking with Teddi.

> She was looking forward to meeting God. I told her that there would be others in heaven she knew, like the boys and girls from camp. I told her I didn't know how they were going to communicate, but that I definitely believed they were. "It will be a lot like earth, Teddi," I had said, "except there won't be any tears."
>
> Teddi would nod on those occasions and would usually say, "Tears are bad, Dave."

Lest those who listened thought Teddi didn't hurt spiritually, he told them of the times when her sadness and anger returned, the times she would ask him why she had been picked to suffer so much. She wanted to live, she said. She wanted to live a long life, become a teacher and do things that so many other kids her age would get to do. He added:

> But in time, Teddi Mervis came to grips with her fate, just as she had with her terrible disease. We talked about suffering and its meaning, and together, we came to the idea that suffering is only meaningless if we can't find its purpose. We talked about camp and all the kids who were now able to enjoy life a little better because of it. Toward the end of her short life, Teddi said to me, "I must have been chosen. I must have been meant to do something on earth. Why not me, right, Dave? That's what I should be saying."

His own feelings of loss filled him now. "She told me, 'Make it happy, Dave. I'm just leaving one side and going to another. It's not goodbye, that's not what I'm doing; I'm saying hello. Tell them not to hang on to goodbyes, that I don't like them.'" Before stepping down from the pulpit, Father Ambuske remembered the message Gary had passed on to him, to invite all those present to the Mervis home after the burial.

The priest and those present sat in silence for several moments. It seemed too much to take in, this story of a tortured child who spoke so clearly and triumphantly from beyond the grave. Cheryl DeBiase was grateful Father Ambuske had stopped when he did. She couldn't handle another word. Bob Mervis seldom cried, but he did then. He had seen Father Ambuske at the hospital, had watched his face. He knew Father Ambuske spoke from the heart. Nurse Barb remembered it being a happy sermon but couldn't remember any of its details. She could almost picture Teddi talking the way she had to the priest, and that made her smile. Anne felt proud that she knew somebody so good. Karen Lenio wanted more, she wanted this eulogy to be "cataclysmic and cathartic." She said she wanted it to be even more "perfect" than it was. Irene was crying hard when the eulogy ended. The Teddi the priest had spoken of was the Teddi she had known. "So up, so cheery," thought Irene. "And so opposite of me, the cynic." Irene abruptly left the church.

Sande Macaluso was standing in the back of the church, his heart hardened. "How could we have spent millions, maybe billions, going to the moon, and we could not save the single life of this wonderful child." Gary and Sheri walked side by side directly behind the casket as it was being wheeled from the church. When the Mervises passed her pew, Polly thought of President Kennedy's funeral.

Muggs watched the procession without tears until some of the children from camp passed by—Laurie Allinger, Mark Dillon and others she had come to know and love. Muggs sat back down in her pew, buried her face in her hands and cried. She felt as though she might not ever be able to stop. She was crying for them, the children, for what they had to endure and for what they had to take on, too—the death of friends.

Irene, pacing outside the church, would remember how Sheri's face looked as she walked down the steps of the church. "The haunting expression, the sunken eyes," said Irene. "She wasn't crying, but I go back to my own religious upbringing, being raised Catholic, and I think of how the Blessed Mother would have felt and looked the day her son was crucified…You could see the devastation on that mother's face."

The shiny black cars, followed by scores of other cars, left the church for the cemetery a few miles away. The February wind blew cruel and crazy as people exited their cars and tried to make their way up the narrow, icy road to the grave site. Some of Teddi's fellow campers needed help along the way, and so did some of the older women and men.

Father Ambuske said but a few words because of the blustery cold. He was surprised so many had come, right to the bitter end, as if they were protesting heaven itself for taking one of Earth's smallest and best.

Sally remembered Sheri with her arm around Gary. Skip, standing behind the Mervises, caught a glimpse of his son, who was standing near the casket, tears nearly frozen on his face.

Cheryl, on the fringe of the crowd, stood with her six-year-old daughter. The child had difficulty making it up the icy road in the fierce wind but refused to turn back. Cheryl tried to make herself happy with the thought that Teddi no longer had cancer, that she was being taken care of by Gary's mother and that she would be with her old friend Chuckie Altamara. But selfish thoughts took over and wouldn't leave. "I don't care if she was sick. Terribly sick. I want her back."

First, the Mervises and then others put carnations on Teddi's casket, whispering prayers of goodbye. A sudden shudder went through Barb that she knew wasn't from the cold. "This is indeed the end," she thought. Teddi wouldn't shed any more tears now. Betty Scobell spotted Tod. She smiled. God, how she liked him. "He's such a Dennis the Menace, but oh, he's so grown up today." She didn't remember seeing tears in Tod's eyes at the wake or funeral service. But as he left a carnation for his sister, Betty saw him bend over, holding his stomach, and begin to cry. Betty gripped her husband's arm tightly.

Uppermost in Tod's mind that morning was doing his job as a pallbearer and doing it well. The sidewalk to the church had been narrow, and on his side of the casket, they had walked mostly in the snow. All of them almost slipped once. He tried to be brave in the church and walking down the aisle afterward. Only now, with his work at an end, could Tod let go.

Skip was one of the last to leave the grave site. He put a carnation on Teddi's casket and whispered, "I love you, *comare*." Father Ambuske, putting his flower on the tomb, wanted to know if he was allowed to cry now.

Two people hung back from the crowd that blustery morning. One was Muggs Register. She felt she had a special relationship with Teddi that couldn't be acknowledged with so many people around. Though usually not a problem for her, Muggs found it hard to communicate and pray. There were so many people, so many faces, so many emotions that it had left her feeling emotionally and spiritually paralyzed. Muggs didn't notice Polly, who had also waited behind so that she, too, could spend a few moments alone with Teddi. "It's just like always," Polly thought. "Always so many people around you. They never seem to give me a chance. I could hardly see the ceremony." Polly put an end to this way of thinking and smiled, believing

that the important thing was that Teddi would be with God now. "Goodbye," she whispered and added, "see you later."

On her way down the hill, Polly saw Laurie Allinger walking alone, her head downcast. She caught up with Laurie and put an arm around the teen. Polly had noticed that others were reluctant to do this because Laurie had only one arm.

"How are you doing with all this?" Polly asked.

Laurie said she rode hard on her horse the night before to try to relieve some of the sadness she felt because of Teddi's death. They talked a little more, Laurie never mentioning that she had only gotten halfway up the hill that morning and turned back, not brave enough to be at the burial ceremony.

Not everyone went to the ceremony that morning. Anne Kiefer, Teddi's first counselor, went home after the funeral service and wrote to some people she had met while on vacation. They had been curious about Camp Good Days and Special Times, and now Anne explained it to them. They responded by giving a substantial donation to the camp.

A Terrible Silence

Sheri reached the front door of her house and stopped suddenly. Bob Mervis was on one side of her and his wife, Linda, on the other. Sheri didn't cry during the wake, funeral service or burial. But suddenly, now on the doorstep of her home, she burst into tears. "I think I'm going to throw up," she said. She trembled; this was home and her first step into it without Teddi.

Linda asked if Sheri wanted to go someplace else for a while.

"No, I'll be okay," Sheri answered, then took a deep breath and went inside.

Friends had prepared and set out an abundance of food, along with silverware, glasses, napkins and all the rest for the very large crowd that had begun to arrive. Commotion reigned, and here and there people began to joke, lightly, as if they needed to do so. "Hey, who cooked this?" somebody would ask. "This is terrible," another person would say.

Throughout the remainder of the day and into the evening, Sheri walked around the house, making sure everyone had something to eat and drink. As she did so, with one hand, she held Teddietta close to her chest.

Skip noticed that Gary seemed withdrawn. The house had become hot and stuffy at one point, with the crowd of people, and Skip said, "Come walk with me." Reluctantly, Gary took Skip's hand.

Once outside, wearing only their sports coats, the two walked up and down the street. At first, the old questions began to return to Gary, the ones that always started with *why*. From there, Gary began to express his disbelief in all that had happened: Teddi getting a tumor, what she had gone through and the fact that she was gone. "I don't know what to do with my life now," he told Skip. "Teddi has been so much of it. So much of my energies have been devoted there."

He told Skip that after the wake, he had gone to the grocery store to pick up a few things and found he had bought a jar of Teddi's favorite marmalade. The morning of the funeral, after pulling out of the driveway, he had headed in the direction of the hospital and not the church.

Gary seemed relieved after they had talked some and said he wanted to go back inside. They both marveled at the number of cars in the driveway and on both sides of the road.

Teddi's three nurses—Barb, Anne and Sally—came. They had debated whether to go to the Mervis house after the graveside ceremony. They knew it would be crowded, that they wouldn't know many people and that, deep down, they also weren't exactly sure if the Mervises were pleased with the care Teddi received.

Gary sat talking with the three of them at the kitchen table for a long while. The attention he paid them demonstrated how much respect he had for them and how close he felt to them. Afterward, Barb would think that the Mervises had gotten close to them because they were the only other ones who saw Teddi day in and day out for the duration of her stay at the hospital. Before the three left, Gary excused himself and said he had something he wanted to give them. He left the room but didn't return for quite some time. The nurses began to get anxious, not knowing what had happened to him and whether they should leave. But Gary came back, smiling, saying he was losing his memory and couldn't remember where he had left two more Teddi Award stickpins. Anne already had one, and now he gave one to Barb and one to Sally. "I know Teddi would want you both to have these for being so brave," he told them.

The three said their goodbyes, with Sally going last. Sally remembered Gary's face looking especially worn, "like he could cry at the drop of a hat." Though sometimes angry with God for her own fate, Sally learned something special that day—while people share in suffering and death, friendship makes it almost endurable. When Barb said her prayers that night, she asked God to watch over the Mervises and to take care of Teddi.

Anne Cameron felt stronger because of her experience caring for Teddi. "If that little girl could be so brave," she said, "then I can be braver, too." Anne wore the Teddi Award on the collar of her uniform

to work each day after that. She missed the children she had taken care of who had died, including Teddi. But the one thing that kept her going was the belief that when it was her turn to go to the other side, those very children would be waiting and happy to see her.

Irene Matichyn remained angry a long while afterward, thinking, "If I was the guy designing the whole thing, there's no way I would do it this way." She couldn't be convinced that there was any meaning to Teddi's death. "Teddi was a beautiful human being, a kind human being, and had she lived, she would have made a lot of people happy."

The DeBiases stayed at the Mervis house until nearly everyone had left. At the kitchen table with Gary and as his farewell for the day, Skip said to his friend, "This has been a hard day. But this is when the day gets the hardest. Now it's you and your family—and this loss is going to have to be dealt with in an entirely different way." Gary walked him to the door. Skip gave Gary a hug and said, "I just hope to God that you're all so exhausted you'll just pass out and go to bed."

When they got home, Skip and Cheryl put their children to bed, and then Cheryl lay down on the couch, quickly falling asleep. She was drained but also at peace. She had remembered the time, before Teddi had gone into a coma, when Teddi had said, "I love my mommy and daddy, but if they weren't here, I'd have you." Not always confident in herself, Cheryl was grateful that Teddi had picked her to be her godmother. Teddi had left her that, along with affection and an abiding love.

With his wife and children asleep and the long ordeal at an end, Skip became agitated, like he didn't know what to do with himself. He paced and then left Cheryl a note. "Don't worry," he wrote, "I need to be alone for a while." He took a bottle of scotch from the liquor cabinet.

Skip drove around the city for a while, ending up near the airport. He thought about that afterward; it was as if somehow he wanted to leave, leave it all behind. Skip pulled into the Sheraton Hotel across the road from the airport and rented a room. He drank his first two glasses of scotch. Then the man who had stood by Gary, sang with Teddi, held up Irene, remained strong for his family and proved that a lake was alive—the guy who had said to so many others, "Come walk with me"—let his heart finally do what it had been aching to do for the better part of three long years. He raised his glass; said, "*Salude, comare*"; and cried. He cried with no one telling him to stop. He cried until sleep came.

On the other side of the city, Father Ambuske was winding his alarm clock. He could see out the window that the wind had died down. It looked

calm outside now, though still no doubt awfully cold. "Finally you are at rest," he said, turning out his bedside lamp. As he lay down, he smiled some, believing that Teddi now had all her answers.

Later, when the priest consoled those who were seriously ill along with their loved ones, he would draw on his experience with Teddi. He would talk about her courage, saying they could pray to her for help.

Laurie Allinger tossed and turned that night. She thought about Teddi and the fact that the foursome was now down to three. She wondered if and when there would only be two of them left or one or none. She remembered saying to Teddi, "I wish you didn't have to go. I'll go and trade you for me so you can live and I can die. You are more special than me, with the camp and all."

When Laurie went to school the following morning, her classmates told her they had seen Teddi's funeral on television with their parents. Toughened by the experience, Laurie started to change her opinion of herself. "I grew up a lot, and when people asked me where my arm was, I told them I left it at home because I didn't need it that particular day."

Polly Schwensen wanted badly to go to the Mervis house after the cemetery service but was scheduled to work. After work, she had a church supper to attend. Still, she felt something akin to being "unfinished." She had one of those little talks with herself. "You're always withdrawing," she thought. "Now you get out there and go over and see the Mervises and tell them you wanted to be there."

Polly wrote them a personal note on a card and, on the way over, stopped and bought some apples. "They probably have had too much starch already today," she thought. "I'll bring fruit."

She rang the doorbell of the Mervis home. As she stood there waiting, with the card and the bag, she felt foolish. "What a dumb idea," she thought. "This is silly. It's nine o'clock and they're probably tired and already in bed." She looked around, "And nobody else is here."

But then Gary answered the door. He smiled and was clearly glad to see her.

"I just wanted you to know that I couldn't come earlier," Polly blurted, sounding as though she was reading from a prepared text. It was partially true; she had thought of what she was going to say and rehearsed it before arriving. "This is the end of my day and the first chance I've had to come over and see you."

Welcoming her inside, Gary thought about how he had come to love this woman of simple honesty and a caring heart.

Polly sprawled on the floor with Sheri while Gary sat in his favorite chair. They reminisced a while, and when Polly was about to leave, she reminded them about the little boy who had come for Teddi, the one whose name was Jesus. Though Kim and Tod were watching television nearby and seemed not to be listening, Tod said later that Polly's remarks about the little boy meant a lot to him. "I knew my sister was all right then," he said.

Polly wanted to know what Gary was going to do the next day.

"I'm going to sit in a hot tub of water all day," Gary said, smiling. And they all laughed.

"And what are you going to do the day after that?" she wanted to know.

"The same thing!" Gary told her.

As Polly drove home that night, she was happy she had stopped by to see the Mervises. She felt complete now. And she thought to herself that if Teddi could get up in front of those TV cameras, and if Sheri—whom Polly thought was extremely quiet and shy—could take charge of running the day-to-day details of a large camp, then she, too, could exercise a little more courage.

Kim Mervis had a difficult time falling asleep that night. Saddened she wasn't always nice to her sister, Kim also knew that her life would never be the same. Tod Mervis said his prayers that night and remembered what his father had said to him time and time again: remember the good and the bad each night and the next day try to keep the good and improve on the bad. Before falling asleep, he asked God "to please take care of my sister."

Tod would go to the cemetery often. And when spring came, he thought Teddi's resting place was a good one. It received lots of sun. Each time he went, as is the Jewish custom, he placed a stone on Teddi's grave. To some, it symbolized the permanence of memory and legacy.

After all was said and done, for Gary and Sheri, there was this terrible, deafening silence. They wanted to hear Teddi's voice one more time. At night when the house was quiet, they listened for her to call to them. They sometimes walked into her bedroom, forgetting.

Teddi's birthday, the start of school and Christmas all lay ahead and would have to be gotten through. Maybe after that, after a full year had passed, Teddi would be able to come back again, only this time to a different place in the heart. Besides, for Teddi, it had always been about hello anyway.

To Go On Anyway

The spring after Teddi died, through early summer, people associated with Camp Good Days and Special Times, especially the children with cancer, had just one question on their minds: would camp continue now that Teddi was dead? They wondered, if there was a third camp, would that be the last one? Would camp organizers give them one more shot at a summer camping experience before it was over for good? Still others wondered if a third camp would be so sad and depressing it would be a good idea to not have it at all. Maybe nobody would want to come back. For all intents and purposes, that third summer camp would be crucial to the long-term survival of Camp Good Days. Given all that had happened, with everyone's energy depleted and no clear answers, it would take an enormous amount of spiritual courage to go on anyway.

THE NIGHT BEFORE THE campers arrived, Gary rose to speak. Those who knew him thought he seemed different, and some glanced at one another to see if others saw it. "You counselors are the ones who make it work now," he said. "You get to know the kids on a one-to-one basis. You're there at night

Miniature golf at camp, being played by giants. *Courtesy of Camp Good Days Photo Collection.*

when they want someone to talk to. You've got a special mission to give the children a week they'll never forget."

All listened intently, including Skip, respecting the difficulty Gary was having. Gary continued, looking down, leaning on his hand, "We lost twenty-one children in two years, and seventeen of them since the last camp." And then he said he expected two things of the counselors: "Send them home happy, and send them home safe."

Those sitting next to Skip felt him move as if he was going to get up. Skip felt an urge to speak but didn't know how his words might affect the Mervises. What he wanted to but didn't say was that not a single kid had died, not really, that the spirit of each one of those children was there in that very room. But Skip hesitated and then let it pass, just as others would let other things pass that week. Everyone would try to make the best of the situation that week, with the Mervis sorrow on the one hand and the desire to give the children as much joy and tender care as possible on the other. Skip knew, and the others soon would also, that Gary's father had died just before camp opened that year. So Gary, in the course of six months, had lost both the eldest and youngest members of his family—his last link with the past and the furthest extension of his future. The future of Camp Good Days and Special Times may have been riding on how Gary finished the summer.

Some of those close to Teddi's story were there the night before camp opened. Each returned that third year for his or her own reasons and the result of personal reflection.

"Why did I go back?" Muggs Register said matter-of-factly. "There wouldn't be any reason for Teddi if I didn't." Polly Schwensen had a difficult time when she arrived that third summer. She was assigned to the same cabin as the year before, the one where Teddi had stayed. Polly asked Muggs to stay with her in the cabin that night, but Muggs declined, saying, "I'm living with the fear that at some moment during the next two weeks Teddi's death is going to hit me, and I'm going to fall on my face and not be able to get up."

Later that same night, as the sun began to set, Skip DeBiase went out to the dock with his son, Alex. They broke worms into small pieces and cast them out on the waters.

The next morning, through breakfast and lunch, the campgrounds were unusually quiet. Some of the veterans noticed. Though nobody said so out loud, a few felt camp wasn't going to work out at all that summer, that something had irreversibly changed.

Counselors and staff walked alone or in small groups. But alone or in groups, they seemed to be turned inward, as if thinking or praying. Some seemed nervous. Others seemed to be storing their last bit of energy for the exhausting time ahead. A few worried about the size of their own courage. Then came a loud, booming voice over the loudspeaker, "Five minutes to go!"

And it was at that very moment that those with doubts began to let them go. They let go of nervousness and fear. It was as plain as day. Counselors and staff came running out of the dining hall, the cabins and from the beachfront. It looked like a human tidal wave of energy and joy. As the bus pulled in, they clapped, jumped up and down and cheered, and, yes, a few had tears in their eyes. Crossroads the Clown blew on his long, blue plastic horn with wild abandon, gleeful and perhaps grateful he could do something useful with the adrenaline bursting inside him.

The first bus crept slowly onto the camp's playing field as "The Olympic Theme" pierced the sky. Tiny faces peered back from behind the tinted dark windows of the bus, watching as hands outside shot up—waving, welcoming or giving the peace sign. Counselors and staff alike pounded on the bus door, wanting it to open.

Amidst the thunderous welcome, with dust flying everywhere, the doors finally opened, and counselors reached in, helping children out, grabbing fishing poles, tennis rackets and sleeping bags. The kids wore cowboy hats, baseball caps and bandanas. Their faces were mostly pale, but a few were sporting tans.

Suzie Parker, one of the blood sisters, found Kim Mervis, and they hugged each other, almost squealing in delight. Then the PA system boomed, announcing that the other two buses were arriving. This time, some of the campers joined the counselors and staff in repeating the whole triumphant welcoming.

"Hi, Dr. Klemperer!" one little boy called out, running and hanging on to his friend and physician. They all seemed to be wrapping their arms around one another, saying hello again from their own sorrow and pain.

Laurie Allinger stepped off the bus. She hesitated, looking around. Though not many would know it, Laurie had struggled that entire spring and summer with the decision about going back at all. She knew, almost instinctively, that leadership of the blood sisters would likely pass to her, which it did. As Teddi's best friend, she felt that maybe some of the burden of continuing the camp was on her shoulders as well.

A short time before, Laurie had called Polly Schwensen and asked if she would take her to the cemetery to see Teddi. What was said is still in

confidence. "I had to go to camp," Laurie said, "even though it was going to be very hard for me with Teddi no longer there. I just had to be there."

Grinning, Laurie greeted those who spotted her and said hello and hugged them. Suzie Parker saw Laurie and broke though the crowd to hold her old friend again. They held on to each other tightly, crying and laughing at the same time. One last child waited on the bus's last step, holding on to the door handle and watching the scene unfold. His face was expressionless as he stood there, slightly stooped, like an old man.

Now a three-year veteran of Camp Good Days and Special Times, LaVerne Haley was also the veteran of a struggle against a malignant brain tumor that doctors could not seem to find. Frequently in the hospital for tests and treatments, if summer was approaching, LaVerne always packed his suitcase for camp and put it under his hospital bed.

LaVerne was the first child to participate in the Teddi Project—the fund devoted to providing the last wish of terminally ill children. LaVerne had gone to Disney World and had the pictures to prove what a good time he had. Pale faced with a red bandana wrapped around his head to cover baldness and surgical scars, LaVerne began slowly stepping down from the bus. He was also wearing a hearing aid.

Gary Mervis had been watching and waiting for him in a reconverted golf cart. Together they rode to the cabin LaVerne was assigned to, like old friends who didn't have the need to talk much.

But when they came to a stop, LaVerne took Gary's hand. "You know, Mr. Mervis," he said, talking with a hoarse whisper, "I felt real bad about Teddi."

Later that afternoon, after the last bus had arrived and all the children were all settled in, Sheri walked briskly to her cabin. Though she was not one to show much emotion, her sunken eyes and faraway look indicated it had been a hard beginning for her.

That night, a huge bonfire on the beach was followed by an extraordinary fireworks display, alerting the residents around Fourth Lake and its environs that the kids with cancer had returned.

From the darkness, a small voice could be heard, saying, "They're so high. I think they're going to touch a star."

Another small voice added, "I wonder if Teddi can touch them." The next morning, and all week, Dr. Klemperer seemed to awake earlier than usual. Whenever he did so, he often read the Bible "for its wisdom." There was also a speech stirring inside him that he would to deliver to his medical students when he returned to the university to begin a new semester. Dr.

Klemperer worked on the speech during those early morning hours while others slept, when the wind was quiet and the lake still. He wrote his speech in the midst of children who were dying.

The camp, extended for two weeks that third year, was a steep, swift rollercoaster ride of emotion. Though counselors and staff tried not to become visibly upset in front of the campers, every so often, one or two might suddenly stop, as if stunned by the reality of the world they had entered. Then, you would see them go off by themselves and, after regaining their composure, return to their responsibilities.

Though Gary Mervis still talked and joked with kids, counselors, reporters and anyone else who needed him, he seemed quieter than usual, more inward. Late at night, when nearly everyone else was asleep, he could be seen sitting on the front porch of his cabin, staring into the darkness.

The nurses seemed to bear the brunt of everyone's pranks, campers and counselors alike. Nurse Anne Cameron was made to challenge Nurse Practitioner Mary Ellen Dasson to a banana-eating contest. Later, they blindfolded Barb Fredette and made her eat assorted foodstuffs from a pan. Barb was doing fine until she picked up a strand of spaghetti and the kids started shouting, "Worm! Worm!"

Sande Macaluso, watching events unfold and friendships form, said, "You know, I'd like nothing better than to see this camp close because they found a cure. But I'd want it to stay open forever if they didn't." Big tough guys like Ron Baldassare, a lightweight boxing champ in the army, could be seen patiently and gently tying the shoes of a little girl, his hands the size of her head. Charlie Fornataro, a security-alarm specialist who grew up in the city, had become Apples the Clown.

LaVerne Haley, probably suffering more in three years than most would in a lifetime, pointed to a child with a missing limb.

"What happened to her?" he asked his counselor.

"She has bone cancer," the counselor answered. "That's why her arm is gone."

He shook his small, frail head slowly from side to side. "That's too bad, isn't it?" he said.

Milly Wolf, who had lost a child to cancer and was the first head of the Teddi Project committee, pretended to be jealous because one of her favorite young male campers was talking to another female counselor. "Sure, you leave me for a blonde," Milly teased. "But I only have this gray hair because I'm married to an older man."

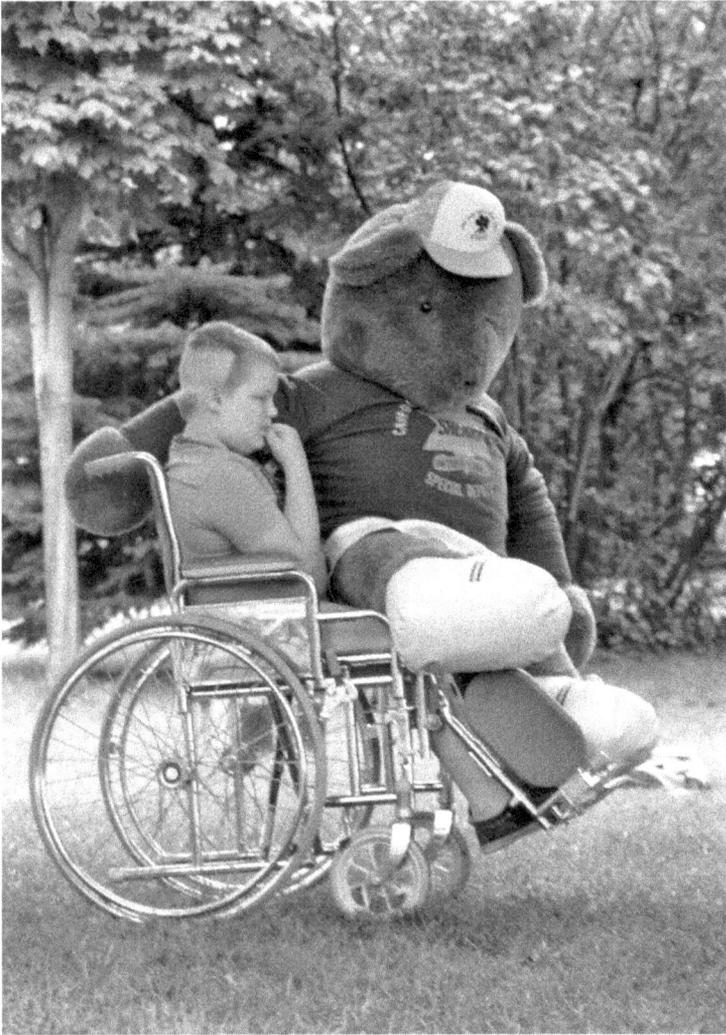

The camp mascot, Teddy Bear, comforting an axious child. *Courtesy of the Camp Good Days Photo Collection.*

The boy looked up. He was deadly earnest. "I don't care if you have green hair," he said to Milly. "I'd love you anyway."

Toward the end of that first week, as campers and counselors passed by the main cabin on their way to breakfast, each was surprised by a huge brown teddy bear sitting in a chair on the front porch. The bear wore a Camp Good Days and Special Times sweatshirt and cap. A note was attached to it and read, in part:

I want to be the camp mascot because it is a wonderful place to live. If you keep me, make certain promises. Make certain I'm always there to greet the buses when they arrive and when they leave. Take me with you on camp activities and give me a new camp button each year. Always make certain that the campers and staff give me a lot of love. I would like to sit on the porch and greet each new person with love.

On the medical history form, also attached to the bear, it requested Dr. Klemperer as its doctor.

Talent Night at camp was quite possibly the most significant event in each of the two weeks. Often with the help of their counselors, the children put on skits and sang songs. Sometimes they chose things that, perhaps unconsciously, symbolized what they wanted, needed or would miss most in the world.

Such was the case with LaVerne Haley, who, at the end of the first week of camp, hobbled on to the stage on Talent Night with the help of his counselor. LaVerne, often cranky and downright irascible at times, was also a hero to many because the doctors kept telling him he didn't have long to live and he kept living anyway.

As LaVerne slowly made his way to the center of the stage, the hall erupted—people clapped, cheered and stomped their feet. Then they rose as one, some shouting and some holding back their tears. All the pent-up emotion of the week broke through. Everyone, it seemed, wanted to tell this little man they loved him and that, in his own fragile way, he had become their symbol of hope.

LaVerne wore a black beret and red sweater. A small plastic guitar was slung around his shoulders. LaVerne seemed nonplussed by the exhibition of such emotion. Then it grew quiet. For a moment or two, it seemed as though LaVerne was uncertain what he was supposed to do. Everyone waited patiently and nervously. At Camp Good Days and Special Times, there was no room for jeering or ridicule.

After a whispered conversation with his counselor, LaVerne began strumming his guitar, saying the same line over and over again. Those present heard it differently. Some thought he was saying, "Don't take my *love* away." To others, it sounded more like "don't take my *life* away."

Nurse Practitioner Mary Ellen Dasson got up and moved to the back of the room, her eyes red. Dr. Klemperer took out his handkerchief. He said he always carried one with him because sometimes doctors had to cry.

Later, they called Dr. Klemperer to the stage, and the place erupted again. School was starting, and he had to go back to the West Virginia medical

college where he taught. As he stood there, he thought of the speech he was to give his students. He would tell them about his time at camp and how much the children had taught him about living and loving. He would tell them that medicine was both a science and an art and that study, apprenticeship and practice would prepare them to treat the body but that they must also come to understand the heart—their own and those they ministered to. He would tell them all to carry a handkerchief with them, and if they didn't use it from time to time, they better think twice about being a doctor.

Dr. Klemperer used his handkerchief one last time at camp and that was when Skip DeBiase came to say goodbye. Klemperer started to reach out his hand, but Skip would have none of it. He kissed the doctor on the cheek instead. "When you're Italian and you love somebody, you kiss them," he said.

Perhaps the hardest time for Gary and Sheri Mervis came on Monday during the second week of camp. That first week, there had been a beautiful child who resembled Teddi a lot—Teddi from that first year of camp, when she was pretty, healthy and alert. So much did the child resemble Teddi that Judge Tony Bonadio, one of the volunteers, mistakenly started to wave to her before realizing it wasn't Teddi. The second week of camp brought a girl who reminded nearly everyone of Teddi the year before, when she had had trouble speaking and walking and death was near. Sheri saw the girl arrive and immediately walked off by herself. She removed her glasses with one hand and brought the other to her eyes. Gary met the girl that first night after flag raising. She was in the golf cart seated next to Nurse Mary Schwartz.

"Hi, I'm Gary Mervis," he said, sticking out his hand.

She could barely stretch hers out far enough.

Gary asked what her name was and where she was from. She told him. And she also told Gary she had had a birthday the day before.

The nurse asked what she got for presents and the child answered, with some difficulty, that she received a Pac-Man quilt, a necklace and a few other things.

Gary was nodding. "So you just had a birthday. How old are you now?"

She told him she was twelve, the same age Teddi was when she died.

"Have you ever been to Disney World?" Gary asked. The child shook her head that she hadn't.

Gary asked if she liked Mickey Mouse, and the child smiled and said she did. "Would you like to go to Disney World?" he asked, and she continued smiling.

Eagerly yet softly she said, "Yes, I would like that."

"We're going to make sure you get to Disney World when camp is over," he told her.

A counselor drove the child down to dinner, and Gary and the nurse began walking toward the infirmary. Nurse Schwartz was on duty. "What does she have?" Gary asked without looking over.

"A brain tumor," answered the nurse.

At the infirmary, Gary looked over the girl's medical record. Attached to the cover sheet, at the top, was a picture of her before the treatments had started, before the baldness and weight gain and all the other side effects occurred, signaling that death was close at hand. Nurse Schwartz saw Gary stroll by himself along the beach after leaving the infirmary.

Meanwhile, at dinner, Sheri watched as Muggs, who had volunteered to be the girl's counselor, got up with the child midway through dinner. The girl had to go to the bathroom. It was then that Sheri made a decision that would not only affect her own life but also, quite possibly, the future of the camp. Though feeling terrible about it, Sheri honestly did not want to see or touch this child because it was like being with the Teddi who was dying all over again. Yet she knew that the girl didn't deserve her coldness or indifference; she was not Teddi but a child who had every right to the attention and love that the camp promised.

Sheri rose from the table. As Muggs wheeled the child back in, some noticed Sheri rise and go over to both of them. From that moment on, Sheri would be their constant companion for the remainder of the camp. Sometimes a counselor or two expressed concern that the girl was being spoiled. But Sheri had heard it all and seen it all before. There is no possible way to ever spoil a child, no way to give a child who is going to die all the love they would have received if they had lived an average life span.

Kim seemed to be having an easier time of it than Tod during those two weeks. She seemed to be without inhibitions, as was evident when she was told that an especially handsome but shy boy was not participating in many of the camp's events.

With the adults gathered together at a meeting in the dining hall, Kim commandeered the camp microphone. "Will all available female campers and counselors please report to the main office. Will all available female campers and counselors report to the main office." After they all had arrived, she set about introducing them to the shy boy, who stood red faced, shaking hands and smiling.

Tod worked and played hard for those two weeks. He was growing up fast. One afternoon as he sat on the steps of his cabin as a nurse walked by. She

asked him what was wrong. "You know, this place is scary," he said. "A lot of these kids are going to end up like my sister."

Later, on a bus ride, the little girl who looked a lot like Teddi, and who for some reason had gravitated to Tod, accidentally bumped him in the nose. It made Tod's eyes water. "Big boys don't cry," she said to him.

He smiled. "Big boys are only allowed to cry when they lose in wrestling or when someone passes away."

The camp really had two endings. At the end of the first week, about half of those due to leave departed. The other half, some begging their parents to stay, were allowed to do so. Counselors volunteered to stay on; Sheri ordered more pasta.

As the second week of camp drew to a close, there was another Talent Night. Dr. Harvey Cohen, from Strong Memorial Hospital, had replaced Dr. Klemperer as the camp's medical director. Klemperer had returned to teaching. A big bear of a man, Dr. Cohen rose from his seat midway through that night's performances and sat in the back of the hall, his face hidden by the shadows. He was thinking about a scene he had seen on *M*A*S*H* once. "A young soldier had died, and the surgeon named Hawkeye was depressed. The old doctor took Hawkeye aside and told him there were only two rules he had to remember. The first was that the young die; the second was that you couldn't change rule number one."

The camp's second ending was even more strained and powerful than the first. A whole year of planning, waiting and giving was now at an end. There aren't many happy goodbyes, but at Camp Good Days and Special Times, that experience was devastating.

The sky was in conflict that morning as the buses waited, and campers and counselors scurried around trying to match clothes with kids and keep too busy to notice the rumbling tide of emotions inside. The sun was still summery, warm and bright. But the clouds were autumnal, leaving the air chilled and the ground with large, dark shadows as they meandered past the sun. The chill and shadows caused people to look up, wondering how long before the sun would be able to warm the ground and them again.

Gary held up a little boy who was crying. "You going to be okay?" he asked, trying to comfort the child. Gary's brother, Bob, standing next to him, let out a deep sigh. Sheri helped the child who looked like Teddi onto her bus and then quickly walked away, her back to everyone. Kim was weeping openly and without reservation. Her brother, Tod, loaded sleeping bags onto the bus and carried those who could not walk. He tried to comfort some

of the children even though tears were falling from his own eyes. Veteran journalists were there, people who covered car crashes, murders and other tragedies, and they stood around speechless, seemingly without purpose, dead center in what appeared to be some kind of profound spiritual experience. Dr. Cohen wandered through the crowd, eyes reddened, hugging everyone in sight.

Charlie Fornataro held up the mascot Teddy Bear, waving its arms. "Say goodbye to Teddy!" he called out, and some of those who heard him ran over or even got off the bus to give the bear, and Charlie, a final hug goodbye. It was a hard time but also a gentle time. As the last of the children climbed aboard the buses and the engines started, the campsite grew markedly quiet. Counselors and staff still waved and called out a last "I love you" and "goodbye," but the sound and the experience of camp had definitely turned in a different direction. The counselors themselves looked a little lost now, a little incomplete, as if part of them left with the buses. Some wandered around, hoping for just one more handshake and hug.

Crossroads the Clown checked the tires and mirrors of every bus before it left. As each bus pulled out, Crossroads ran alongside it, as if wanting to stay with it all the way home. But each time he ran alongside one of the buses, he bumped into a large tree beside the road and stopped dead in his tracks, legs and arms flailing every which way. It was absurd to watch, and yet it was fitting, for there are few things as absurd as the death of children.

The leaves at the top of the particular maple tree that stopped Crossroads were turning a bright crimson. Autumn came early to the Adirondacks, and the leaves of these and other trees would feel the cold and depart from their branches earlier than trees elsewhere in the state.

The campground was silent, except for the sound of the wind. For two full weeks, children laughed, shouted, sang, cheered and told secrets, and now all was quiet.

Then, a hawk came into view, flying high over the road that the buses had taken. It circled and soared, like a silent soul, wondering, it seemed, why the strange silence had descended over the land. The Native Americans who had lived there believed that a hawk flying overhead before a difficult journey meant good luck.

IV
The Legacy of Teddi Mervis

A Place in the World

That difficult third summer and the years following produced irrefutable evidence that Camp Good Days was not only here to stay but would also make a sizable difference in the lives of children with cancer and other life challenges. The camp continues to take a leadership role in unchartered territories, such as sickle cell anemia and gun-related violence. Many of its programs and services have been used as models for childhood cancer treatment centers in America and abroad. What started in 1979 as a residential camping experience for Teddi Mervis and sixty-two other children with cancer has become one of the largest organizations of its kind.

Yet the need for Camp Good Days remains. From newborn to age fourteen, cancer remains a leading cause of death. For those between ages thirty and sixty-five, cancer claims more lives than the next three leading causes of death combined. And from newborn to age eighty-five, cancer is the number one leading cause of death. Many believe that if something isn't done by the end of 2016, then cancer—regardless of age—will be the leading cause of death in the United States.

There's a comment frequently heard at camp, and it goes something like this: "I wish there wasn't a need for Camp Good Days, but as long as children are sick, I'm glad it's here."

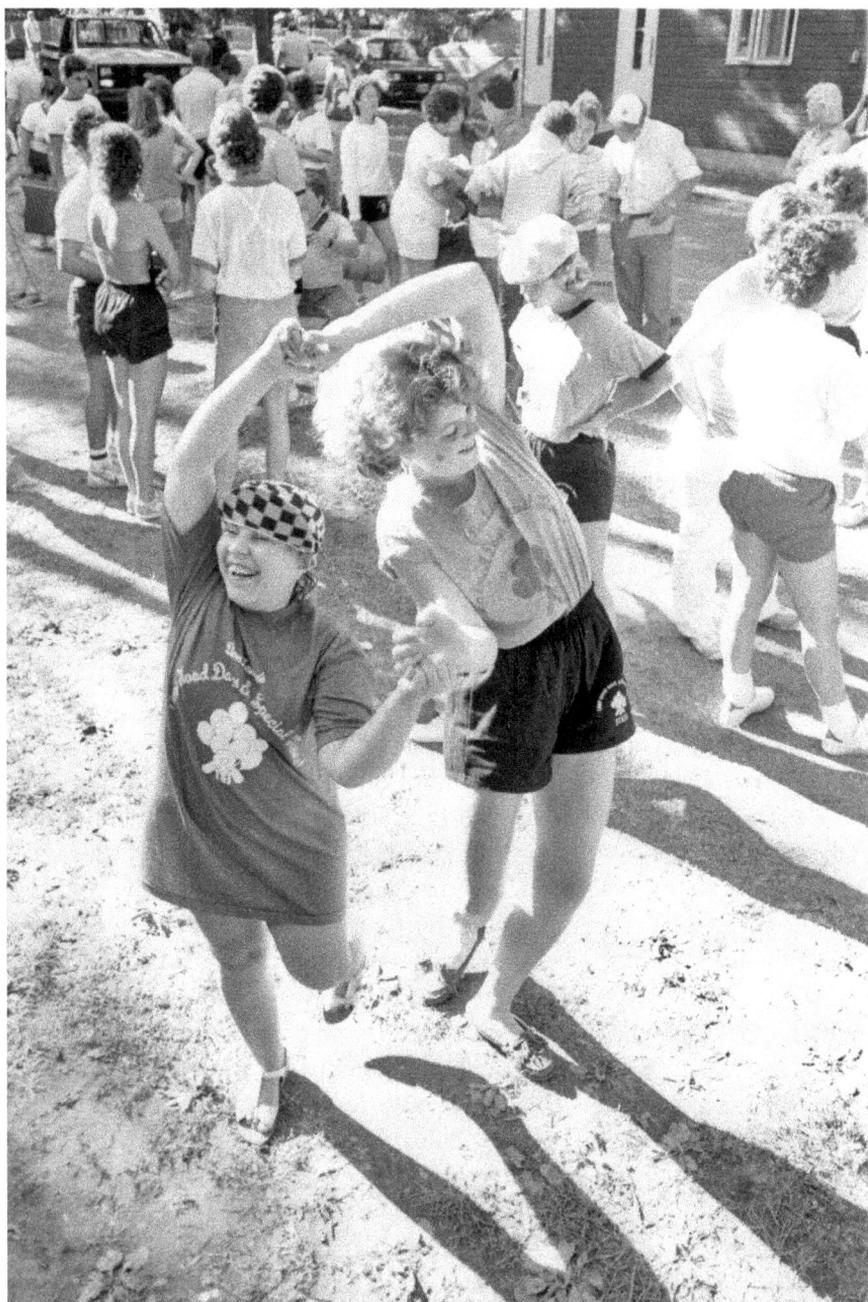

"Dance, dance my friend, as if there is no tomorrow." *Courtesy of the Camp Good Days Photo Collection.*

Gary was asked in 1989 about his future goal for the camp and replied, "I want to close its doors." It was time, he was beginning to feel, that a cure be found.

BEGINNING WITH 63 CAMPERS, Camp Good Days is now the summer home to more than 1,500. By 2015, their cumulative numbers had grown to a point where it served more than 45,000 campers from twenty-two states and twenty-nine foreign countries.

Volunteers at the camp are all unpaid. Those selected represent a variety of occupations, from blue-collar workers to doctors, lawyers and judges. They vary in age, as well, and include high school and college students, mothers, fathers and grandparents. They come from all parts of the country and from as far away as Australia.

The camp continues to witness the return of former campers as volunteers. This group composes an estimated 15 percent of the total volunteer staff, and that number is expected to grow as more and more survive cancer. Their arrival is an inspiration to younger campers.

It's obvious but should nevertheless be stated that camp volunteers return to their workplaces and communities with new understandings about children with cancer. In this way, too, the wall of ignorance with respect to childhood cancer gets chipped away. Many would argue that they have become more compassionate as individuals because of their experience at camp.

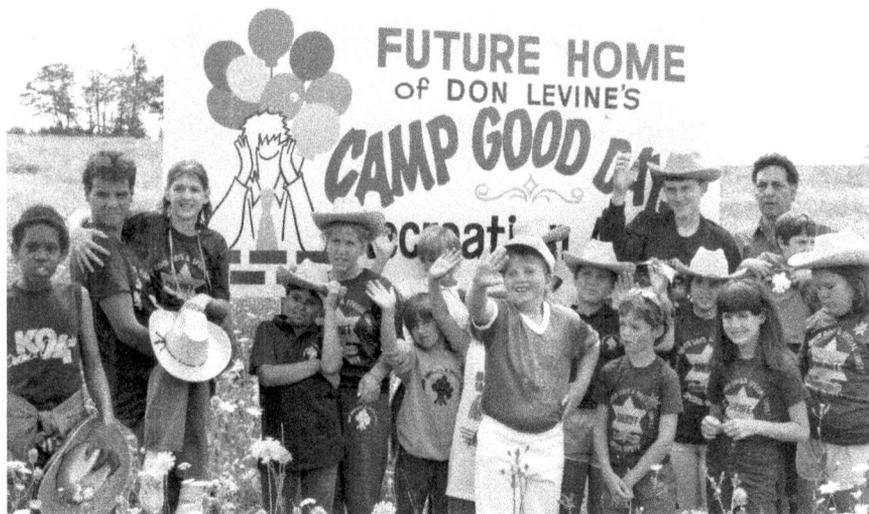

A new home at Keuka Lake for Camp Good Days. *Courtesy of the Camp Good Days Photo Collection.*

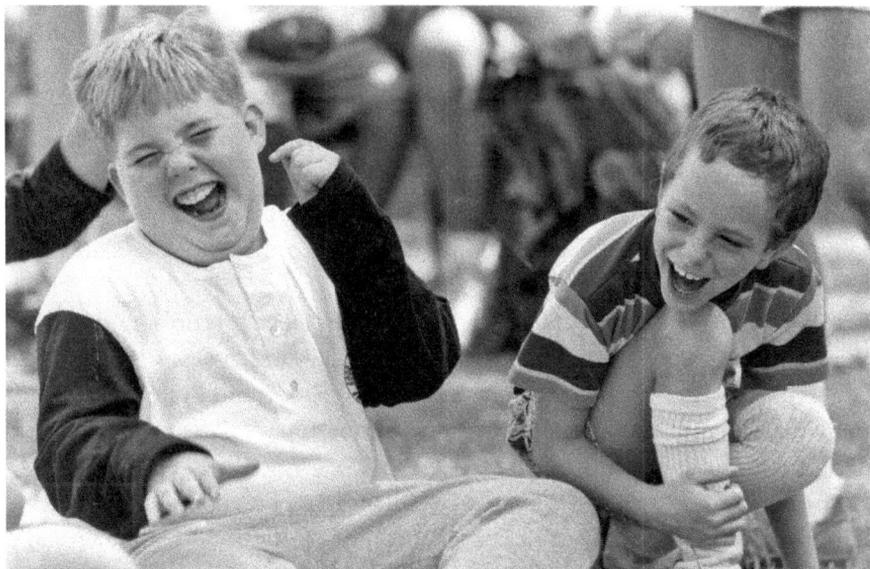

"Is there anything better than a good belly laugh?" *Courtesy of the Camp Good Days Photo Collection.*

THE SUCCESS AND VISIBILITY of Camp Good Days from 1981 to 1986, and the increasing number of campers who applied to come, meant more volunteers and staff were needed. There wasn't enough room. Children had to be put on a waiting list, and nobody wanted that. These factors, along with the desire to create year-round programs, made it necessary for Camp Good Days to purchase and renovate a permanent facility.

Under Gary's leadership, a $1.7 million fund drive was launched. An added bonus to the campaign was the arrival of actress Candice Bergen as chairperson of the drive. Bergen came to Upstate New York often, donating her time and talent to meet and greet, record public service announcements and participate in fundraising videos.

"With a permanent home," Gary would say at meetings and in the press, "we'll be able to concentrate fully on the quality of our programs and not worry about the logistics of setting up and tearing down five times a summer." The dream was to have a place specially designed to meet the needs of all those who came. "Besides having plenty of room for everybody, everything will be accessible to the handicapped. Our infirmary will be permanently equipped for emergencies...We'll be able to devote a whole summer to Good Days camping and have a home for programs throughout the year."

IN 1986, CAMP GOOD DAYS purchased a site on the shores of Keuka Lake near the village of Branchport, New York. The thirteen and a half acres already had existing buildings, but these had to be renovated and made handicap accessible. New buildings were also needed. Business contributed money and materials; labor donated skills, equipment and time. Thanks to these and other contributions, the estimated $250,000 expense cost the camp only $50,000.

Camp Good Days opened its permanent home in 1989. "It's really been a dream come true," Gary told a reporter. Everything in the new facility was accessible to handicapped campers, and there was even a handicapped-accessible swimming pool so that wheelchair-bound children with cancer could go in the water. The new camp has an infirmary specially designed for all kinds of emergencies. The new facility was now large enough so that no child would ever have to be put on a waiting list.

The camp now boasts tennis courts, a dodge ball pit, an eighteen-hole miniature golf course and a nine-square-foot basketball court. Youngsters dance to the music of rock bands, walk nature trails and still sing around campfires. There are two camp dogs with which to play. Children go canoeing, swimming and play on the inflatable water slide. They can also play softball and volleyball. They can go for hot-air balloon rides and try their hands at Project Adventure—a ropes course designed to help build cooperation and trust.

"A picture? How's this?" *Courtesy of the Camp Good Days Photo Collection.*

Peace for maybe one of the first times in public. *Courtesy of the Camp Good Days Photo Collection.*

In 2004, the camp opened a $1.3 million meeting, dining and recreation hall. The new 3,200-square-foot facility allows Camp Good Days to offer programs year-round. It has a 2,500-square-foot basement and a modern, high-tech kitchen. A heated dormitory was added and the camp's infirmary expanded. This, too, was in large part due to the financial contributions of business and laborers in terms of materials, skills and time.

CAMP GOOD DAYS CONTINUES to evolve, adding and deleting programs based on need and whether that need fits its vision. Recently, the camp's programs consist of weeklong summer camp sessions, adult oncology programs and community partnerships. All camp programs are free of charge. To obtain the most updated information, visit the camp's website, http://www. campgooddays.org.

The summer camp sessions are divided into various age groups for children who have cancer, sickle cell anemia or a parent or sibling diagnosed with these diseases. An entirely new program, different from the camp's earlier experiments, deals exclusively with brain tumors. It offers a weekend camping retreat for families with one member dealing with a malignant brain tumor.

The camp now fosters support and provides women who are dealing with cancer the opportunity to share life experiences. Designed by

"Gentle. Gentle, my new friend." *Courtesy of the Camp Good Days Photo Collection.*

women for women, the women's oncology program addresses the risks, fears and barriers of everyday life most women face during and after diagnosis and treatment. A supportive spouse/friend program has been added, and men participate in these programs too. The camp has also introduced a new men's prostate cancer retreat that some of the best doctor's in New York State attend.

Gary and the camp saw a need to protect and nurture those affected by violence. The Partners Against Violence Everywhere (PAVE) Initiative provides a series of antiviolence programming and support services, including Project Exile, the purpose of which is to help remove illegal guns from the community. Project TIPS—which stands for Trust, Information, Programs and Services—involves community agencies and law enforcement personnel working together in select neighborhoods to rebuild trust between residents and those in law enforcement. A number of law enforcement and social welfare agencies are part of the program.

ONE OF THE MOST venerable programs of Camp Good Days is the Teddi Project, started to grant the last wish of a terminally ill child. Gary announced it in 1982 while Teddi was in a coma. Over the years, hundreds of children have been granted trips to Disney World, visits to grandparents who lived far away and many other wishes. Some, such as Clarence "Huggy" Pettway, got his wish to meet his favorite celebrity, Bill Cosby, and the story evolved into an unexpected magical moment for the child.

"Funny. I don't feel alone." *Courtesy of the Camp Good Days Photo Collection.*

Huggy, his mother and his sister flew to New York City to watch a rehearsal of *The Cosby Show*, a trip paid for by the Teddi Project. Huggy gave Cosby a sweatshirt printed with the camp's name and logo. Later, after Huggy returned home, Cosby learned that the boy's condition was worsening. The comedian's agent called Huggy's mom and told her to watch the upcoming show.

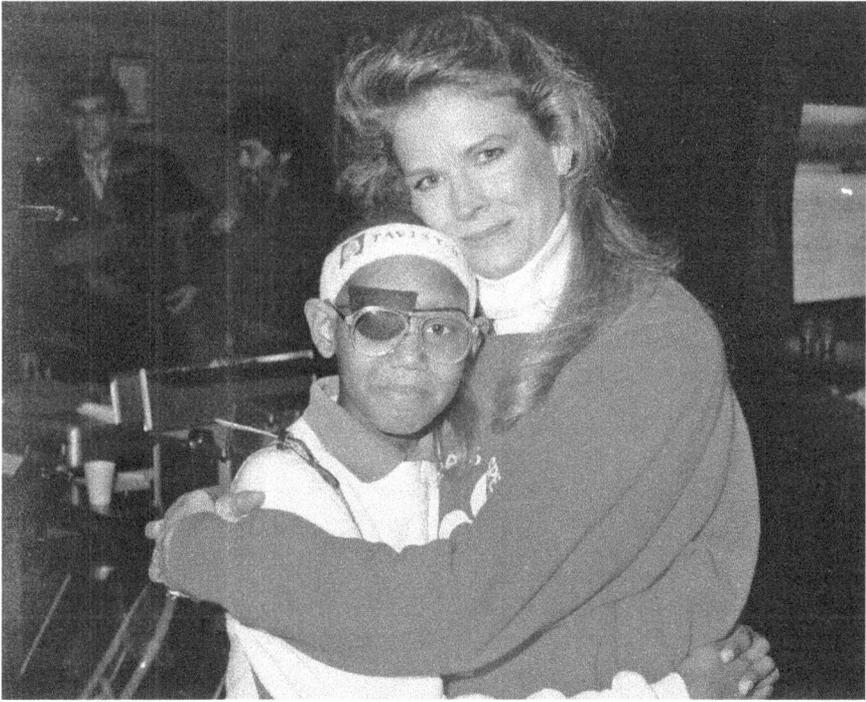

Actress Candice Bergen with Clarence "Huggy" Petway. *Courtesy of the Camp Good Days Photo Collection.*

The camp hosted a large gathering at a local restaurant with a big screen TV. It was a special moment for Huggy and his family, and scores of campers and volunteers wanted to share it with him. Cosby wore the sweatshirt that night but didn't say anything in the body of the show about Huggy. The disappointment was palpable. But then the show's epilogue came on, and Cosby told his onscreen wife that he only wanted a small birthday party, with only special people invited. It was then that he said Huggy's name. The restaurant erupted in a standing ovation. Too weak to stand, Huggy sat in his wheelchair, a patch over one eye, smiling.

GARY AND CAMP GOOD DAYS have a special relationship with St. John Fisher College (SJFC) in Rochester, New York, a small liberal arts institution, which has numerous undergraduate and graduate programs. It's not far from the Mervises' residence, and Gary recalls the time when he and Teddi were at a stoplight in front of the college. "Out of the blue," Gary recalls, "Teddi said she wanted to go to school there." She has, though not in the way either envisioned.

St. John Fisher College, Pittsford, New York. *Courtesy of Deedee Carey.*

Since the 1982 inception of the twenty-four-hour dance marathon at SJFC, known as the Teddi Dance for Love, Gary has been there to speak at every opening or closing ceremony except one when he was sick. He always brings some campers to the dance, which inspires Fisher students. The camp's relationship with St. John Fisher College further deepened with the advent of the Courage Bowl, a football game between SJFC and an opponent that benefits Camp Good Days. The event also includes campers in the festivities. It's been said on the Fisher campus that students hold two things dear: the Teddi Dance for Love and the Courage Bowl.

When I returned to St. John Fisher College for the fall 1982 semester, I was finishing this book. So moved by my first summer at camp, I told a handful of students in my office that we had to do something more for those children. Students Nate Daniels, Neil Trama and Mary Cronin kicked the idea around with me, and from that meeting, a twenty-four-hour dance marathon was born. That was 1982, and we raised nearly $8,000. It was hard going, but the idea caught on, and before long, the Teddi Dance for Love became the single most important college experience for Fisher students. Though mainly attended by students, one could always find Fisher's president, the dean and other faculty and staff members participating in some way.

The year 2015 marked the thirty-third year of the Teddi Dance for Love marathon, making it the longest-running tradition at SJFC. The annual February event was led by a 150-member organizing committee. More than five hundred students, alumni, faculty and staff participated.

One of the more moving moments at the marathon each year is when the dancing stops and a special camper is honored and remembered. The

One of the camp's honorary cheerleaders at the Courage Bowl. *Courtesy of the Camp Good Days Photo Collection.*

2015 honoree, Ashley Nagel, lost her battle to cancer at age five. Her family attended the event, and her parents shared their appreciation with the students. Afterward, they led students outside, and a balloon launch was held in their daughter's honor.

During the closing ceremony for that thirty-third marathon, Dr. Don Bain, president of the college, and Gary Mervis were on stage. "Never forget how you feel right now," Gary told the students. "Over the past twenty-four hours, you did something very special. And you did it for all the right reasons." The Teddi committee honored Dr. and Mrs. Bain for their participation and dedication to the event, presenting them with the Dr. Lou Buttino Faculty and Staff Award. The thirty-third annual Teddi Dance for Love was also special in that it has put the cumulative funds raised at over $1,000,000 since 1982. The funds that the Dance for Love raises go into the Teddi Project, which has been adapted into a group trip for children and women battling cancer to experience the magic of Central Florida.

The 2015 Florida Trip featured a day at Disney World's Magic Kingdom, a day at Universal Studios and two days on the Gulf of Mexico. Wendy Bleier-Mervis, Camp Good Days' executive director, takes fifteen volunteer chaperones and a practical nurse to dispense medications. "They create a special bond—help each other," she said. Being parents of children with cancer twenty-four-seven is exhausting, and so "their parents get a respite." Thus began what is now called the annual Florida Fun Fest.

There are spin-off dance marathons at the junior and senior high school levels. The Fayetteville-Manlius community hosts fundraising events and a twelve-hour marathon for students. The community raises more than $100,000 each year for the camp.

GARY MERVIS IS THE "kicking/punting" and longest-serving football coach at St. John Fisher College. He also leads the Fellowship of Christian Athletes Huddle.

Rochester, New York, and its suburbs are fiercely passionate about football, and St. John Fisher College is a top-ranked Division III powerhouse. With that as background, Gary was the driving force behind the creation of the annual Courage Bowl, a football game between the SJFC Cardinals and, initially, crosstown rivals the University of Rochester Yellowjackets. The game is dedicated to the children of Camp Good Days, and proceeds benefit the camp. The game has been played every year since 2005, though the SJFC opponent changed to Alfred University and then the State University of New York at Brockport. The Cardinals remain undefeated in Courage Bowl play.

What started as a rivalry has turned into a major community event. Before each year's game, honorary coaches and cheerleaders are selected from among the children at Camp Good Days. There are now established rituals. The two competing teams go to Camp Good Days for a day during the summer and visit with the children. They partake in camp songs and get to experience the magic of Camp Good Days firsthand. This allows the student athletes to get to know what they're playing for. It's manifest in the event's slogan: "More Than Just a Game."

In the week preceding the game, the honorary coaches and cheerleaders attend practice with their designated teams and practice with the varsity cheerleaders. On game day, these same children have a pregame meal with their teams, travel with them to the game, lead their teams onto the field and walk to midfield for the coin toss. The boys are given football jerseys, and the girls get their hair done and are outfitted with cheerleading uniforms. The selected children remain on the sidelines throughout the game, which is carried live on local television and radio. The winning team receives the Teddi Trophy, inscribed with the name of the team and the names of the honorary coaches and cheerleaders. Approximately 6,500 attended the inaugural game in 2005; now it's a sellout crowd of some 10,000.

The relationship between Gary and St. John Fisher College was sealed in 2005 when the school awarded him an honorary doctor of laws degree. In 2007, he was inducted into the SJFC Athletic Hall of Fame.

PROFESSIONAL ATHLETES AND COACHES have not only made financial contributions to Camp Good Days but have also headlined fundraising events benefiting the camp. Significantly, many find time to visit the camp itself and meet, eat with and play with the kids. They see firsthand what their support makes possible, and their life perspective is altered in some way. In turn, the children of Camp Good Days are made to feel even more special by people they've seen on television. Additionally, these professionals contribute their expertise with such things as game tickets, artwork and special activities for the campers.

The list of luminaries is long and continues to grow. Those from the world of basketball include Jim Boeheim (Syracuse), John Thompson (Georgetown), John Calipari (Kentucky) and Jim Valvano (North Carolina State University). In football, Jerry Glanville, former head coach of the Houston Oilers and the Atlanta Falcons, helped promote the camp, along with several other football representatives, including Buffalo Bills kickers

Steve Christie and Scott Norwood. In hockey, Lindy Ruff and Rene Robert, former Buffalo Sabres players, promote the camp.

Mia Hamm, world-renowned soccer star, also visited the camp. She disclosed to about seventy-five boys and girls who had siblings with cancer that her older brother Garrett died in 1997 from complications related to a bone marrow transplant. Garrett had guided her when she was young and coached her from the sidelines as Hamm grew into one of the best female soccer players in history. Garrett was her best friend. She told one reporter, "The grieving part is really tough. It's not something you get over with in a hurry. The thing about coming here is that I bet this may wind up being more therapeutic for me than it is for them."

The late New York governor Mario Cuomo and his wife, Matilda; Jack Kemp, housing secretary under President Reagan; Congresswoman Louise Slaughter; New York senator Charles Schumer; and other political notables have acknowledged the camp's importance and contributed a large part of the change in attitude toward childhood cancer to Camp Good Days. Teddi, when she was alive, sat on President Gerald Ford's lap and received an autographed picture from him. A group of campers later visited Ronald Reagan in the White House and had their pictures taken with the president and his wife.

THOUGH GARY USUALLY CONFINES his soft-spoken comments to interviews with reporters and press conferences, on April 17, 2006, he wrote a hard-hitting newspaper essay titled "Balance War on Cancer, War on Terror." It signaled a new idea that had been percolating in Gary's mind. A lifelong Republican who worked with both political parties, Mervis publicly criticized President George W. Bush for proposing cuts in the Centers for Disease Control and Prevention budget by $179 million and another $40 million from the National Cancer Institute. After 9/11, Gary wrote, "[America] has given carte blanche to anything to fight the war on terror but we are turning our back on the efforts to defeat one of the nation's biggest killers—cancer." He added, "I am tired of watching parents bury their children, as we buried my daughter Teddi."

A year later (in 2007), Gary called for a highly coordinated, concentrated effort in the war against cancer. He urged those voting to ask political candidates at all levels to be "committed to doing what President Nixon had hoped to do some thirty years ago and declare an all-out war on cancer, so that all of the Teddis of the future will be able to live their lives and go on to become wives, mothers, and viable members of society."

In 2008, drawing on his experience in politics, Gary wrote, "Our government is not visionary, but reactionary and it will not be until we as citizens and constituents demand that our money be spent on finding the answers we have been seeking for years…As we focus on our choices in the coming elections, we need to start asking now what our representatives at all levels of government are going to do to find the solution to cancer."

In 2009, Gary called a summit of survivors, professionals and those with an interest in cancer to brainstorm ideas for raising awareness and getting cancer back on the nation's agenda. Gary and his team researched and talked with most of the major cancer centers in the country. On December 2, 2010, Cancer Mission 2020, "The end of cancer by the end of the decade," was launched. At a press conference, Gary said that this grass-roots initiative would call for government funding and a coordinated approach to research, promote clinical trials and create a national cancer summit. To find out more, see http://www.cancermission2020.com.

As the 2012 elections approached, Gary was once again proactive.

> We have had four and a half hours of presidential debates, and during those 270 minutes, not once did either candidate make mention of cancer and what they were going to do about the war on cancer. For the past thirty years, I have dedicated my life, with the help and support of so many, to the founding and building of Camp Good Days and Special Times…I have seen what the diagnosis of cancer can do, both emotionally and financially, to the person battling this horrible disease and their family. I have been to more funerals than anyone should ever go to, because of this disease that will kill some 600,000 Americans this year and more than 7 million people around the world.
>
> It has been my dream that, during my lifetime, I would no longer have to watch parents go against the laws of nature and bury their children, as I did. Instead, children should be burying their parents after a long and prosperous life. After watching and listening to President Obama's State of the Union, where he had said he felt confident there would be an end of cancer in his lifetime, I turned off my television and went to bed with a new sense of hope!

Camp Good Days has caught the attention of prominent newspapers—such as the *New York Times*, the *Toronto Star*, the *New York Daily News* and *USA Today*—and has been written about in national magazines, such as *McCall's, USA Today, Family Circle, Ladies' Home Journal, MAMM*

Magazine and *Seventeen*. Several major medical journals—such as *Oncology Times*, *Cancer Today* and *Cancer Nursing*—have also focused on the camp, along with scores of national television and documentary programs.

WHEN CAMP GOOD DAYS began, there were only four pediatric oncology camps in the United States; now, there are eighty similar organizations from Vermont to California. These camps have collectively joined together to share information and ideas in a national organization called Childhood Oncology Camps of America (COCA). Many are modeled after Camp Good Days.

Camp Good Days began its international endeavors in the early 1990s when six youngsters from Hadassah Medical Center in Jerusalem, Israel, were invited to take part in two one-week sessions at the camp. Representatives from Mexico, Germany, Latvia, Poland, the Bahamas and other countries are visiting the camp and taking ideas back home. A German social worker said, "We have copied this idea completely."

Though the children speak different languages, they have one language in common: cancer. These children from foreign places said that the other children with cancer understand them better than their own compatriots. A child from Poland put it this way, "We have no trouble understanding one another. We all have the same fears and the same hopes." The camp's executive director, Wendy Bleier-Mervis, commented, "The camp lets all the world come together. It's a change from the real world, since there is no religion or politics here."

THE CAMP'S PHILOSOPHY IS that programs should be free of charge because families dealing with cancer have such high costs related to the disease. But that comes at an enormous price. With little administrative overhead, the camp has raised more than $77 million for its programs and services, with less than $1 million of that in government funding. The camp relies on volunteers for almost all of its activities and the tireless efforts of its leaders. An attitude that pervades the camp is that it will outwork similar organizations in regard to its mission. When the economic downturn hit in 2008, the staff took the hits and not the programs, making such sacrifices to ensure that the programs would still be provided free of charge to its participants.

A major storm hit Camp Good Days' campgrounds in the spring of 2014. Severe thunderstorms rolled over the area, causing an estimated $500,000 in damages. The flooding ruined the lower camp's infrastructure, flooded several buildings and damaged other facilities at the property. Gary said,

"I don't know when I've been so overwhelmed by the devastation. All I could do is go to my car in the parking lot, and I just broke down and cried." He said he hasn't cried that hard since his daughter Teddi died. Camp was scheduled to open at the end of June, but with so much damage and a small budget, it looked like opening week was questionable.

What did Camp Good Days mean to people? Scores of volunteers came, from the Rochester area and from other states. In fact, so many came that some had to be turned away. Money began to pour in. Gary had not seen some of the volunteers in years, and others he simply did not know. He was overwhelmed by the response, which also included hundreds of notes, letters and prayers. He told Wendy it was like being at his own wake. The camp opened on time, and not a single children's program had to be scrapped.

Gary and Wendy Bleier-Mervis on their wedding day, June 10, 1995. *Courtesy of Kevin Higley.*

GARY, AT SEVENTY, IS SLOWLY relinquishing control of the camp. He married Wendy Bleier in 1995, and she became his partner in life and at Camp Good Days.

A 1984 graduate of West Irondequoit High School in Rochester, Wendy was a star in soccer, basketball and softball, earning All Monroe County and All Greater Rochester honors. She won Female Athlete of the Year and landed a scholarship to Colgate University in Hamilton, New York, and remains one of its top female athletes.

Wendy Bleier-Mervis started as a lifeguard at the camp in 1991, while she and Gary were dating. She continued teaching and coaching in high school, while

Wendy Bleier-Mervis with a camper at Keuka Lake. *Courtesy of the Camp Good Days Photo Collection.*

becoming the camp's program director. Currently, she is its executive director. Wendy is likely to succeed Gary when he steps down officially. She has experience at every level of camp activity and administration. She is energetic, passionate about the camp's mission and an intelligent, kind and thoughtful person.

It's clear, as Wendy herself says, "There will never be another Gary Mervis." When he retires, others, including the board of directors, will have to step up to fulfill the enormous hole that will be left by his departure. A highly successful fundraiser and a savvy marketer, Gary is persuasive and a tireless worker. In Latin, an adjective that would best describe him is *sui generis*, "unique" or "one of a kind."

Gary carrying the Olympic torch in 1996. *Courtesy of the Camp Good Days Photo Collection.*

A Spiritual Journey

For me, this was a spiritual journey even before the Mervises saw the short story "A Cloud for Kate" in the newspaper and wanted me to write this book.

When I first finished the short story, I was teaching at St. John Fisher College. It was 1979, and when I began class that morning, I must have exhibited the fact that I was very happy about something. The students asked what was going on, and I told them that, while walking to school, I had finished a story I had been working on for about six months.

"Read it to us!" they chanted. But they couldn't trick a veteran professor. "Those who want to hear the story can wait until after class is over, and I'll read it to you then. It should only take a few minutes." Most stayed.

The story is about a little girl named Kate who loved her grandpa because he often answered her questions with a story. She wanted to know where clouds came from, and he proceeded to tell her a tale that concludes with the notion that when people die, their spirits enter us and we truly see them in their entirety for the first time. It is for that reason we should be saying hello and not goodbye.

Kate spent the summer watching clouds and reading the stories they told. But that autumn, her grandfather died, and she was very sad. Then, early one spring morning, she saw the biggest, most beautiful white cloud she had ever seen sailing toward her. The story ends with, "And with a cry that could have awakened the whole world, she shouted hello to her grandpa."

One of my students came up to me after class and asked if he could have a copy of the story. I ran one off for him at the copier. He said he wanted to show it to his mom and waved goodbye.

Steve was absent from class the following Monday. One of his classmates told me he died of an aneurysm over the weekend. Steve was a good kid, smart and funny, and I missed him. It's never easy to lose a student.

Weeks later, a handwritten envelope arrived at my college mailbox. I found an isolated bench outside to open it. The letter was from Steve's mother.

She said that she and her son were constantly trading magazine articles because both differed politically and that on Friday, the last she would ever see him, they had exchanged articles like always. But he added something new. He told her that at the bottom of the pile was a short story his professor had written. He wanted her to read that, too.

"I took my time making my way through the pile Steve had left me," she wrote. "They were the last things I would ever receive from him." She

came to the end of the articles and found the short story. Though she had forgotten about it, she did not forget what her son had told her.

"Dr. Buttino," she wrote, "I read the story and had an overwhelming sense of Steve's presence. I got up, went to the window and saw this beautiful white cloud in the sky. I was sure it was Steve come to tell me he was all right and that I could be at peace."

When I was at the camp that third year, children, counselors and staff began to address me as "the Writer." I always had a notepad with me, and they knew I was writing a book about the camp.

During the camp's powerful ending, when the children were about to leave, I wandered through the crowd, jotting down notes about scattered impressions and conversations. I spotted the mascot Teddy Bear, the huge bear on the steps of the recreation hall that often had notes pinned to it. I knelt beside the bear, wanting to observe that hard farewell from the same spot Teddi had viewed it the year before.

Gary Mervis walked past. "What do you think, Writer?"

Looking up, I answered, "There are no words." But he was already gone.

LaVerne Haley strolled by himself through the crowd of hugging and tears and made his way to the mascot bear. At other summer camps, kids might be sad because they won't see a friend for another year; at Camp Good Days, they might not see each other ever again.

Out of the corner of my eye, I saw LaVerne climb into the chair. He made for a tight fit with the bear.

LaVerne turned to me and asked, with an old man's low, raspy voice, "Do you mind if I call you 'uncle'?"

This was the first time he had talked to me. I was surprised by the question but told him it would be okay. And then LaVerne asked if he could see my pen.

I tried to explain that I needed it in order to record the details of what was happening, but LaVerne wasn't the least impressed. I gave him my pen, which he promptly took apart. He couldn't put it back together again, so I had to help him. LaVerne then asked for a piece of paper.

While LaVerne drew on the paper, a "boy-clown" came over to him. The boy-clown never talked in costume nor did he disclose his identity. People at the camp believed he was a child with cancer, too, but nobody ever knew for sure. LaVerne looked up. "*If* I grow up," he told the boy, "I want to be

a clown, too." And then the two kissed, on the lips, tenderly and without embarrassment. I thought of the little boy who had come for Teddi that previous autumn, when the trees were bare and hope dying. It was also a reminder to me that children with cancer live in a world of their own.

I watched LaVerne as he folded the paper, drew a heart on the outside and then handed it to me. I thanked him. Without a response, he climbed down from the chair, after refusing my help, and entered into the whirl of people gathered for the waiting buses. I wished I had hugged him then, but somehow it felt like I would be intruding. This is the same little boy who had his suitcase packed and under his bed when he went in for brain surgery. He didn't want to miss camp. It was also the same kid who sang at Talent Night, repeating over and over again to a standing ovation, either "don't take my *love* away" or "don't take my *life* away." Who the heck knows, maybe he was saying both. I wished I had hugged him then, and I know it doesn't make sense, but I also felt if I had hugged him, then I would be giving up on him.

Slipping LaVerne's folded paper into my pocket, I returned to writing down what I had seen and was seeing. It was several days before I came upon my old jeans, lying in a pile ready for the laundry. Emptying the pockets, I found LaVerne's slip of paper. Exhausted for days after camp closed, I had forgotten all about it. Unfolding the paper, I found that inside LaVerne had drawn my face—beard, baseball cap and all.

What was he trying to tell me from that world he inhabited? Was he saying I was not only writing the story but was also part of the story? Was disassembling and putting back together that pen a symbol that I had entered a different world, his world?

The spiritual nature of the journey I had embarked on continued. For example, about a quarter of the way through writing this book, I was awakened one night by the sound of a child crying. I lived alone, and when I reached the bottom stair, the crying stopped. I felt it was Teddi and that I could hear her now. One time, when we were discussing this book in class, a look of surprise came over a student's face. I asked him about it. "I was the kid that sold Skip the worms that the children caught fish with from what we all thought was a dead lake."

Further, the book ends, as the reader knows, with the flight of a hawk over the campground after the buses leave. For the Native Americans who lived

there and named the mountains, a hawk flying overhead before a difficult journey meant good luck.

A memorial service was held a year after Teddi died. Father Ambuske officiated, and his small church overflowed. It was cool outside, and the sky was overcast. Rain threatened.

Leaving the church after the service ended, I felt a tug at my sleeve.

"You're the Writer, aren't you?" a woman wanted to know.

It took me a moment to understand what she meant.

I nodded, noticing as I did so, that the man walking beside her had begun to drift away. His face was flushed, and he took out a white handkerchief and began to pat his eyes. I suspected it was her husband.

I stopped and motioned her off the sidewalk, away from people leaving the church. We kept walking, more slowly now, and stopped on a more isolated part of the grass.

"I want to tell you a story," she said. "I thought you would like to know."

"Please."

"Gary gave me your book to read after I lost my own little girl to cancer. He said it might be of comfort. It took a long while to even begin reading it because I was overcome with grief. But once I started, I couldn't put it down. Read it straight through in a single afternoon. And then, just a few moments after I had finished, flushed with emotion, I heard the screen door slam and my little son come rushing in."

"Mommy! Mommy!" he cried. "Come with me! I want to show you something!"

"I told him I didn't feel up to it just then. But he insisted, took my hand and tried to pull me out of the chair."

Once outside, he shouted, "Look!"

"He was pointing at a thicket of bushes behind the sandbox where he and his deceased sister often played. At first I didn't see anything," she said, tears beginning to brim in her eyes. "But then I saw this big hawk, whose shades of browns had blended in with the wooded area it was in. We stared at each other for a few moments, the hawk and I, and then he began his slow ascent into the sky. I watched him disappear. Like a soul. And I knew my daughter was going to be okay."

She held on to me, and I let her weep. It seems people hold on to to each other when there is little left to hold on to.

A big story making the newspapers, magazines and subsequent books nationwide was the April 6, 1987 fight between boxing legend Sugar Ray Leonard and the ferocious "Marvelous" Marvin Hagler. It was the most anticipated fight in the boxing world since Muhammad Ali and "Smoking" Joe Frazier battled each other in the "Fight of the Century." Hagler had not lost a single fight in more than ten years; Leonard was retired from the ring and had only one fight in five years. The odds makers were sure Leonard wouldn't have much of a chance against Hagler.

But right before the fight, Leonard made a surprise announcement. He said he was dedicating the middleweight championship bout, to be viewed by millions, to the children with cancer from Camp Good Days and Special Times. His son Jarrell had read this book in his school library in Maryland and insisted his dad read it.

In a stunning upset, Leonard beat Hagler that night. Many of us with the camp, hearing about the dedication, watched the fight. Leonard's reason for dedicating the fight the way he did was never disclosed. One can only surmise that he saw something in the children's courage that inspired his own.

There were more such instances, directly connected with the book, but I also found inspiring moments at the annual Dance for Love marathon at St. John Fisher College. I know it sounds hokey, but I started to think of the dance as the night of the small miracles. Each year there were these small moments—small in terms of global politics and the shifting of constellations. Yet the world probably changes in small ways. Being at camp among the children with cancer was teaching me to look for and appreciate the smaller things in life. The night of the small miracles was about healing, courage and growth. What happened that night spilled over into other occasions, when there was no music and the dancing at an end.

Sean danced for twenty-four hours his junior year, but in his senior year, the basketball team had an away game, so he couldn't be there. Yet three days after the marathon's end, on the same gym floor as the dance had been, the men's basketball team took on archrival Nazareth College. Fisher was the clear underdog, but the game was passionately contested, and the score edged back and forth. At the buzzer, the game was tied and went into overtime.

Sean played a remarkable game that night. I was sitting on the bottom row of bleachers and could see him time and again struggle hard for rebounds against a much bigger opponent. I saw him offer words of encouragement to his younger, less-experienced teammates. Then, in the final play of overtime, about ten feet from where I was sitting, Sean stole and hung on to the ball even though he was being bumped and challenged with a ferocity that belonged more to a street fight than a basketball game.

Sean broke the school record for rebounds that night. He was still holding on to the ball when I hugged him. "I did it for Teddi!" he said. "I did it for her, Doc!"

A few days later, I heard from Sean's mother. She wrote that her son was much too private to tell me that she had cancer and that he called her after the game to say he had done it for her, too.

Less than a year after LaVerne Haley died, we dedicated the dance to his memory. His parents came. At the end of the dance, they thanked the students and then called me to the stage. LaVerne's father presented me with a framed color portrait of his son. There are times when the heart goes numb.

The sorrow of going to the funerals of too many children were as difficult for me as for others involved with Camp Good Days. It was hard to see children you talked with and held suddenly lie frozen in time in their small caskets. It was hard to look their parents in the eyes. And somehow hardest of all was when the doors opened to the funeral

A night of healing: Dr. Lou Buttino with student leader Missy at the close of the St. John Fisher College dance marathon. *Courtesy of Lou Buttino.*

A night of compassion: two friends at the close of the Dance for Love. *Courtesy of Lou Buttino.*

parlor and there, down the sidewalk and in a long line winding out of view, were the children from camp, waiting, despite their own pain and grief, to pay their respects to a fallen comrade.

———

Gary Mervis and I have a friendship unlike any other. Though we haven't seen each other often since I left New York State to teach in North Carolina, we have an understanding that seems to deepen over the years.

I was the first person he told the whole story about his daughter's diagnosis, treatment and death. He entrusted me with this story, without review of the manuscript by him or anyone else. Even in this third publication of the book, Gary never once asked to see a single chapter, paragraph or sentence. This is an enormous trust, given how visible he is in the Rochester community. And it is something I do not take lightly.

In our last interview, I told him I still didn't fully understand why he and Sheri wanted me to write the book.

"I never once hesitated," he said. "It was part of a plan."

I should have followed up but didn't—I guess I was too surprised by his answer.

Before the second edition of this book went to press, my own daughter was born. It was then I felt an even deeper bond with Gary. When my daughter was born, I felt as though I was holding my breath. I feel I am still holding it. Having a child is like having your heart out in the street somewhere and there's not much you can do about it. I named my daughter after Teddi's given name, Elizabeth.

Gary and I also coached football together at SJFC. He was the kicking coach; I was the "academic" coach. I helped with the recruitment and retention of student athletes but didn't do much on the practice field. Sometimes I added my weight to the "blocking sled" while lineman took turns pushing it—and me—around the field. Sometimes I would give mini-lectures from the sled in regard to upcoming tests the players had. Sometimes I simply erupted into spontaneous lectures. Gary and I shared Fisher football practices, road trips, games and related events.

The Simon and Garfunkel song "Old Friends" ran through my mind when I interviewed him for this edition of the book:

> *Old friends, old friends*
> *Sat on their park bench like bookends...*
> *Old friends, winter companions, the old men*
> *Lost in their overcoats, waiting for the sunset*

Like most old friends, only a minute or two rather than years seems to have passed when we sit down together.

After more interviews with Gary; his wife, Wendy; and others for this edition of the book—after researching Gary and the camp in newspapers, articles and in TV interviews and news clips—I get a sense of how Gary has changed over the years. His mission to reduce, as Camus said, the number of suffering children has transformed him.

Gary has given his life and career over to Camp Good Days and not because he was incapable of success in other endeavors. He was on his way to being a top Republican strategist when his daughter was diagnosed with a brain tumor. He is a demonstrated success as a coach and could have gone on in that field as well. But Camp Good Days is what he chose—or what chose him.

Philosopher Blaise Pascal said, "A man does not show his greatness by being at one extremity, but rather by touching both at once." Gary said as much; he gave examples of extremes in his own work when he wrote, "As Chairman and Founder of Camp Good Days and Special Times...I have had the chance to see the very best of the human spirit, through our programs for children battling cancer, and the very worst of the crime and violence in our community."

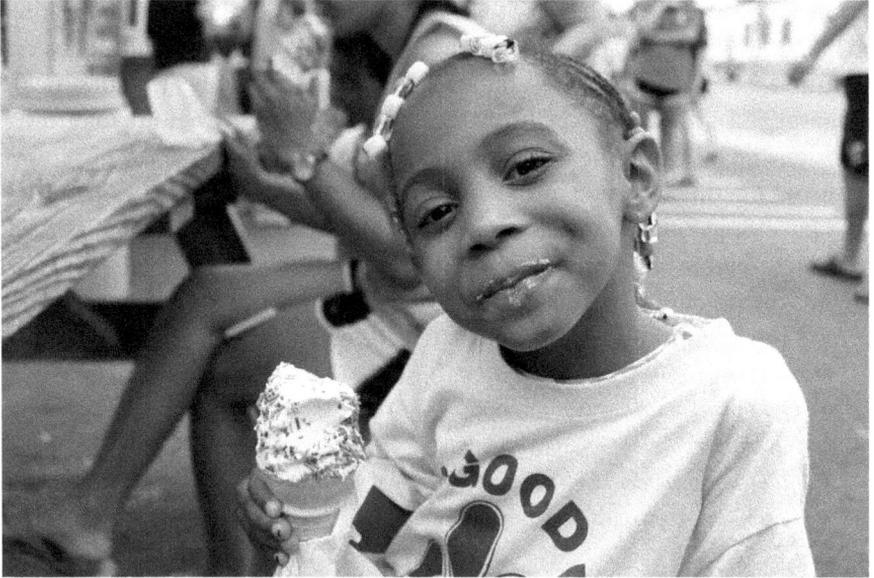

"You can take my picture but not my ice cream!" *Courtesy of the Camp Good Days Photo Collection.*

He saw these extremities in other ways, too. "Oftentimes after I have spoken to a group about Camp Good Days, people will approach me and say that they would love to get involved but that they think it would be far too emotional to volunteer…I always feel bad when people say this, as I know they are truly missing out on something very special and uplifting." At another point, he said, "The one thing I can promise you, as a volunteer at Camp Good Days, you will experience a number of full days during which you will have the chance to laugh, at yourself and with others; you will have the chance to learn a little bit about yourself and about others; and your emotions will be brought to tears, sometimes tears of joy and sometimes tears of sadness."

Gary has gone to more funerals than anyone I know, and they are mostly children's funerals, the hardest kind. Yet he continues to find joy in the midst of such sorrow. He said it was hard to explain "what it is like to see a young person on their very first airplane ride or to see their faces light up when they

enter the attractions or when they step into the ocean for the very first time. That experience is etched in my mind forever." One of his favorite passages is from Satchel Paige, the longtime Negro baseball league star, "Don't pray when it rains if you don't pray when the sun shines."

Many, many people have supported Gary and Camp Good Days over the years, from volunteers to those who contribute financially to the camp itself. So many volunteers apply that some have to be turned away. Under his leadership, the camp has raised more than $77 million for its free-of-charge programs and services (approximately $1 million is from government funding). The sustained support of Camp Good Days for more than three decades has made Gary an even more demonstratively grateful person. It is an everyday kind of gratitude, from words to a behind-the-scenes idea to surprise a kid in need.

He invites veteran campers and volunteers back for reunions as a way of showing his appreciation. He hosts the annual, jam-packed A Night of Gratitude. There's a social gathering and then a ceremony where individuals who have exhibited a special dedication to the camp are honored. Those who truly went above and beyond to help camp fulfill its mission in the previous year are given the Teddi Award. And those who have made the self-same commitment to camp from its inception—be it individuals, groups or companies—are inducted into the Ring of Honor. This is the most prestigious award given by the camp and one of the most revered in the Rochester community. Gary's gratefulness reminds me of what theologian Meister Eckhart said once, "If the only prayer we ever say in our lives is 'Thank you,' that will be enough."

Gary admits that he has become more spiritual the older he's gotten. He uses the word "miracle" and talks about his "heroes" as those being from camp. He talks about "hope" and uses phrases such as "it's up to the good Lord" or "if the good Lord allows." I don't recall this being so pronounced when Camp Good Days began.

His emotions are also closer to the surface now. Though not afraid to express them, he doesn't overindulge them. After receiving the news that one of his

camp heroes had died, he said he "buried his head in the pillow and cried." As previously noted, Gary went down to camp immediately after the flood and said at a press conference that afterward he went to his car, got inside and cried.

Gary is still writing and speaking powefully about the effect his immersion in the world of childhood cancer has had on him. At one point, he noted that cancer is a "disease that not only takes the lives of so many prematurely, but seems to have to humiliate them in the process." He also has said, pointedly, that cancer "is an equal opportunity killer. Cancer, unfortunately, doesn't care if you are rich or poor, young or old, black or white, Democrat or Republican."

But I find him more frustrated these days. He told me he was coming back from a child's funeral and asked himself why he was still going to them, after all these years, and why more hadn't been done to make cancer something less than a death sentence. His writing and speaking in the advent of Cancer Mission 2020, cited in the previous chapter, is evidence of this heightened level of frustration.

Gary has a good sense of humor, and that should not be forgotten. One time when we were standing next to each other on the practice field, he called over a young Italian kid, one of our best players. He lifted up my cap, exposing my bald head. "Bingo," he said, "This is what you're going to look like in thirty years."

I waited for just the right opportunity to respond.

He, Fisher head coach Paul Vosburgh and I were walking off the field at halftime in one of our games. Paul turned to me, "One of the refs said he didn't care if you were a priest, he was going to throw a flag if you kept getting on his case."

Paul asked, "Why does he think you're a priest?"

I made sure Gary was close by and could hear. "Well, Coach," I said, "every time Gary's punter goes back to kick, he closes his eyes. I make the Sign of the Cross then, and probably that's what the ref was seeing."

Out of the corner of my eye, I could see Gary smiling. And I knew he would wait for the best timing for a comeback.

Gary makes me think there is some kind of relationship between humor and hope. Voltaire said if it weren't for humor, human beings would surely hang themselves. I think humor gives us a second spiritual wind to reenter the world and face life's inevitable challenges and struggles.

One of the things I think about is how many people in the book and at camp do good and kind things without concern for being acknowledged or rewarded. Sally Masten put a heart in Teddi's medical record on Valentine's Day, not knowing that I or anyone else would ever see it. Perhaps this is a world steeped in agony, but I wonder if a great deal more good is taking place than is reported or realized.

When I think of the thousands of children and volunteers, including dance marathon participants, Courage Bowl athletes and campers and so many other programs and events, I wonder if compassion and courage have not become a more formidable part of Rochester community life than they otherwise might have been.

Though I had moved to North Carolina to teach, I would occasionally return over the years. I noticed that the founding members, close friends of Gary's, had trouble looking me in the eyes, at least at first.

Gary is well known and recognized in the Rochester community. I counted more than thirty awards and honors, from high schools to nationally prestigious awards such as the 2013 FBI Director's Community Leadership Award and the Ellis Island Medal of Honor.

Yet even though he's accomplished and recognized so much, to this day, I believe he'd trade it all to have his daughter back—even for a few minutes. In the interview I did with him for this edition of the book, I said, "I ought to be asking you something about Teddi but don't know what it is."

He smiled, tears brimming in his eyes, and said someone asked and answered her own question about that. She said Teddi would probably say she's proud of her old man.

There is a quote hanging on the wall of his office, filled to overflowing with memorabilia. It's by Mark Twain and reads, "The two most

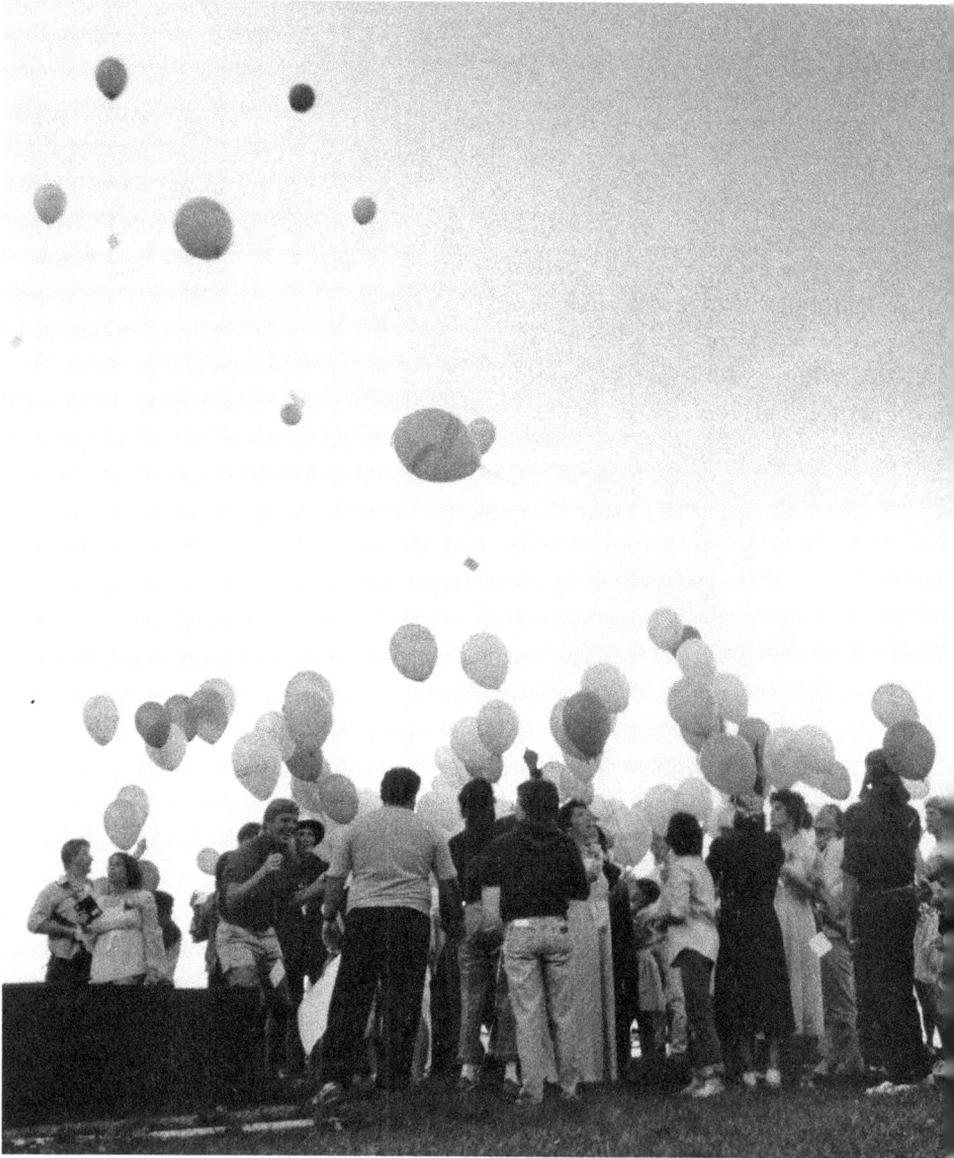

important days in your life are the day you are born and the day you find out why."

I asked him if he found out why.

He nodded and said, "Yeah, a while back."

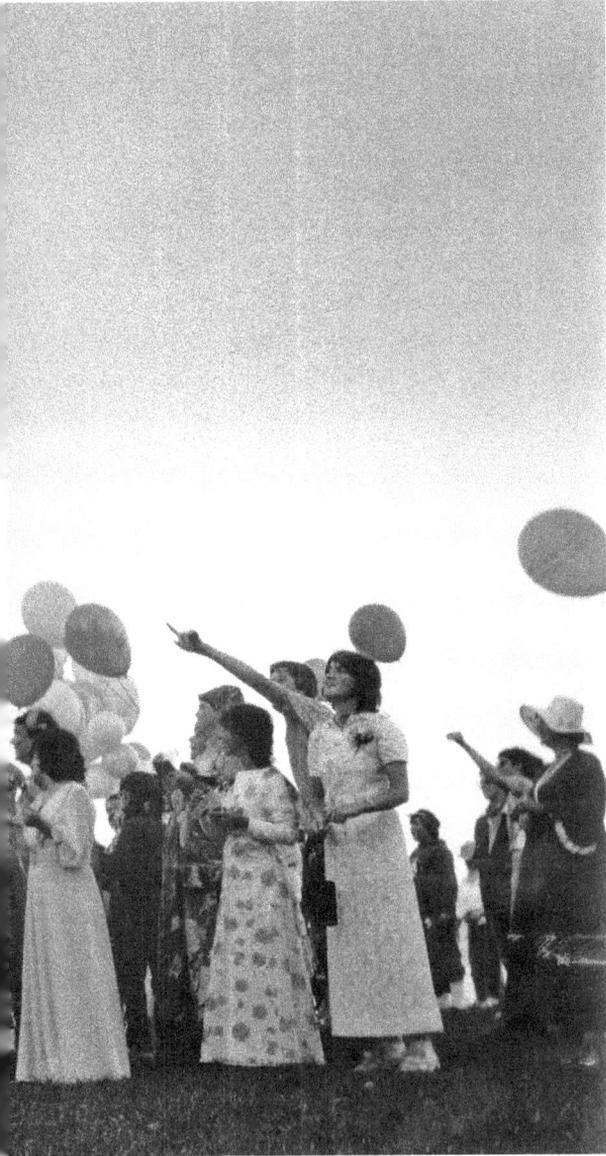

Another soul. Another goodbye.
Courtesy of the Camp Good Days Photo Collection.

What began as a father's desire to see that his terminally ill daughter was modestly happy has had a positive impact on the lives of thousands of children who were once ignored and largely absent from life itself. What began from frustration and anguish has changed the consciousness of

literally thousands about suffering children. Looking back, that young attorney, now a grown man, married and with children of his own, had called it right. With Gary at the helm, "It all seemed preplanned."

The Camp Good Days and Special Times story is one of fortitude and triumph. It has been an enormous practical success. It also has pushed the human heart to redefine what it knows about hope and to understand more fully the costs of truly loving.

The spiritual journey continues for me, and for so many others who have come into contact with Gary and Camp Good Days and Special Times. The experience makes thin the veil separating this world from a more spiritual other.

About the Author

Lou Buttino—who is from Canastota, New York, near Syracuse—is a graduate of Colgate University and holds MA degrees from the University of Miami and Colgate Rochester Divinity School. His PhD is from the Maxwell School of Citizenship and Public Affairs, Syracuse University.

Dr. Buttino taught at St. John Fisher College in Rochester, New York, from 1973 to 1993 and at UNC-Wilmington in North Carolina from 1993 to the present. He received each institution's award for teaching excellence, outstanding scholarship and service to students and the community. A two-term chair of the Film Studies Department at UNC-Wilmington, he helped bring the program to national attention. Over the years, Buttino has developed and taught fifty-five courses across four disciplines: political science, communications, film studies and creative writing.

Outside the classroom, Buttino is an award-winning filmmaker, author and playwright. His documentaries have received national broadcast on PBS, NPR and ESPN. The *New York Times* has critically reviewed his work, and he, with co-author Lou Giansante, is included in a text alongside writers such as James Baldwin, Annie Dillard and Alice Walker. He has received numerous writing awards in screenplay competitions and in theater. His screenplay *Shadowboxing the Mob* won ten festival honors and is slated for production.

Throughout his career, Dr. Buttino received numerous academic grants; was an invited speaker at Harvard, Brown and Syracuse Universities; and has been interviewed scores of times by television,

radio and print journalists. A special manuscript and film collection of his work is housed at the William M. Randall Library, UNC-Wilmington. Among other work, he also is a freelance writer. His website is http://www.LouButtino.com.

www.ingramcontent.com/pod-product-compliance
Lightning Source LLC
Chambersburg PA
CBHW070359100426
42812CB00005B/1568